COLLECTOR'S ENCYCLOPEDIA OF

CALIFORNIA POTTERY

COLLECTOR'S ENCYCLOPEDIA OF

CALIFORNIA POTTERY

by
Jack Chipman

COLLECTOR BOOKS
A Division of Schroeder Publishing, Inc.

The current values in this book should be used only as a guide. They are not intended to set prices, which vary from one section of the country to another. Auction prices as well as dealer prices vary greatly and are affected by condition as well as demand. Neither the Author nor the Publisher assumes responsibility for any losses that might be incurred as a result of consulting this guide.

Searching For A Publisher?

We are always looking for knowledgeable people considered to be experts in their fields. If you feel that there is a real need for a book on your collectible subject and have a large comprehensive collection, contact us.

COLLECTOR BOOKS
P.O. Box 3009
Paducah, Kentucky 42002-3009

Additional copies of this book may be ordered from:

Collector Books
P.O. Box 3009
Paducah, KY 42002-3009

@ $24.95. Add $2.00 for postage and handling.

Copyright: Jack Chipman, 1992.
Values Updated, 1995.

This book or any part thereof may not be reproduced without the written consent of the Author and Publisher.

Printed by IMAGE GRAPHICS, Paducah, Kentucky.

Dedication

I purchased my first piece of "made in California" pottery at a flea market near San Francisco in 1972. But like most beginning pottery collectors at that time, I gravitated to the better-documented Ohio potteries like McCoy, Weller, and Roseville at first.

It took six years of fervent collecting and "selling off" before I decided to completely shift the collection's focus to the ceramic heritage of my own native state.

Since then my collecting habit has become more of a personal extension of my developing aesthetic sense. But it also reflects a continuing fascination with the unique commercial ware that was once an indispensable part of life in Southern California.

I don't really consider myself a historian, but I have taken considerable (perhaps too much) time to learn about the local industry that left us these artifacts. And I have had the great pleasure of meeting and interviewing many people (some of them legendary) who were once connected with the industry. I must thank them above all for their kindness:

Sascha Brastoff, Michael Brayton, Herb Brutsché (Bauer), Frances and Carlotta Climes (Will-George), Kay Finch, Betty Davenport Ford (Florence Ceramics), Douglas and Claudia Gabriel (Winfield), Anna Haldeman, Bunny Hamilton (American Ceramic Products), Ida Harris (Brayton Laguna), Victor Houser and Tracy Irwin (Bauer), Marie Johnson (Pacific/Catalina), Brad Keeler Jr., Phil Keeler, William Manker, Howard Pierce, John and Maxine Renaker (Hagen-Renaker), Hedi Schoop, Richard Steckman (Freeman-McFarlin), Roger "Bud" Upton (Catalina), and Don and Bruce Winton.

Others who gave of their time and talents or made a special contribution toward making this book possible include:

Deborah Agata, Al Alberts, Melinda Avery, Danny Babcock, Gary Booth, Pam Bossick, Rena Bransten, Virginia Carpenter, Tony Cuñha, Harvey Duke, Delleen Enge, Al Fridley, Roger Goldstein, Norman Haas, Barbara Jean Hayes, Wilbur Held, Ann Kerr, Margaret Key, Bill Kochanski, Marianne Marchesini, Nancy Alison Martin, Maxine Nelson, Donna Obwald, Mary K. Poxon, Keith Robinson, Gayle Roller, Gloria Samario, Carl and Maire Schrenk, Jack Shafer, Howard Smith, Judy Stangler, Lou Volse, Marilyn Webb, and Buddy Wilson. If I have overlooked anyone here, I sincerely regret the omission. Your help was appreciated! Lenders–people who entrusted me with examples from their personal collections to be photographed – comprise a separate list.

In addition, I would like to express my gratitude to Steve Quertermous, Lisa Stroup and the staff of Collector Books for recognizing the growing need for a book on California Pottery and devoting so much care and attention to its final realization.

During this project's lengthy gestation I have relied on many dedicated collectors of California Pottery. Most of them are far more committed to their collections than I will ever be. It is with fondness that I dedicate this book to them.

Foreword

California Pottery has for too long been a missing chapter in the annals of collectible American ceramics. In fact, California Pottery has been one of the least documented of all collectibles. As a result of this neglect it has also been one of the most misunderstood. With the publication of this book, the author hopes that the confusion will begin to abate.

My overriding goal during all stages of its preparation has been to showcase the best that the Southland's ceramic industry had to offer – the prominent and innovative studio-level producers as well as the major manufacturers. Because it is my firm belief that in completely demystifying a subject one tends to debilitate it, I have not delved too deeply in this investigation into individual company histories or products.

The ceramic industry we are concerned with was primarily a Southern California phenomenon. Northern California pottery reflected a different attitude and would certainly be the subject of an interesting inquiry. Likewise tile companies (that produced tiles exclusively), though they form the backdrop for what developed later on, have not been considered in this survey. The vastness of just the Los Angeles-based industry dictated that I draw lines around it. As work progressed I found myself weeding out many businesses that I had initially intended to include. Some, as in the case of Padre, for lack of available data and others for aesthetic reasons.

Because my background is in fine art, artware may have been afforded a more prominent position in the final selection process at the expense of dinnerware. This leaves room for other authors to focus more conclusively on dinnerware, which actually launched the California Pottery industry and to a large degree sustained it.

The companies presented here, then, are those considered to be the movers and shakers of their day. The individual examples included in the photo plates admittedly reflect the author's bias to some degree. Many were conveniently drawn from my own collection or were purchased specifically to illustrate the text as they became available during the photographing sessions.

Much of what is pictured here easily qualifies for "sleeper" status in today's market. This indicates the potential for investment that California Pottery offers to those inclined to consider it. Mostly, it tells me that the subject is still wide open to the joy of discovery. May California Pottery continue to offer the collector the combination of art and accessibility that was its original hallmark.

Introduction

Boom and Bust: A Historical Perspective

"Wise indeed is a community which develops
products that are indigenous to its surroundings." [1]

Fifty years ago, Helen E. Stiles began a critical chapter of her book, *Pottery In The United States* with these words. In concluding a brief but enthusiastic account of "Pottery Made in California," Ms. Stiles made the following observations:

"We in the East have opened our eyes to the ceramic products of the West, our shops display their wares, each new season brings new designs, but, as elsewhere, it is only when artists and craftsmen of integrity and ability are employed in this work, that we have a truly worthy product. Many such are today being produced in California, but there are those who fear that the wave of popularity may cheapen the products of some factories, and entice those of lesser abilities to set up their shops and cater to a not always discriminating public. Though this may, and probably has, occurred in some instances, California seems to be on the road to a period of prolific production and in many cases most outstanding ceramic wares. Southern California, especially, has every opportunity to produce indigenous design which will hold great interest, not only for the local consumer, but for many purchasers in all parts of the country." [2]

Predicting the future isn't easy, but Ms. Stiles was somehow able to see ahead to the unprecedented growth of Southern California's pottery industry.

Most people think of California Pottery as the vividly colored earthenware dishes manufactured in the thirties and forties by big industrial plants in and around Los Angeles. And they would be right. But California Pottery also embraces many other products of these companies as well as the decorative housewares and giftware turned out by a multitude of smaller potteries operating throughout Southern California between the early thirties and the early sixties.

The roots of the California Pottery industry are still observable today in the colorful tiles that embellish the numerous Spanish-style dwellings erected in Los Angeles in the twenties. Red-roofed minihaciendas dot the City of the Angels as well as many outlying suburbs, and are a fitting tribute to the Southland's Hispanic origins. Many of these homes conceal elaborately tiled bathrooms or kitchens made possible by skilled industrial artisans who duplicated ancient Spanish and Moorish designs.

But what appeared on the scene in 1930 was a strikingly original clay product which its creator, the J.A. Bauer Pottery Company of Los Angeles, called "California Colored Pottery." It was as ornamental as it was useful and

was introduced to a mass market by utilizing the creative skills of both artists and industrial clay workers. Making it all the more remarkable, another local ceramic firm had been working on a strikingly similar line of goods. But due to its remote location on Catalina Island (about 25 miles off the coast of Southern California), rival Catalina Clay Products Company was unable to market its line nearly as quickly or successfully.

The ware devised by Bauer amounted to simple yet robust earthenware placesettings and accessories in a rainbow of solid colored glazes. The dishes could be purchased in mixed or matched sets at the whim of the consumer. Flower pots and vases glazed in the same bright colors as the dishes were also available to add a cheery note to indoor-outdoor settings.

This revolutionary concept instantly caught on with progressive minded "Angelinos" for two reasons. Prior to this the available dinnerware was either fussy European china or pseudo-European china manufactured in the East. Secondly, the new lines were specifically designed to accommodate Southern California's penchant for patio dining.

Bauer's California Colored Pottery, returning to Helen Stiles' remarks, was unique because it accom-

modated the Southland's peculiar lifestyle. Informal social interaction was fostered very early in this region by a benevolent climate and a population of diverse cultures. No single overriding ethic or ethnic attitude shaped the inhabitants into a cohesive union. Instead, a sense of opportunistic experimentation existed here. This extraordinary environment allowed a personal vision, no matter how unconventional, to make a difference.

That the origins of California Pottery coincided with the onset of the Great Depression is worth considering. The Southland, bolstered by the unique prosperity of Hollywood, offered at least a partial haven from this economic catastrophe. And the emerging pottery industry provided a significant measure of employment as surely as its output buoyed sagging spirits.

Ironically, California Colored Pottery reached its zenith with the introduction of the phenomenally successful "Fiesta" ware by the Homer Laughlin China Company of West Virginia in 1936. Every major ceramic plant located in or around L.A. had by this time marketed its own adaptation of the Bauer/Catalina wares. It was a simple matter of economic survival. Pottery yards which featured the various lines, like the famous Pottery Shack in Laguna Beach, multiplied rapidly throughout California in the thirties. Because it was cheerful and relatively inexpensive, colored pottery helped brighten the lives of Californians during the Depression years. By the late thirties it had been embraced by the rest of the country.

The Southern California potteries found themselves in a very favorable position as most of the ceramic raw materials they needed were obtainable within a short distance of Los Angeles. Adding to this was the fact that the city was at one time a leading producer of natural gas and fuel oil. Talc, a mineral mined in abundance in the California desert, proved to be a significant component in commercial clay bodies after it was found useful for tile production in the twenties. It was possible, as the chemists at Gladding, McBean & Company later discovered, to manufacture lightweight, durable and non-crazing dinnerware in a single firing cycle using talc as the primary ingredient. Most of the major producers of California Pottery – Bauer, Pacific, Gladding-McBean, Metlox, and Vernon (known as the "Big 5") – had turned to talc by the late thirties. Many of the smaller companies followed suit while the mineral was touted as one of the greatest advances in the history of pottery manufacturing. Still, it was the brightly colored glazes and the underglaze decorations offered by the various firms that sustained the industry in difficult times.

World War II ushered in the period of greatest growth for the ceramics trade in California. Although many government restrictions were placed on materials and a few companies converted to defense work, it was a boom period. The factor accounting for most of this productivity was the war-time curtailment of imports from Europe and Asia. With the traditional lines of china from the British, French and German factories and the ceramic goods from Italy and Japan no longer available, wholesale buyers for the nation's department stores found themselves in the awkward position of relying almost exclusively on domestic sources to stock their shelves.

A few Southern California firms, like Gladding-McBean, took full advantage of the situation and developed lines of porcelain dinnerware as fine as any imported china. The bulk of production, however, involved lines of earthenware dishes and decorative housewares. Much of the tableware, sporting trade names like "Franciscan" and "Poppytrail," was decorated by hand. The housewares included figurines and related items for individual use or for gift-giving. The company that spearheaded this type of production was Brayton Laguna. Their acclaimed and highly successful hand-painted figurines gave rise to a multitude of competitors and before long the promise of something special became associated with the backstamp "made in California."

Small, usually family-owned, potteries sprang up all over the Southland during the war. By 1948, the peak year for the industry, over eight hundred ceramic concerns were in operation throughout California -- exceeding even that of Ohio. Hedi Schoop, Kay Finch, Florence Ward, Brad Keeler, and Will and George Climes were outstanding contributors to the local giftware explosion. But, as Helen Stiles had predicted, not all of the small businesses catered to a discriminating taste. Despite this warranted criticism, the Southern California spirit of ingenuity and abandon prevailed, resulting in a bumper crop of ware which certainly interested consumers nationwide.

The overseas goods which were unavailable during the war suddenly reappeared in the early fifties. Only a trickle at first, the imports grew to flood proportions as the Japanese, and later the Italians, dispatched an endless flow to rival the California designs. Unable to compete with the quality and low cost of the imports, many Southern California potteries began to close up shop.

Had it not been for the highly publicized ceramics career of Sascha Brastoff in the fifties and the many small businesses his success inspired, the local pottery industry would have succumbed much sooner than it did. Even so, the number of producers had been reduced to a fraction of the post-war high by the early sixties. Today only a handful remain. Their presence is an uneasy reminder of the boom and bust of California Pottery.

[1] H.E. Stiles, *Pottery In The United States*, pg. 138.
[2] Stiles, op. cit., pgs. 153-155.

Contents

American Ceramic Products

The predecessor of American Ceramic Products was Cecil Jones' La Mirada Potteries. Jones was a talented and accomplished English ceramist with extensive experience working for potteries in England as well as the United States. He was affiliated with the Claycraft Potteries in Los Angeles prior to founding La Mirada in 1935.

The La Mirada Potteries began operations at 3221 San Fernando Road in Los Angeles, where only a year earlier the Robertson Pottery had been established. Jones' company produced a pioneering line of Chinese Modern style housewares consisting of low bowls, vases, wallpockets, figurines, and figural planters. His Oriental designs were complemented by a series of brightly colored, transparent crackle glazes that were perfected with the help of George Robertson of the Robertson Pottery.

The La Mirada business was purchased by Thomas F. Hamilton in 1939 and renamed American Ceramic Products. With Jones remaining as plant superintendent, it continued unchanged until the early part of 1940, when a fire destroyed the factory. Operations were subsequently housed in a larger building constructed at 6205 Compton Avenue in Los Angeles. After completion of the new facility in 1941, American Ceramic Products was incorporated and full production was resumed.

In 1945, the same year that Cecil Jones retired, owner Tom Hamilton was approached by the Winfield Pottery of Pasadena, desperately in need of assistance with a huge backlog of war-time dinnerware orders. After an unprecedented licensing arrangement was worked out and some new machinery installed, Winfield China was produced as a separate division of the business. Bamboo, Avocado and a few other patterns originated by the Pasadena company were turned out by both the Winfield Pottery and American Ceramic Products for a short time.

With aggressive mass-marketing, Hamilton's Winfield line quickly expanded and in 1946 a separate manufacturing facility for it was constructed. The new Winfield Division of American Ceramic Products was a fully modern, 65,000 square foot factory and showroom located at 1825 Stanford Street in Santa Monica. Many hand-painted Winfield China patterns were designed and produced in the well-equipped plant. Bird of Paradise, designed by Ayako Okubo, was the most successful of the new lines which were marketed through major department stores across the country. After 1959, Winfield China was distributed by means of the direct sales approach used in the promotion of Tupperware products.

The La Mirada Division of American Ceramic Products was maintained at the Compton Avenue location. In 1947 the original crackle glazed artware underwent a facelift and a new line of tableware called La Mirada Mandarin was introduced to coordinate with it. The Mandarin line was a lightweight earthenware. Basically square in format, it was, like the artware, offered in decorator color combinations such as dawn pink and dusk gray. Hand-decorated patterns were also produced.

In 1963 Tom Hamilton sold the La Mirada plant. The Winfield China Division remained relatively prosperous as late as the mid sixties despite mounting competition from less-expensive Japanese china. The skill and dedication of the employees (about 250 at the time), and their willingness to work for less than union scale, helped sustain the business.

Thomas F. Hamilton died in 1964 and his son Tony took over management of American Ceramic Products until its sale in 1965. The new owners filed bankruptcy in 1967, with the company closing later that year.

The early La Mirada pottery was sometimes incised in-mold with the mark shown , (1) however, paper labels were used to identify much of the ware. "Winfield" (2) and "Winfield Ware" (3) were early Winfield China marks and were stamped on the unglazed bottoms of most items. The later mark shown (4) was an underglaze backstamp. "Winfield China Gourmet" (5) was a special line of the early sixties, with the mark being stamped underglaze. La Mirada dinnerware carried a circular backstamp reading "La Mirada Mandarin Los Angeles." After the sale of the La Mirada trade name, the ware bore the circular stamped mark "Winfield Handcraft China." This was somewhat misleading, as the line remained a non-vitreous product.

La Mirada.

(1)

Winfield

(2)

Winfield Ware
HANDCRAFT CHINA
SANTA MONICA CALIF.

(3)

TRUE PORCELAIN
Winfield
HAND CRAFTED
CHINA
MADE IN USA

(4)

Winfield China Gourmet

(5)

Batchelder

One of the most influential figures of the American Arts and Crafts Movement was Ernest A. Batchelder. He was a dedicated and respected teacher, writer and civic leader. The tiles he produced in Pasadena and Los Angeles served to advance his reputation as an authority in the design field of his day.

Batchelder was born in New Hampshire in 1875. He received his education at the Massachusetts Normal School in Boston, graduating in 1899. Summer classes with Denman Ross helped shape the design ethic which he espoused in the *Craftsman* magazine during the years 1906-09. In 1910 a compilation of this series of articles was published titled *Design In The Theory and Practice*. It was his second book, the first being *Principles Of Design* which appeared six years earlier.

In 1904 Batchelder moved to California. Locating in Pasadena, he taught at Throop Polytechnic Institute (now California Institute of Technology) from 1904 to 1909. As an instructor there, Batchelder helped foster the manual arts movement, whose aim was the restoration of handiwork as an integral part of education. He left his post at Throop in order to establish a tile studio on land purchased in Pasadena in 1909. The following year a small workshop was erected on the property, which was located on the east side of the Arroyo, at 626 Arroyo Drive. By 1912, the Batchelder business had outgrown its modest beginnings and was relocated to a structure on what is now Arroyo Parkway in Pasadena. Frederick L. Brown was made a partner at this time, and sculptors Charles and Emma Ingels were employed as master mold makers.

Batchelder tiles of the period were formed by hand pressing slabbed clay into plaster molds. Relief tiles were sprayed with engobe in a variety of colors, the excess wiped off elevated areas before firing. Clays came from various regions of California, with both red and buff burning types used.

Business continued to expand at a rapid rate and by 1916 a new partner, Lucian H. Wilson, was associated with Batchelder. A larger and better-equipped factory was built on a six acre site at 2633 Artesian Street in the Lincoln Heights district of Los Angeles. The new Batchelder-Wilson Company evolved into a full-service tile plant offering glazed faience tile in innumerable designs, along with architectural panels, moldings, corbels, fireplace facings, pavers and fountains. In addition, architectural terra cotta, garden pots and bookends were produced.

Though showrooms were maintained in San Francisco, Chicago and New York, the majority of the firm's trade was local, with Batchelder supplying an abundance of Spanish tile to contractors during the building boom of the twenties. Glaze colors ranged from the vivid hues of the outdoor Spanish tile to the more subdued "patina glazes" (ivory, tan, gray-blue, blue-green, orchid, lavender and others) used in interior settings. The range of subjects depicted on figure tiles was as broad as the colors employed.

William Manker, hired in 1926, became Batchelder's personal assistant after a brief apprenticeship and was responsible for many of the company's designs. By 1930, and the end of the construction boom, the effects of the Depression had set in. Bankruptcy was declared in 1932, with the Batchelder-Wilson plant and stock later sold to the Bauer Pottery.

In 1936 Batchelder began a second phase of his ceramic career with the establishment of Batchelder Ceramics at 158 Kinneloa Avenue in Pasadena. Batchelder Ceramics was a completely divergent line of fragile slip-cast bowls, vases and related articles inspired by the success of former associate Manker. Batchelder, like Manker, designed and produced modern adaptations of classical Chinese forms in earthenware. The glazes he developed were extraordinary and added to the success of this later endeavor. Working closely with him was a handful of people who had been associated with the tile business.

Batchelder kept his second operation small so that he could supply a personal touch to the work, including hand-incising his name on most pieces. In this way he was able to continue the operating philosophy of his early tile business contained in the motto, "No two tiles the same." Batchelder Ceramics was distributed to department stores and gift shops throughout the country and in South America. In 1951 Ernest A. Batchelder retired; he died in 1957.

Unlike many tile businesses, Batchelder tiles were diligently marked. The mark shown was used by the Batchelder-Wilson Company. The early ware was similarly impressed "Batchelder Pasadena." Batchelder Ceramics pieces bore the hand-incised (most often by Batchelder himself) name of the owner. A few variations and abbreviations are shown. The words "Kinneloa Kiln" were occasionally included in the marking process.

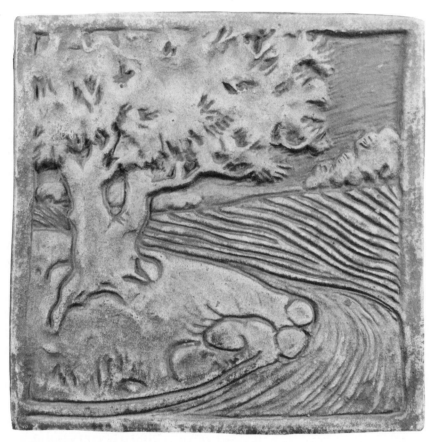

Batchelder unglazed (engobe) landscape with oak tree tile, 7¾". Impressed "Batchelder Los Angeles."

Batchelder Marks

EA Batchelder
Pasadena
MADE IN
U. S. A.

KINNELOA
KILN

E.A.B.
PASADENA

EABatchelder

Bauer

The J. A. Bauer Pottery was founded by Kentuckian John Andrew Bauer. In 1909 Bauer transplanted a successful stoneware business from Paducah to Los Angeles seeking a more hospitable climate for an asthma condition. The new plant, which was constructed at the corner of Lacy Street and Avenue 33, in the Lincoln Heights district, boasted four large-capacity periodic kilns. By virtue of an aggressive sales force, the company quickly established a reputation as California's foremost manufacturer of redware flower pots. Stoneware production commenced somewhat later due to the difficulty Bauer had in obtaining suitable stoneware clay. Among the domestic items eventually offered were mixing bowls, nappies, ramekins, bean pots, whiskey jugs and covered crocks. During Prohibition the latter articles were utilized by enterprising individuals to concoct and bottle alcoholic beverages.

In 1912 a skilled Danish designer by the name of Louis Ipsen was hired. Matt Carlton, an experienced potter from Arkansas, joined the firm the following year. Both men were instrumental in the development of an artware line of glazed vases, bowls and jardinieres. Molded forms were the work of Ipsen, while hand-throwing was accomplished

Bauer's Watson E. Brockmon

by Carlton. Matte green glazes were used on the standard redware body of the period. When the Bauer Pottery exhibited at the Panama-California Exposition in 1915-16, it was awarded the Bronze medal. Shortly thereafter the firm's artware gave way to a line of molded stoneware vases which were glazed only on the inside.

The Bronze medal was a coveted award, but founder John "Andy" Bauer was not destined to witness his company's greatest achievement. Just prior to Bauer's death in 1922, the business was entrusted to a partnership that included his son-in-law Watson E. Bockmon. It was Bockmon who oversaw the introduction of the firm's inventive and very influential colored pottery.

Victor Houser, a ceramic engineer from the University of Illinois (hired in 1929), perfected the opaque colored glazes which enabled the Bauer business to popularize the concept of casual tableware in mix 'n match sets of bright colors. An initial line of dishes was modeled by Ipsen in 1930. In 1931 the popular and enduring "ring" ware was introduced and it, combined with the earlier "plain" setting, comprised the organization's original California Pottery package. The highly successful ring design was characterized by closely spaced concentric ridges on holloware and a series of three ridges in relief on plates and platters. Included in the complete assortment were table and kitchen items, including more than one hundred different shapes and sizes offered for casual dining and food preparation.

So great was the demand for Bauer's colored pottery that a second plant was added in 1935 after neighboring Batchelder-Wilson ceased operations. Following Bockmon's purchase of the well-equipped facility, new tableware and artware designs were produced there on a regular basis. The successful tableware lines included: Monterey (1936-1945), La Linda (1939-1959), Monterey Moderne (1948-1961), and Brusché Contempo (1948-1961). Gloss Pastel Kitchenware, introduced in 1942, included Ipsen's distinctive "Aladdin" teapot design.

Technician Houser created a new series of glazes during World War II in response to the government ban on essential materials. Original colors – green, yellow, orange-red, dark blue, light blue, burgundy, ivory, black and white – were either reformulated or replaced by pastel hues. Artware, both cast and wheel thrown, continued to be produced; the latter work performed by Carlton and Fred Johnson. Cast forms of the thirties and forties were designed by

Johnson and Ray Murray and produced in the same monochrome glazes used for dinnerware.

Tracy Irwin, another talented Bauer designer and modeler, devised a collection of up-to-date floral containers during the company's final decade. He was also responsible for that era's most popular Bauer tableware, Monterey Moderne, which was a sophisticated coupe design inspired by Russel Wright's "American Modern."

With increased competition from local manufacturers in the late forties, Bauer no longer dominated the Los Angeles market as it had done in the thirties. Because the business depended almost exclusively on its California accounts to sustain it, the slump experienced in the late fifties was inevitable. Management difficulties compounded the situation which culminated in a bitter strike in 1961. The Bauer pottery was closed by W. E. Bockmon's widow in 1962.

Various recessed in-mold marks were used by Bauer. Shown is a selection of the more common ones in use from 1930-on. Some Bauer ware was marked "Made in U.S.A." The hand-thrown pottery produced by Matt Carlton and Fred Johnson was not marked. In addition, much of the regular jiggered and cast production found today will be unmarked. Paper labels were used for a brief period in the thirties.

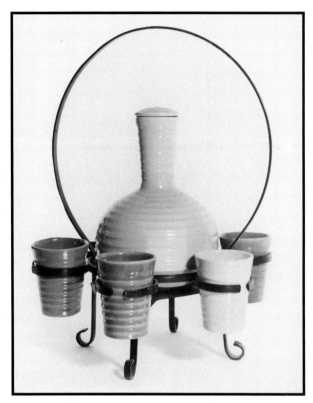

Bauer "Ring" covered water jug and 6 ounce tumblers in metal caddy. Photo courtesy of Roger Gass.

BAUER
USA

BAUER
LOS ANGELES

BAUER

BAUER
MADE IN
U.S.A.
LOS ANGELES

Brusché

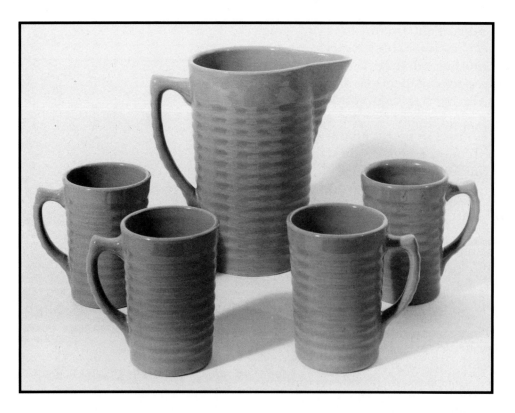

Bauer "Ring" ware beer pitcher and mugs, c. 1932. Photo courtesy of Roger Gass.

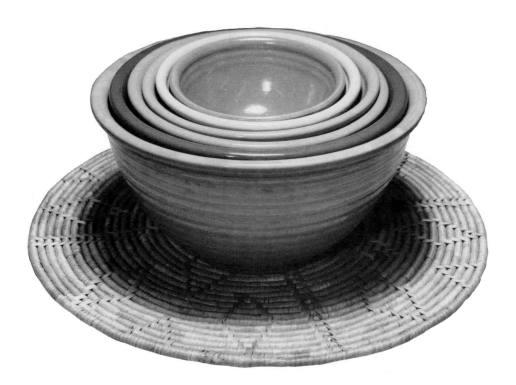

Ever popular nested set of "Ring" mixing bowls. In-mold marks. Photo courtesy of Richard N. Levine.

The Sascha Brastoff saga is unique. His was the quintessential example of an artist's personal vision reaching an appreciative mass audience!

Sascha Brastoff was born to Russian and Hungarian parents in Cleveland, Ohio in 1918. For two years (1935-36) he attended the Western Reserve Art School in Cleveland before leaving, at age 17, to further his education and begin working on his own in New York. In Manhattan, Brastoff worked at the Sculpture Center. Two of his terra cotta figurines won the award for "Sculpture Showing Unusual Humor or Whimsy" in the National Ceramic Exhibition at the Syracuse (now Everson) Museum of Art in 1939.

Participation in the U.S. Army Air Force's entertainment services during the war fostered an interest in show business which continued when Brastoff moved to Los Angeles in 1945 and was employed as a costume designer for 20th Century Fox. Through Marion Daniels, a Fox publicist, his terra cotta sculpture came to the attention of Winthrop Rockefeller. Rockefeller responded favorably and expressed an eagerness to finance Brastoff in the creation of a quality line of American-made china.

In 1948 a small plant was erected on Sepulveda Boulevard in West Los Angeles. Because Brastoff was basically untrained in ceramic production, a crew of skilled technicians was hired along with a salesman and three decorators, one of which was Marion Daniels. The product at first was earthenware; the body and glazes worked out from scratch. Early designs included vases, bowls and ashtrays. Around 1950 a series of figurines was introduced. Nearly everything was hand painted, with Brastoff's artisans being throughly trained to duplicate his personal, flamboyant style of decoration. Overglaze gold trim was lavish and eventually became one of the hallmarks of the business. Gold, platinum, and other, sometimes unorthodox materials were utilized to produce unique decorative effects.

Demand steadily grew for Sascha Brastoff's unusual wares and in the early fifties Tom Hamilton (of American Ceramic Products) proposed a limited partnership with quick expansion to a larger plant he owned in Hawthorne. This was agreed to by Brastoff and Rockefeller, and in April of 1952 Sascha Brastoff of California, Inc. was launched in

a better-equipped facility with additional employees. This arrangement proved to be ill-fated however, when the plant was completely destroyed by fire less than eight months later. Resolution of the crisis came with the construction of an all-new factory, designed by noted architect A. Quincy Jones, at 11520 West Olympic Boulevard in Los Angeles. With Rockefeller's backing, Brastoff's plant became an elaborate ceramic studio, gallery and tourist attraction. When it opened in 1953, over eighty people were employed – about half of them artist-decorators. Sascha Brastoff supervised this productive assembly and was responsible for all shapes, decorative patterns and glazes. Entire lines, at times encompassing two hundred custom coordinated items, emerged twice a year.

Winthrop Rockefeller's wish was realized in 1954 when the first of ten fine china dinnerware lines was marketed. Earthenware table settings were also offered, the most successful being Surf Ballet, a marbleized pattern of gold (or platinum) against various background colors. Among the decorative items produced at the Olympic Boulevard plant were flower bowls, vases, figurines, lamps, wall plaques and masks. Smoking accessories, including an astonishing variety of ashtrays, were the most popular of Brastoff's articles. An extensive output of enamel-on-copperware was also produced over the years.

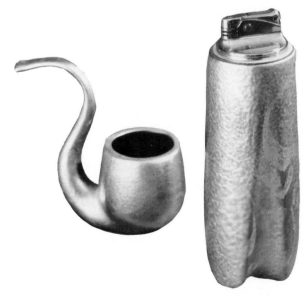

Sascha Brastoff pipe-shaped cigarette holder and pepper-shaped lighter in satin-matte gold glaze. Both signed "Sascha B."

Stricken with nervous exhaustion in 1963, Sascha Brastoff was forced to withdraw from his thriving business. The constant rigors of designing and decorating new lines, training and supervising artists, and personal promotion trips throughout the country finally took their toll. Even without his direct involvement, the Brastoff line of goods was sustained for another decade by plant manager Gerold Schwartz.

Since retiring from ceramics, Sascha Brastoff has pursued successful careers in fine art, retailing and free-lance design. His focus in recent years has been custom jewelry. Brastoff's works are included in numerous museum collections including the Metropolitan Museum of Art, Los Angeles County Museum of Art, Cranbrook Academy, Guggenheim Museum of Art, Everson Museum of Art, and the Houston Art Museum.

An early Sascha Brastoff painted mark is shown (1). After relocation to the Olympic Boulevard plant, the chanticleer (rooster) was adopted as Brastoff's trademark and incorporated into a backstamp (2) for use on both earthenware and china. These were often applied overglaze in gold or platinum. Brastoff's success was partly the result of a personal notoriety which he augmented by having his "signature" appear on every piece produced. His decorators signed the name "Sascha B." (3), but only those pieces signed "Sascha Brastoff" (4) & (5) were actually hand painted by Mr. Brastoff himself. A copyright registration symbol was sometimes added. Very few unmarked examples have been observed. The enamelware was marked as described or with paper labels.

SAScha

(1)

(2)

SASCHA B.

(3)

Sascha
Brastoff

(5)

SASCHA BRASTOFF

(4)

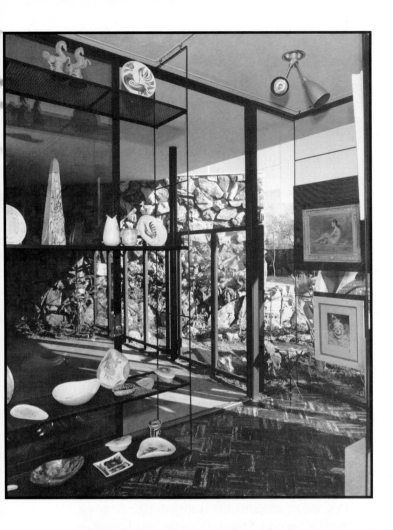

Interior view of the Sascha Brastoff plant showing a section of the gallery.
Photo courtesy of Julius Shulman.

Exterior view of the Sascha Brastoff plant on Olympic in Los Angeles designed by architect A. Quincy Jones.
Photo courtesy of Julius Shulman.

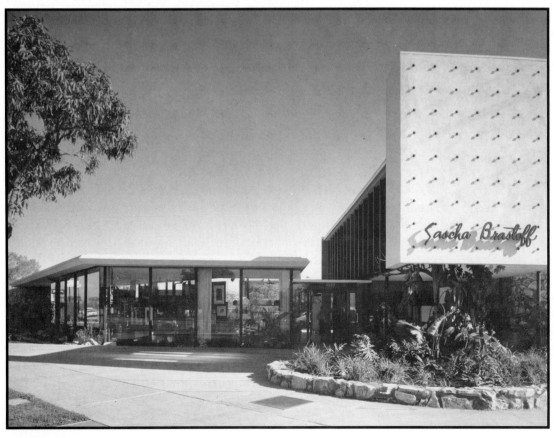

Brayton Laguna

In view of its innovations and influence, the Brayton Laguna Pottery ranks as one of the foremost companies in the history of Southern California pottery. The business was founded in 1927 by Durlin E. Brayton, a California native and alumnus of Hollywood High School. Brayton, who also attended the Chicago Art Institute, was self-employed as a carpenter before venturing into ceramics. At his residence on the Coast Highway in Laguna Beach he built a modest kiln and workshop. With the help of his first wife, Durlin Brayton introduced a line of simple earthenware dishes in sets of mixed colors in the late twenties, probably the first of their kind produced in the United States.

Brayton's pioneering colored pottery was press-molded by hand and then dipped in a remarkable series of opaque glazes including rose, strawberry pink, eggplant, jade green, lettuce green, chartreuse, old gold, burnt orange, lemon yellow, silky black, and white. Basic placesettings were made along with accessory pieces such as tea pots, pitchers and large serving bowls. The charming, unpretentious shapes perfectly accommodated the casual seaside life style. Brayton also designed vases, flower pots, tea tiles, wall plates, and figurines, all of which were produced in limited quantities. The colorful display of goods in the Brayton's front yard attracted both Laguna residents and tourists and provided a sustaining occupation for a handful of assistants during the early Depression years.

Durlin met and married his second wife, Ellen Webster Grieve in 1936. "Webb," as she was called, was an artist with a keen business sense, and through her efforts the Laguna Pottery changed from a small cottage shop to a significant commercial enterprise. Mrs. Brayton realized that a sizable market could be developed for mass-produced figurines designed and decorated by the abundance of artistic talent in the immediate area. This concept called for larger facilities which Durlin designed and constructed on a five acre site between the Coast Highway and Gleneyre in 1938. The most modern production equipment, including a continuous tunnel kiln, was installed on the premises along with ample work areas, offices and a large showroom. Noted Swedish woodcarver H. S. "Andy" Anderson was the first outside designer hired. He modeled many whimsical figures and groupings including an English hunter with fox and hounds, a hillbilly shotgun wedding set, and one of Brayton Laguna's best-sellers: the purple cow, bull and calf family inspired by a popular Gelet Burgess poem.

Because of the company's reputation for quality figurines, it was the first pottery licensed by the Walt Disney Studios to produce ceramic likenesses of their famous animated characters. Among those marketed from 1938 to 1940 were Snow White and the Seven Dwarfs, Pinocchio, Jiminy Cricket, Figaro, Ferdinand the Bull, Donald Duck, Mickey Mouse and Pluto.

Hand-decorated figurines were so successful for the business that more than twenty-five designers were eventually employed. Among the early model makers were Letitia Ann Dowd and Frances Robinson, who each created a large number of figurines of children. A partial listing of the talented designers who added distinction to the Brayton Laguna line over the years includes: Walter Bringhurst, Ruth Peabody, Charles Beauvais, Kay Kinney, Jules Erbitt, William Lyons, Carol Safholm, Jean Yves Mock, Peter Ganine and Ferdinand Horvath. Most of these artists also maintained studios where they produced and marketed their own work.

Brayton Laguna's various sales representatives promoted the company's wares during World War II. By the end of the war, retail outlets had been secured in every major American city and in many foreign countries. This was the most productive period for the business, when overseas ceramic goods were unavailable to the giftware trade. The plant operated at capacity day and night, with over 150 people employed on two shifts.

Laguna Beach, well-known as an art colony and beach resort, also became (for a short time) one of the major ceramics centers in California as a result

of the operation's success. Over a dozen separate potteries had sprung up in the area by 1941, with the number exceeding 65 during the war. A cooperative organization known as the Laguna Beach Ceramic Society was established to help publicize the Laguna potters and foster better relations between them.

After the war the situation for Brayton and the other companies began to reverse. With Japanese and Italian companies flooding the domestic market with an abundance of cheaper wares, the extra help hired by the firm during the war had to be dismissed. Webb Brayton's untimely death in 1948 was a serious loss for the company. After 1951 and the passing of founder Durlin Brayton, the spark was gone and the business gradually declined. In 1968 a truly important chapter in California's ceramic history ended. Today the buildings comprise the Laguna Art Center.

Brayton Laguna also produced what it termed sculpture: animals, birds and human figures of moderate scale, usually offered in sets of two or more. Various finishes were used for these including hand painting, airbrush decoration, monochrome and crackled glazes, woodtone (a stained textured bisque) and combinations of the above. Vases, planters, ashtrays, candle holders, cookie jars, salt & pepper shakers and other household items rounded out the line. All of the ware was cast.

There was a definite evolution in Brayton Laguna's marking system. Knowledge of the timeframe of the various marks is a key to dating examples. The earliest mark (c.1927-1930) was "Laguna Pottery" (1) incised in Durlin Brayton's distinctive handwriting. From about 1930 to 1937, "Brayton (or Brayton's) Laguna Pottery" (2) was incised. An early ink-stamped mark (not shown) was applied to some of the early designer figurines. It consisted of the opposed silhouettes of two vases and a gypsy walking his dog, with "Brayton California U.S.A." centered below. Stamped marks of the forties were simpler, with the words "Brayton Pottery" or "Brayton Laguna Pottery" printed in block letters. Occasionally the designated name of a figurine appeared as part of these marks. The small paper label shown (3) was used from the late thirties into the forties. There was a variation of this label which was used on the Disney figurines of 1939-40, reading "Walt Disney Enterprises Made By Brayton" plus the copyright date. A special stamped mark (4) appeared on the Pinocchio series. The incised "Brayton's Mark" (5), used from

the late forties into the fifties, is shown. Some variations on this exist. From the later fifties through the sixties, incised in-mold marks (6) & (7) were utilized. There are numerous variations on these also. Much Brayton Laguna ware was not marked simply because there was no room for a mark. This holds true for most of the company's four-footed animal figures. One clue to their identity: an incised or painted decorator's initial is almost always present.

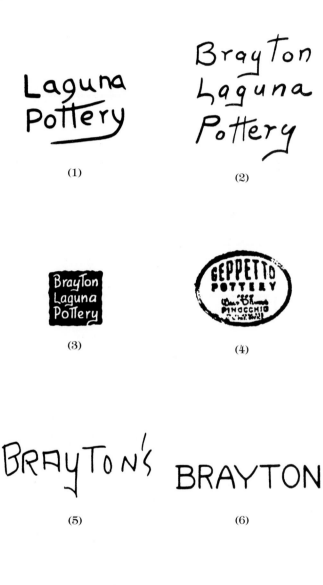

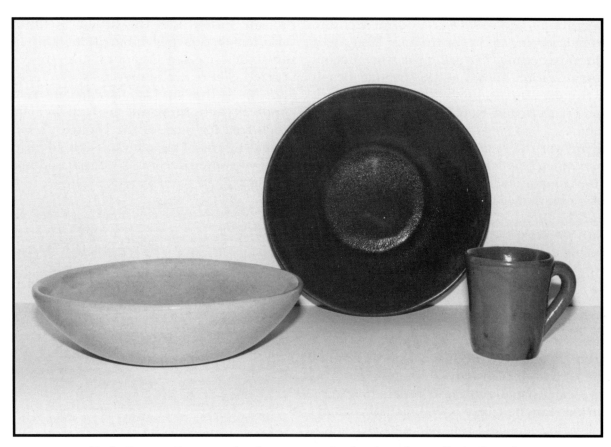

Early Brayton Laguna colored pottery serving bowls and mug. Incised marks.

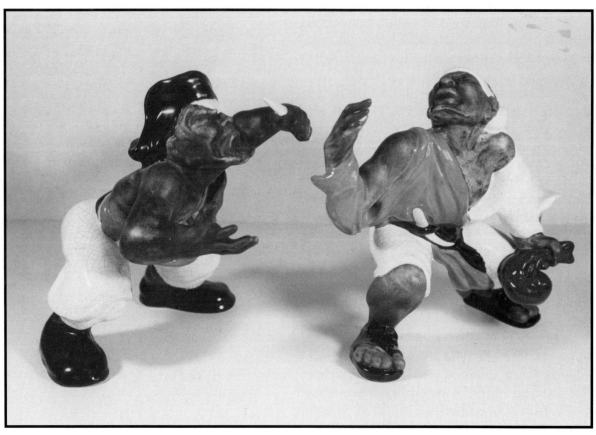

Brayton Laguna Fighting Pirates, 9", designed by Carol Safholm. Dark brown-stained bisque with colored and crackle glazes, c. 1956.

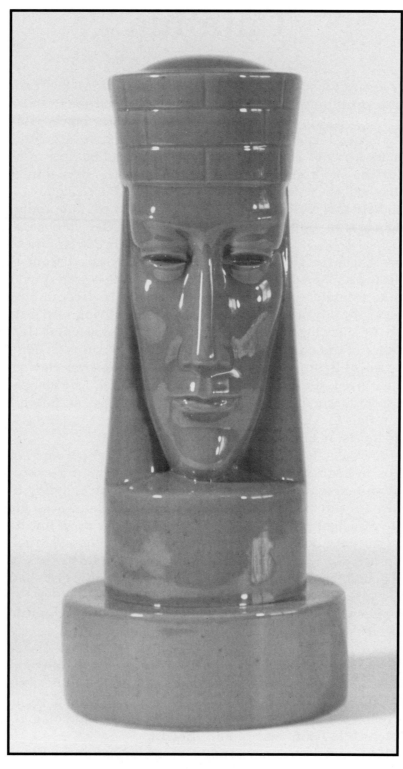

Castle piece, 10½", from large-scale chess set designed for Brayton Laguna by Peter Ganine in 1946. In-mold mark.

Catalina

The Catalina story is another fascinating chapter in the history of Southern California pottery. In operation just ten years, Catalina Clay Products, a project of the Santa Catalina Island Company, produced an extraordinary array of articles from materials indigenous to the picturesque island located twenty-five miles off the coast. It also provided a number of individuals with the necessary background to launch successful mainland potteries.

The Catalina venture began in 1927, shortly after discovery of the island's extensive clay and mineral deposits, with the establishment of a tile plant at Pebbly Beach, near the city of Avalon. The business was conceived by chewing-gum tycoon William Wrigley, Jr., owner of the island, and his close business associate David Renton. Their idea was to serve two functions: give Catalina residents much needed year-round employment and provide economical building materials for the ongoing development of Avalon as a tourist resort. At its peak the operation was the cornerstone in an alliance of self-sufficient indigenous industries, including a furniture workshop and ornamental iron foundry, employing several hundred residents.

In the beginning the principal product of the Catalina plant was tile. By 1929 a line of ornamental pottery was being turned out in vivid colored glazes to help meet the demands of civic improvement. Harold Johnson, who joined the business in 1928 after a long association with Pacific, contributed numerous pottery designs and glazes. Wrigley's most ambitious undertaking in Avalon was the huge multi-level Catalina Casino, which kept the factory operating at full capacity during its first three years. More than 100,000 pieces of roofing tile alone were used to complete the facility. Inside walls utilized hollow tile, while floors and promenade were paved with handmade octagonal patio tile interspersed with colorful glazed inserts. When it was finished in 1929, the Catalina Casino received the Honor Award from the Southern California Chapter of the American Institute of Architects.

After completion of the monumental casino project, Catalina Clay Products began to diversify. Island souvenirs were stressed, but a complete line of vases, flower bowls, candle holders, lamps and other decorative accessories for the home was produced and made available in island gift shops. Most of these slip-cast items were quite functional and original in design.

The clay used in production was a brown-burning type trucked in from a dry lake bed located a short distance from the plant. Pulverized rock (felsite) recovered from the Pebbly Beach rock quarry was also used. David Renton, who managed the pottery, hired ceramic engineer Virgil Haldeman after Harold Johnson's departure in 1930. The glazes of Johnson and Haldeman were developed from native oxides. When the glazes united with the island's brown clay some remarkable effects were achieved. The company's press kit included the following description of one of the Catalina glazes:

> "The yellow found in Catalina Pottery is one that has for centuries been the royal color of the reigning house of China, and therefore known as Mandarin or Manchu yellow. The exact hue has never before been duplicated outside the great wall of China, though chemists the world over have striven to achieve this one shade of yellow that can be best described as "yellow-yellow" or the true gold of a California sun."[1]

Other standard glazes were Catalina blue, Descanso green, Toyon red, turquoise, pearly white, sea foam, and Monterey brown. Later colors, which Haldeman furnished, included beige, coral island, powder blue, and colonial yellow (all satin-matte finish).

The output of the Catalina pottery, which covered several acres and included twelve kilns of various size and type, averaged between 10,000 and 15,000 pieces per week. The wide range of clay products was well suited to the Spanish architecture seen throughout Southern California in the twenties.

The ware was further enhanced in this capacity

by the addition of Spanish style wrought-iron frames and stands crafted by the island's foundry. Both the foundry and the furniture shop produced attractive tables that were fitted with scenic tile panels designed by a crew of Catalina artists. Motifs for these, and a related series of decorative wall plates, were suggestive of the island: undersea gardens, exotic birds of the Avalon Bird Park (now closed), flying fish, and Spanish galleons. Numerous hand-painted scenes were also rendered overglaze on plates of various size.

Tableware was introduced about 1930, with the entire spectrum of pottery glazes employed. Three basic dinnerware designs were offered along with many interchangeable serving pieces. In 1936 another complete service, with a raised rope border, was added in all satin-finish pastel colors. The pottery was popular with Catalina residents and tourists despite the Depression, and was shipped to many retail outlets on the mainland of California and elsewhere.

The only flaw in an otherwise successful operation was the native brown clay which proved to be brittle and damaged easily. William Wrigley insisted that Catalina pottery be manufactured only from indigenous materials. Even though it was less than satisfactory the clay body could not be improved until after Wrigley's death in 1932. At this time a tougher white-burning clay was imported from Lincoln, California. The costly importation of clay to Avalon was ironically the major factor necessitating the sale of the Catalina line to mainland competitor Gladding-McBean in 1937.

Catalina Island ware can be distinguished from other Southern California lines of colored pottery by its remarkable series of glazes and, in the case of the pre 1932 ware, its brown clay body. Marks are also helpful. There were a few that were impressed into the leather-hard clay. The words "Catalina" or "Catalina Island" are the most common of these. Sometimes these words were incised by hand, with variations in handwriting. Certain early items were stamped underglaze "Catalina Island" in an oval, or similarly stamped overglaze. Variations on most of the marks exist, making it difficult to determine the dates that specific ones were in use. Paper labels were also used. The recessed or stamped mark "Catalina Pottery" was used by Gladding-McBean on its Catalina Pottery line and should not be confused with the earlier island production.

[1] A. Overholt, *Color To Order,* from company publicity kit of c. 1933.

CATALINA

CATALINA
ISLAND
624

CATALINA
624
ISLAND

CATALINA
ISLAND

Catalina
Island

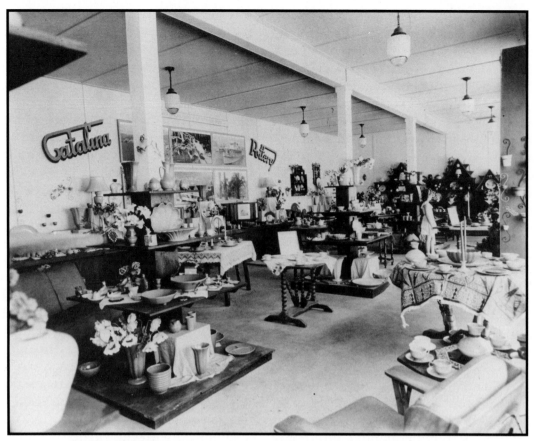

Interior view of the Catalina pottery retail outlet in Los Angeles' legendary Olvera Street arcade. Mid thirties. Archival photo.

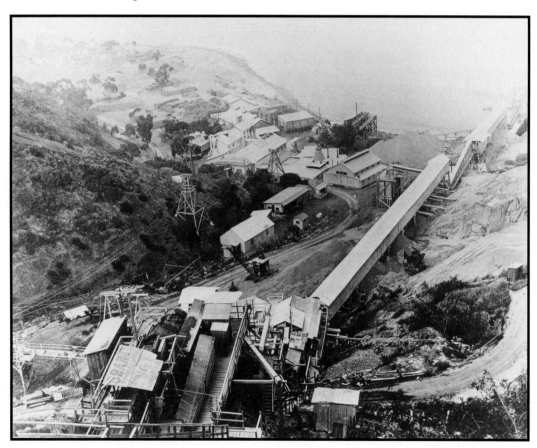

Aerial view of the Catalina pottery plant at Pebbly Beach, near Avalon, Santa Catalina Island, c. 1930. Archival photo.

California Pottery

Cleminsons

Many of the smaller Southern California potteries had their beginnings in family garages. The suburban Monterey Park garage of George and Betty Cleminson witnessed the birth of one of the most successful husband and wife owned giftware companies to emerge in the World War II period.

The enterprise began in 1941 as a hobby of Betty Cleminson. Betty's initial, tentative efforts were crude but charming and included a hand-painted pie bird. This modest item was greeted with such neighborly enthusiasm that a pastime was immediately turned into a full-time business. Originally calling it "Cleminson Clay," Betty enlisted the services of her husband George to manage the business affairs while she created.

Timing played a large part in the success of most of the garage-based potteries that appeared during the war in Southern California. With overseas goods virtually non-existent, the Cleminsons and others like them were able to sell most everything they could make in the way of ceramic giftware. Because of the popularity of the pie bird, Mrs. Cleminson concentrated her efforts at first on kitchen related articles. She added spoon rests, cookie jars, canisters, salt & pepper shakers, butter dishes and string holders over the two year period the business remained in its original location. Much of the ware at this point was personally decorated by Betty Cleminson.

The pottery outgrew the confines of the garage in 1943 and a factory was constructed in El Monte in which all the necessary equipment for mass-production was installed. Over fifty workers, many of them decorators, were hired at this time, and the name of the company was changed to The California Cleminsons.

One of the most successful products manufactured in the new plant was a line of tableware called Distlefink, featuring a bird motif in a style akin to Betty's Pennsylvania German ancestry. Numerous kitchen items were added during the many years this pattern was produced. In the mid forties the output of the business was broadened to embrace various giftware novelties – wall plaques, vases, figurines, hanging plates, cup & saucer sets, children's dishes, pitcher & mug sets, etc. – many featuring homey hand-lettered phrases. At the height of production (just after the war), the Cleminsons pottery employed over 150 people.

After her own plant was destroyed by fire in 1958, Hedi Schoop created (on a free-lance basis) a successful line of household articles for the Cleminsons with an up-to-date fifties look. Business in the fifties remained good for the company because most of the items in the line were inexpensive and could compete with the imported Japanese wares. By the early sixties, however, it was no longer possible to offer a competitive product of any quality due to the amount of hand work involved. In 1963, rather than cheapen their merchandise, George and Betty Cleminson decided to close the pottery.

The regular stamped Cleminsons mark is shown. A variation, without the children on either side of the circular shield, was also used. Special lines, like Distlefink and Galagray, had individualized marks (also stamped). Betty Cleminson's incised monogram appeared on certain early items, including the pie bird.

Hand Painted

Kay Finch

Kay Finch Ceramics was one of the most respected and successful of the California commercial artware studios of the forties and fifties. Its originator, Katherine (Kay) Finch was born in rural west Texas in 1903. An early interest in clay modeling led to formal instruction at Ward Belmont College in Nashville, Tennessee in 1920-21. While studying there she met husband-to-be Braden Finch; they were married in 1925. Braden's acceptance of a job offer in California brought the Finches west the following year, with Kay continuing her art education in evening classes at Scripps College in Claremont. They moved to Corona del Mar in 1930 after Braden's acceptance of a position with the *Santa Ana Register*.

In 1937 Kay Finch returned to Scripps in order to study with William Manker in the newly established ceramics department. Kay's terra cotta sculpture so impressed Manker that he urged her to make art more than just a hobby. With added encouragement from Braden, she began producing clay models for production in a studio adjacent to the Finch residence. But prior to establishing the business, the Finchs took an around-the-world trip. This experience solidified Kay's determination to pursue pottery commercially, as she made a study of native ceramics in the various countries they visited.

The Kay Finch business was officially begun in 1939, with Braden resigning his newspaper job in order to assist his artist wife. He assumed all the administrative duties, leaving Kay free to create. Their first commercial success came in 1940 with a whimsical series of pig figurines and banks hand decorated with fruit and flowers. An expanded studio and retail showroom located at 3901 East Pacific Coast Highway in Corona del Mar was inaugurated on December 7, 1941. With only ten employed in the beginning, the company quickly grew to over forty full-time workers.

Kay personally trained each of the thirty female decorators in her own painting style, but performed much of the work herself. Animals of all kinds were her specialty and she modeled and painted them with a genuine sense of self-expression. No competitors matched Kay's unique combination of animated form and hand-painted linear detail. Human subjects were more limited in number; the most impressive being Oriental figures measuring up to twenty-five inches in height. The Finches' son George designed and modeled most of the non-figural items the company produced, including vases, bowls, planters, bath accessories and ashtrays, in a modern style which nicely complemented his mother's more flamboyant approach. Breakfast sets of dishes, for which Kay created the decorative patterns, were also his work.

In the forties Kay Finch began a life-long interest in champion dog breeding. This led to her extensive line of ceramic dogs (modeled after American Kennel Club champions), with wall plaques, ashtrays, tiles, steins, pins, and figurines of all sizes and breeds among her canine creations.

In 1950 a series of Christmas plates was initiated and continued through 1962. Measuring 6½", each was hand-painted. Other seasonal items were offered and distributed to fine gift and department stores in all parts of the country. Although the business was affected by cheap foreign copies and other imports after World War II, the impact was not as severe as was the case with most giftware manufacturers in California, a testament to the high quality of the Kay Finch line and the esteem it enjoyed. It was Braden's death in 1963 that ended the highly successful enterprise. Without

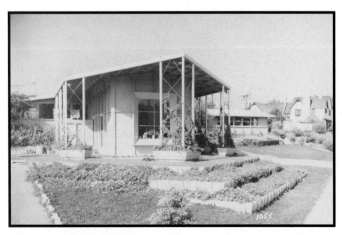

The Kay Finch studio and showroom, Corona del Mar in 1947. Archival photo.

his support, Kay ceased operations and devoted her full attention to breeding show dogs.

In the mid seventies the Freeman-McFarlin Potteries, which had earlier purchased her molds, commissioned Kay Finch to model a new set of dog figurines. Production of these and various other models was undertaken in Freeman-McFarlin's standard glazes and finishes until 1980.

The Kay Finch marking system ran the gamut from impressed and incised (in-mold) marks to ink-stamped and hand-painted ones. A cross-section is shown. Paper labels were also used. Very small figurines were usually not marked. It should be noted that certain Kay Finch models have entered the arena of molds-for-hobbyists. The results of these are easily distinguished from the genuine article however.

KAY FINCH
CALIFORNIA

Kay Finch
Calif

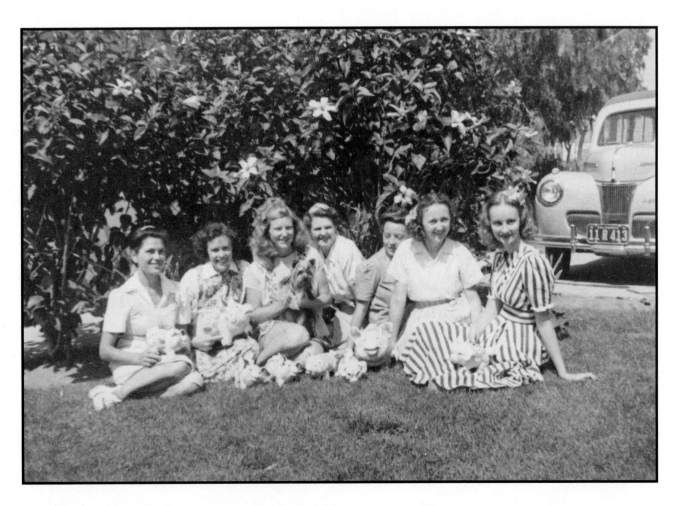

Kay Finch decorating staff of 1941. Kay Finch is third from left. Archival photo.

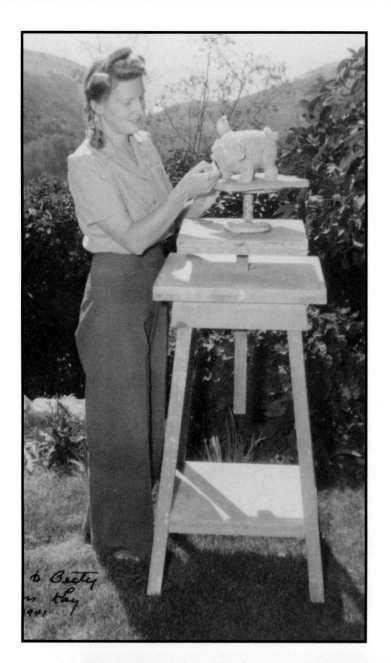

Kay Finch working on a clay model outside her oceanside studio in Corona del Mar in 1941. Archival photo.

Southern Comfort "Missouri Mule" tumblers made by Kay Finch in the forties. Overglaze platinum was used on these examples. Paper labels.

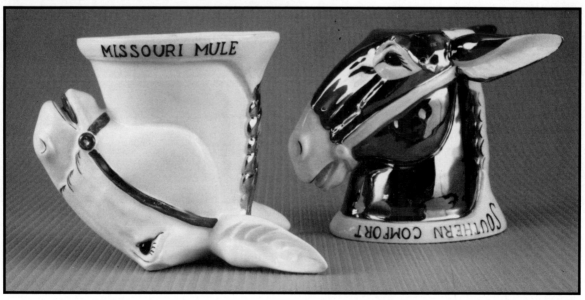

California Pottery

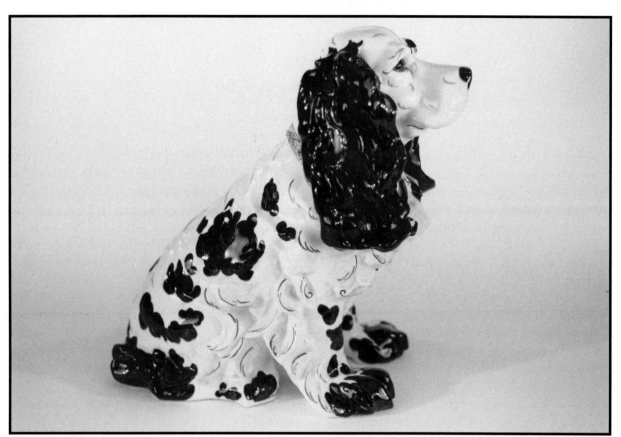

Cocker, 11", was one of the many canine models produced by Kay Finch. In-mold mark.

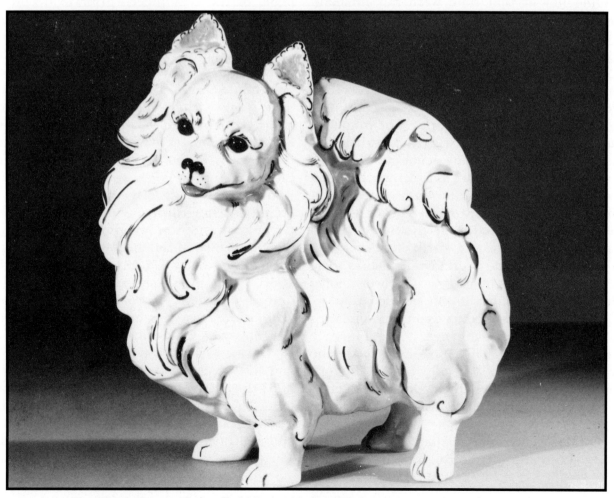

Kay Finch Pomeranian called Mitzi, 10". Hand-decorated, c. 1944. Archival photo.

Florence

The Florence Ceramics Company owed its existence to a tragic event in the life of founder Florence Ward. In 1939, after death had claimed one of her two youthful sons, Mrs. Ward began to dabble in clay as a means of overcoming personal grief.

Not surprisingly, her first pieces were of children, individually shaped and decorated in the garage at her residence in Pasadena. Florence Ward, who was basically untrained in art, decided to turn her engrossing hobby into a full-time occupation after attending a ceramics class in 1942. With her husband and other son away during the war, she boldly established the enterprise on her own. When it had outgrown the family garage, Florence Ceramics moved into a modest sized plant on the east side of Pasadena in 1946.

Joining her at that time were her husband Clifford, her son Cliff Jr. and over forty employees. The Ward's company sold its output of hand-decorated figurines through a local jobber prior to 1946. After relocating, the firm began displaying its wares at the Los Angeles gift shows and selling directly to retailers throughout the United States, Hawaii, Canada and South America. The volume of business increased rapidly with the addition of sales representatives in many major cities, and in 1949 a modern 10,000 square foot factory equipped with a continuous tunnel kiln was erected at 74 South San Gabriel Boulevard in Pasadena. The company was incorporated at this time with Clifford D. Ward, President; Florence Ward, Vice President; and Clifford Ward, Jr., Secretary-Treasurer. The latter was also sales manager. The work force totalled over one hundred in the new location.

Florence Ceramics produced some of America's finest semi-porcelain figurines. "The Florence Collection," as it was called, featured authentic and exquisitely detailed reproductions of historical couples in period costume. Fictional characters were also produced, such as Rhett and Scarlett from the motion picture *Gone With The Wind*. Figures of European royalty included Louis XV and Madame Pompadour, Louis XVI and Marie Antoinette, and Queen Elizabeth and King Arthur. Gainesborough's "Pinkie" and "Blue Boy" were faithfully reproduced and added to the line which featured an extensive offering of individually named ladies and gentlemen outfitted in the Godey fashions of the late 19th century. A less expensive line of figurine-vases was also produced, along with various small scale children in period attire. Other Florence articles included busts, wall plaques, wallpockets, candle holders, picture frames, clock frames, vases, smoking sets, and a large assortment of birds. Some of the more elaborate human figures were incorporated into lamps complete with custom shades.

Florence was one of the first potteries to utilize actual lace decoration on figurines. The lace was cut to size and then dipped in slip and applied to many of the cast pieces prior to decorating. In firing, the cloth burned away leaving a delicate ceramic replica. Clays used to manufacture the Florence artware came from Kentucky, Tennessee and Florida. Body and glaze (with underglaze china-painted decoration) were matured in separate firings. Items with overglaze 22K gold trim received a third trip through the kiln. Imports had a limited effect on the business when they were reintroduced in the early fifties. By then the reputation of the Florence line was so firmly established that wholesale buyers eagerly awaited Mrs. Ward's latest creations when they were unveiled semi-annually.

In an attempt to broaden its scope, a separate offering of bisque-finished animal figures modeled by sculptor Betty Davenport Ford was added in 1956. These highly stylized sculptures, which required minimal airbrush decoration, included rabbits, doves, squirrels, dogs and cats. Production on this series was continued for only two years.

Business slowed somewhat in the early sixties, and following the death of Clifford Ward, Sr. in 1964 the company was sold to the Scripto Corporation. The Florence trade name was retained by Scripto, but advertising specialty ware (ie. mugs and ashtrays) was the extent of their production. The company ceased operations entirely in 1977.

Florence diligently documented its product with stamped and incised marks where possible, or with paper labels. The top of the line figurines were generally stamped with one or the other of the circular marks shown (1) & (2). The second (2) mark was also used on less expensive figurine-vases. The finer figurines usually bore their designated name (in-mold) as well as the company name. Some items were stamped with the "Florence Ceramics Copyright" block lettered mark (3). Others were incised in-mold "Florence Ceramics" in script (4). The stamped "Floraline" mark (5) was used on a special offering of floral containers and accessories. Betty Davenport Ford's line bears her name in addition to the company name. The paper label shown (6) may also be found on a variety of ware.

(1)

(2)

(3)

(4)

Floraline
BY
FLORENCE CERAMICS INC
PASADENA, CALIFORNIA

(5)

(6)

Freeman–McFarlin

Freeman–McFarlin was a partnership between Maynard Anthony Freeman and Gerald H. McFarlin. The business was a reorganization of the McFarlin Potteries, which Gerald ("Mac") McFarlin had owned and operated in El Monte since 1927. After joining the business in 1951 Freeman became the chief designer. The union of McFarlin the businessman and Freeman the creative spirit resulted in a long and rewarding association.

Success for the new firm came with the introduction of Maynard Anthony Freeman's distinctive line of slip-cast earthenware sculpture. Subjects for this ware ranged from wild and domesticated animals (including many unusual varieties), to common and exotic birds. Human figures were occasionally combined with an animal (usually a horse with rider). Freeman's output included both naturalistic and highly stylized models, all of which bore the trademark "Anthony." Favored designs were copyrighted.

Accounts were obtained with many fine department stores in California and elsewhere for the Anthony collection which included horses, dogs, cats, mice, rabbits, giraffes, elephants, llamas, owls, roadrunners, flamingos, parakeets, eagles, falcons and many others. Most of these figurines remained in production until the business was sold, and were produced in a variety of colored glazes and finishes. The Freeman-McFarlin Potteries utilized numerous non-glazed finishes over the years, such as woodtone and gold leaf, which were routinely juxtaposed with its staple of high-gloss glazes. The company also produced an extensive line of decorative household items. These included bowls, vases, compotes, candlesticks, ashtrays and numerous related articles. Free-lance designers were responsible for some of this ware, as well as a line of unglazed stoneware planters cast in the shape of various animals.

After Kay Finch closed her pottery in Corona del Mar in 1963, Freeman-McFarlin purchased all of her molds. Selected figurines were reproduced in the Freeman-McFarlin glazes and finishes and were markedly different from Kay Finch's original hand-decorated models. At a later date Kay was commissioned to create a series of new pieces. At least ten animals (mostly dogs) were modeled and added to the line.

In 1968 Freeman-McFarlin added a second plant in San Marcos (in San Diego County). The El Monte factory was closed about 1975, with operations subsequently consolidated at the San Marcos location. By this time the company was distributing its line worldwide and employed about 150 people.

Gerald McFarlin sold his interest in Freeman-McFarlin in the late sixties. Freeman and new partners Leland McKenzie and Pat Callahan sold the business to International Multifoods in 1972. Hagen-Renaker purchased the plant in 1980.

Maynard Anthony Freeman's sculpture line and most of the other articles he designed bore the incised in-mold "Anthony" designation. A copyright symbol often accompanied this trademark. Freelance designed pieces were sometimes incised with the designer's name in-mold. The "Hetrick" mark is one of these. Most other items were impressed "F.McF.", aligned either horizontally or vertically. The example shown includes the words "Calif. USA" and the copyright date. At least two sizes of the Freeman-McFarlin paper label as shown exist.

Anthony

F_McF
19 © 61
CALIF
USA

Gladding-McBean/ Franciscan Ceramics

The Franciscan plant of Gladding-McBean & Company was California's largest and most technically sophisticated. The substantial success the business experienced was commensurate with its contribution to the industry.

Gladding-McBean was originally founded in Lincoln (Placer County) in 1875 by Charles Gladding, Peter McBean and George Chambers. Owing to the initial success and rapid expansion of its ornamental terra cotta and other building materials, it evolved into a diversified organization which, by 1926, was the largest clay products concern in the western United States.

The Southern Division of the business, after merging with the Los Angeles Pressed Brick Company in 1924, consisted of plants in Los Angeles, Santa Monica, Alberhill and Glendale. The Glendale (later Los Angeles) plant, where Franciscan Ware was produced, started in 1902 as the Pacific Art Tile Company, the first factory of its kind on the West Coast. Tile, along with terra cotta garden pottery, was the principal product there until the early thirties when the plant, which was located at 2901 Los Feliz Boulevard, initiated its earthenware production.

The patenting in 1928 of a one-fire talc body, designated Malinite (named after technician Andrew Malinovsky), lead to Gladding-McBean's first dinnerware line in 1934 called El Patio. It was designed by Mary K. Grant, wife of Frederick J. Grant, who was hired in 1934 to head the new pottery division.

El Patio was introduced in eight brilliant glaze colors in order to make it competitive with the colored ware which Bauer originated in 1930. The trade name "Franciscan" was chosen to be symbolic of California. In 1936 the company conceived the starter set, consisting of four place settings packed in an individual carton. Both El Patio and Coronado, another successful line introduced in the early thirties, were included in these sets which were ideal for newlyweds and as such set an industry standard for marketing.

In 1937 Gladding-McBean produced its initial hand-painted Franciscan pattern (on the El Patio shape) called Padua. Following this came other decorated dinnerware lines including Del Mar and Mango in 1937, and Hawthorne in 1938. This progression culminated in 1940 with the Apple pattern, the firm's most popular hand-painted underglaze dinnerware. Apple's embossed border design was embossed in-mold and hand-tinted by a large and skilled staff of decorators. The other two best-selling underglaze patterns introduced in the wake of Apple's success were Desert Rose (1942) and Ivy (1948.)

In 1937 the Catalina Clay Products line was purchased from the Santa Catalina Island Company. This major transaction included dinnerware and artware molds and the use of the trade name "Catalina." It added about 175 new items immediately, with additional artware designs created between 1937 and 1942. Catalina Rancho, a simple and graceful tableware in solid colors (satin-matte and high-gloss) was produced from Catalina Island molds between 1937 and 1941.

An extensive artware assortment, consisting mainly of vases and bowls, was marketed under the heading "Catalina Art Pottery" and included the following design groups: Angelino, Aurora, Avalon, Capistrano, Coronado, Encanto, Floral, Nautical, Polynesia, Reseda and Saguaro.

The well equipped and staffed lab developed some extraordinary glazes for the artware package, from monochromes and duotones (various gloss and matte color combinations) to attractively mottled finishes such as matrix blue, gold, agate, and verde green. But the firm's crowning achievement in glaze chemistry was the Ox Blood line perfected by ceramic engineer Max Compton using selenium under specially controlled kiln conditions. Many of the Chinese style shapes that hosted the Ox Blood glaze were utilized for the Angelino ware which was produced in periwinkle blue, light bronze and satin ivory. Dorr Bothwell's Samoan Woman & Child and Reclining Samoan Girl figu-

rines and her popular Peasant Girl flower holder were included in the miscellaneous articles that rounded out the Catalina Art Pottery.

New York's Metropolitan Museum of Art commissioned Gladding-McBean in 1939 to produce a prototype set of the prize-winning dinnerware submitted to its 15th Exhibition of Contemporary American Industrial Art by Morris B. Sanders. Designer Sanders' prototypes for the competition proved to be so striking that they were purchased by the company and put into production the following year. The Metropolitan service, in a variety of monochrome and duotone satin-finish pastels, was nationally advertised as the first entirely square shaped dinnerware made in America. The successful line was renamed Tiempo in 1949 when new high-gloss decorator colors were applied to the basic shapes.

The hotel china developed in 1939 for the Dohrman Hotel China Company of San Francisco provided the Gladding-McBean technicians with a trial run for a new vitrified body which was perfected and introduced the following year as Franciscan Fine china. Distinguished by its extreme thinness and formal elegance, the Masterpiece China line, produced from 1941 to 1979, included over 165 decorative patterns undertaken on nine basic shapes. Otto J. Lund and George James designed most of the decorative patterns for the top ranked Masterpiece China.

The patterns for the medium weight and informal china called Discovery (1958-1975) were created by a distinguished group of ceramic artists associated with the design department. The designers included Francis Chun, Dora DeLarios, Rupert Deese, Harrison McIntosh, Jerry Rothman, Henry Takemoto and Helen Watson. Contours, a china artware collection of ultramodern free-form shapes designed by George James, was produced in the mid fifties. Numerous other china lines were offered to accommodate a wide range of tastes and incomes.

Fine quality, inexpensive Japanese china began to appear domestically in the fifties. The imported goods ultimately prevailed and the company's china production had to be terminated in 1979. The imports situation was not quite as devastating for the earthenware division. An overall decline in sales, however, was a factor in Gladding-McBean's decision to sell its Franciscan plant to the Lock Joint Pipe Company in 1962. This merger resulted in the formation of the International Pipe and Ceramics corporation, simplified to Interpace Corporation in 1968.

In the sixties and seventies the firm's major expenditure of time and resources was put into generating competitive lines of dinnerware. Mary J. Winans supervised the design department after Mary K. Grant's retirement in 1952. The older Apple, Desert Rose and Ivy lines were supplemented with Winan's new patterns Tulip Time, Pebble Beach, Hacienda and Madeira, among others. In 1968, due to a renewed interest among collectors in the colored pottery of the thirties, Franciscan created Kaleidoscope, a simple tableware design in monochrome glazes. The tile division (utilizing the trade name Hermosa Tile) continued to manufacture plain wall and floor tile as well as decorative tile, including tea tiles to match many of the dinnerware patterns, until 1982.

Because of the worsening imports problem, Interpace sold Franciscan Ceramics to Josiah Wedgwood and Sons, Ltd. of England in 1979. Determining that it could more profitably produce the successful Franciscan lines in its Stoke-on-Trent facility, Wedgwood ceased operations at the Los Angeles pottery in 1984. Two hundred and eighty people were employed at the time of the plant's closing. The sprawling forty-five acre site included fifteen periodic kilns and thirty-six tunnel kilns, many of which were idle in the later years.

A great many identification marks, labels and backstamps were used over the years. Only a selection of these is shown. The earliest backstamp used on earthenware production was the abbreviated "GMcB" in an oval (1), sometimes with "Made in U.S.A." added. A considerable amount of early (and later) ware was stamped simply "Made in U.S.A." (2). The "Tropico Pottery" stamp (3) appeared on a limited line of artware and kitchenware in the mid thirties. Gladding-McBean's Catalina Pottery line bore a variety of impressed (4) and stamped (5) & (6) marks as well as the paper label shown (7). The first backstamp to indicate the Franciscan trade name was the letter "F" in a square (8). It replaced the early oval mark in 1938 and was in use less than a year. The first Franciscan Ware backstamp, of 1938, (9) was followed by a circular stamp (10), with slight variations, used from 1939 to 1949. An arched backstamp (11) was used from 1949 to 1953. Another circular stamp (12) came into use between 1953 and 1958. A Franciscan Ware paper label (13) was affixed to

various items during this period. Beginning in 1958 a backstamp resembling a TV screen was adopted. There were over thirty variations on this mark (14), including a paper label, which was used to identify both earthenware and china, with the appropriate wording included, such as "Master-piece China as shown (15). Prior to 1958, oval backstamps were utilized on china (16). The Contours china artware had its own decal (17). More recent backstamps include the elaborate "California Craftsmen" mark adopted in 1974 (18) and a restyled "F" (19).

MADE IN
U. S. A.

(1)

MADE IN
U.S.A.

(2)

TROPICO POTTERY
CALIFORNIA

(3)

CATALINA
C 806
POTTERY

(4)

CATALINA
MADE IN
U.S.A.
POTTERY

(5)

CATALINA
REG. U. S.
PAT. OFF.
RANCHO

(6)

GLADDING, McBEAN & CO.
Catalina Art Pottery

(7)

F
MADE IN
U. S. A.

(8)

FRANCISCAN
+ + + WARE
MADE IN U. S. A.

(9)

FRANCISCAN
WARE
MADE IN
CALIFORNIA
U.S.A.

(10)

FRANCISCAN
MADE IN CALIFORNIA

(11)

FRANCISCAN
MADE IN
CALIFORNIA
U.S.A.
HAND DECORATED
GLADDING,
McBEAN
& CO.
OVEN-SAFE

(12)

FRANCISCAN WARE
CALIFORNIA
REG. U.S. PAT. OFFICE

(13)

INTERPACE
Franciscan
FINE DINNERWARE
MADE IN U.S.A.

(14)

RONDELAY
GLADDING, McBEAN & CO.
Franciscan
MASTERPIECE
CHINA

(15)

FRANCISCAN CHINA
MADE IN CALIFORNIA

(16)

Franciscan
fine China
MADE IN U.S.A.
®

(17)

The California Craftsmen since 1875.
FRANCISCAN

(18)

GF

(19)

The Home of
FRANCISCAN WARE and Catalina Art Pottery
REG. U.S. PAT. OFF.
Made in California

Two views of the sprawling Gladding-McBean plant, c. 1940's.

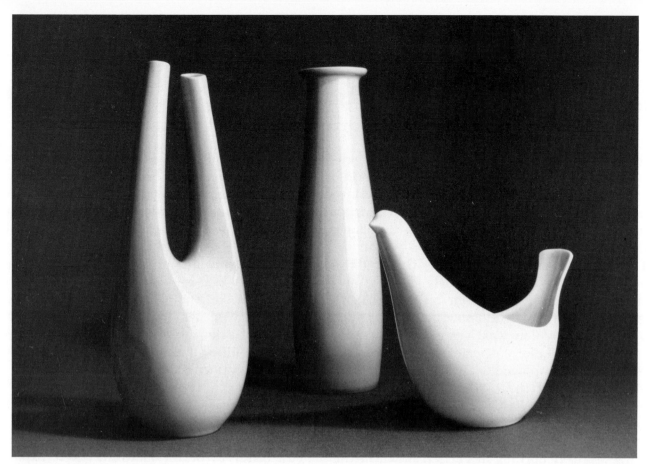

Gladding McBean's "Franciscan China" artware line called "Contours" designed by George James in 1955: large twin vase, tall bottle (stopper missing) and bird, 7" x 8".

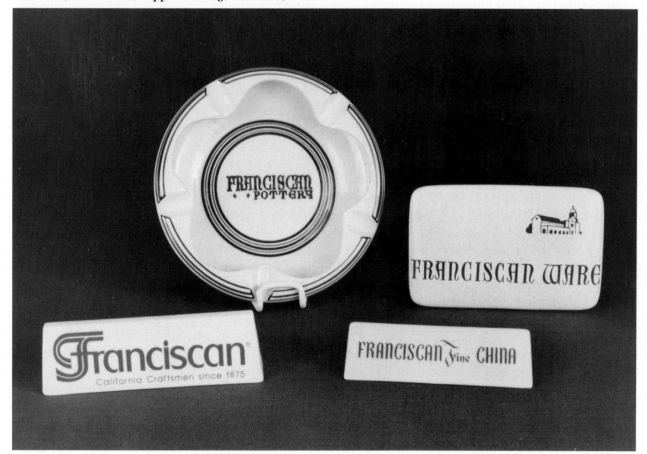

"Franciscan Pottery" ashtray of 1937, "Franciscan Ware" dealer sign of the fifties, "Franciscan-California Craftsmen since 1875" dealer sign of the seventies/eighties, and "Franciscan Fine China" dealer sign.

Hagen-Renaker

Specializing in miniatures has made Hagen-Renaker a stand-out among California potteries. The firm's continued prosperity is a testament to the dedication of the employees and to the high standards of design and workmanship that have been maintained.

The business formally began in 1946 in a facility of modest proportions in Monrovia. Maxine and John Renaker, with help from Mrs. Renaker's father Ole Hagen (hence the name Hagen-Renaker), built the plant, which was located on Chestnut Street, near the Walker Potteries where John had previously been employed.

Maxine's set of three tiny simplified ducks originated the miniatures, and the trend gained further momentum when a similar skunk family was added. Other ceramic items were produced in the early years but nothing succeeded as well as the hand-painted miniature animals.

Helen Perrin Farnlund joined the company as a decorator in 1947, but her talent for designing was soon discovered and encouraged. Over the years she has been responsible for modeling most (about 90%) of the Hagen-Renaker miniatures. Maureen Love Calvert, the second designer hired (in 1951), has made an exceptional contribution with her naturalistically modeled horses, both miniature and large scale. Both Farnlund and Calvert are currently associated with the business on a retainer basis, contributing new designs periodically.

Maxine, who was born in North Dakota, and John Renaker, a third generation native Californian, have made it a point to cultivate exceptional designers. Those who have been affiliated with them include: Tom Masterson, who was responsible for the acclaimed Pedigree Dogs line; Nell Bortells, creator of the Little Horribles series which depicted puns and popular expressions; Will Climes, who (in collaboration with Masterson) created the highly stylized Black Bisque line; and Don Winton and Martha Armstrong Hand, who modeled most of the Walt Disney characters. From 1955 to 1960 the company produced, under license from the Disney Studios, miniatures and other figural items based on characters from the films *Alice In Won-*derland, *Snow White And The Seven Dwarfs, Sleeping Beauty, Cinderella, Bambi, Fantasia, Peter Pan, Lady And The Tramp* and others. Mickey Mouse, Donald Duck, Pluto and Goofy were also included in the line which was marketed mainly through the gift shops at Disneyland in Anaheim.

A business related to Hagen-Renaker, known as Walker-Renaker, was organized by John Renaker and Joseph Walker in 1952. This offshoot, which was located across the street from the latter's Walker Potteries on Magnolia Street in Monrovia, produced a line of humorous porcelain miniatures and salt & pepper sets with clever titles like "Holy Cow," "Bum Steer" and "Pig O' My Heart." Also produced was a series of "Puti" figurines modeled by the noted Austrian ceramist Susi Singer. The Walker-Renaker operation closed in 1959.

In order to better facilitate their expanding miniatures trade, the Renakers constructed a larger Hagen-Renaker factory at the corner of Shamrock Avenue and Duarte Road in Monrovia in 1961. The business experienced some difficulty with foreign competition in the sixties, but through determined effort it emerged even stronger, moving to a better-equipped facility in San Dimas in 1966. The current plant encompasses an area of about 100,000 square feet on a seven acre site and employs over 190 people. Here another facet of the business, known as Designers Workshop, was expanded. Maureen Calvert and Helen Farnlund were the exclusive designers of this collection begun in the fifties of larger and more detailed figures. After Hagen-Renaker purchased the Freeman-McFarlin plant in San Marcos in 1980, Designers Workshop, under the supervision of the Renaker's son John, was relocated there. The line was discontinued in 1986 and the plant was subsequently sold.

Hagen-Renaker, Inc. continues today as a successful family-owned corporation, although founders John and Maxine are now semi-retired and daughter Susan Nikas is in charge. The clay used in production is a mixture of talc from California and ball clay from Kentucky and Tennessee. Every miniature undergoes more than a dozen steps from the casting and bisque firing stages through the

hand decoration, final glazing and labeling. The entire process, though streamlined to keep costs to a minimum, renders a lovingly hand-crafted appearance to the finished product. The company has experimented with a variety of supplemental (non-miniature) ware over the years, but with limited success. Hagen-Renaker's specialty has become its trademark.

Aside from their obvious characteristics, most Hagen-Renaker miniatures have been labeled where possible or attached to paper bases that include the name and address of the pottery. Some early models were incised with a conjoined "HR" plus a copyright symbol. Others were stamped with all or a portion of the words "Hagen-Renaker." About twenty different styles of paper label have been used through the years. Only a few are shown (in approximate chronological order.) Some of these include the designated name of a particular model or figure, and some include a copyright date. Supplemental ware was marked in a variety of ways with the company name.

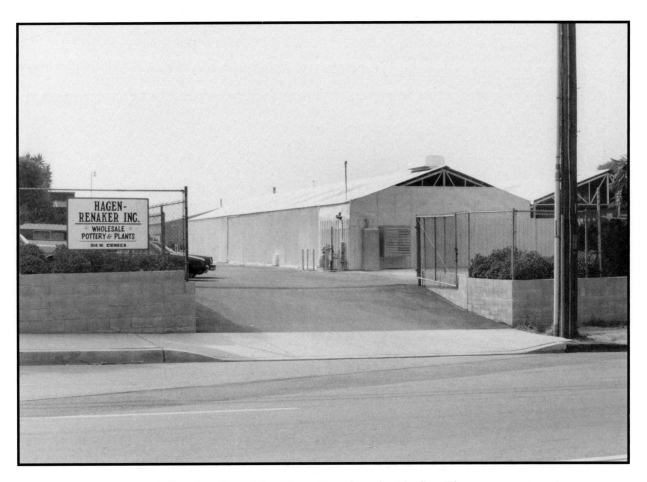

Exterior view of the Hagen-Renaker plant in San Dimas.

Hagen-Renaker miniature "Malificent" figurine, 1½", from the Disney movie "Sleeping Beauty." Designed by Martha Armstrong Hand, c. 1954.

Three Hagen-Renaker mini bunnies of the early fifties. One in center measures 1½".

Worker attaching miniature animals to paper bases inside Hagen-Renaker's San Dimas plant.

Hagen-Renaker decorators at work inside the San Dimas plant.

Haldeman

Virgil K. Haldeman, along with his wife Anna, established the Haldeman Pottery in Burbank in 1933. Virgil Haldeman was a prominent figure during the time that he was active in the Southern California pottery industry. He was born in 1899 in Kansas and received his primary education there. Trained as a ceramic engineer at the University of Illinois, he graduated with honors in 1923.

After working briefly for a tile plant in Pennsylvania, Virgil moved to California. In 1927 he and a partner organized the Haldeman Tile Manufacturing Company in Los Angeles. This business was sold in 1930 when Haldeman went to work for the Catalina Clay Products Company on Catalina Island. He remained there as ceramic engineer and plant superintendent until leaving in 1933 to start his own business. That same year, the Haldeman Pottery began operations at 41 East San Jose Avenue in Burbank in a plant equipped with two large periodic kilns. Anna Haldeman worked closely with her husband from the beginning (they were married in 1931), processing the orders and supervising in his absence.

The Haldeman Pottery's Virgil K. Haldeman. Archival Photo.

The designation "Caliente" was selected as the trade name of the company and was used on vases, low flower bowls, flower frogs and figurines. The chief designer from 1933 to 1941 was Andrew Hazelhurst. Virgil, who specialized in glaze chemistry, created all the glazes. The variety was remarkable and included satin matte colors white, black, green, pink and blue; and high-gloss colors turquoise, burnt orange, yellow, maroon, jade green, chartreuse, gold, light brown and red brown. Blended colors included green-pink, blue-pink, turquoise-gold and others.

During World War II, despite Virgil Haldeman's recruitment for defense work, the business experienced its greatest growth. A new line of "hand made" low flower bowls with overlapped edges, introduced at the Los Angeles Gift & Art Show in 1941, was an immediate hit. This was followed by baskets with rope handles (hand-fashioned from twisted coils of clay) and bowls and vases with attached roses, poppies, dogwood, holly or oak leaves. Other items in the Caliente line were ewers, candle holders, ashtrays, planters, and numerous small figurines of animals and birds. An outstanding series of Art Deco dancing ladies was also produced.

In 1947 the Burbank factory was sold and the business was moved to Calabasas, in the outer reaches of the San Fernando Valley. Only about a half dozen of the twenty-five employees transferred to the new location, which was a cooperative involving several applied arts industries. Here Caliente ware was produced for six more years before the business closed in 1953.

At the same time he was operating the pottery, Virgil Haldeman was active in local ceramic organizations. He was president of the Southern California Chapter of the American Ceramic Society in 1947 and president of the Southern California Potters Guild in 1949. It was through the auspices of the latter group that Haldeman established Registered California as an attempt to uphold high technical standards in a mushrooming industry. During the war, when many essential ceramic materials were requisitioned by the government, Virgil aided several small potteries by helping

them revise their glaze formulas and thus maintain their businesses.

After closing his own pottery, Haldeman worked for tile companies in Texas, New Mexico, and again in California before retiring in 1974 at age seventy-five. He died at Lake San Marcos, California in 1979.

No consistent system was developed to mark the Caliente line. The earliest products bore raised numerals or "Made in California" in a semi-circle (1). Many of the later figurines were impressed "Made in California" in "block" letters (2). Numerous items were not marked; their only identification being the paper label as shown (3). An earlier version of this sticker exists without the Registered California logo. On later period low bowls, baskets, etc., a hit-or-miss method was used, with all or some of the following words included: "Haldeman Potteries/Caliente/hand made/California" (4). These were incised in-mold in a variety of handwriting styles. If a mold was overused, these markings will appear faint and almost unreadable.

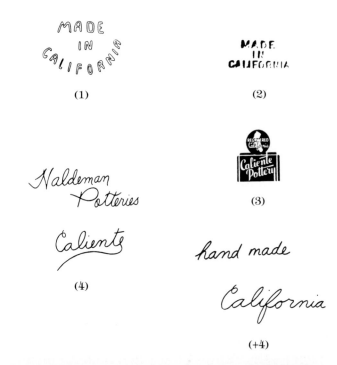

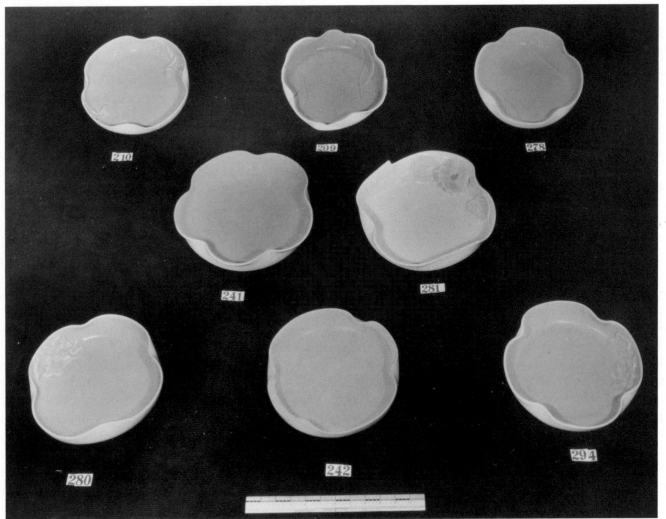

An assortment of "Caliente Pottery" low flower bowls, c. 1946. Archival photo.

Brad Keeler

Brad Keeler was born in Lincoln, California in 1913. He was the eldest son of four children born to Mr. and Mrs. Rufus B. Keeler. At the time of Brad's birth Rufus was employed as a ceramic engineer and designer at Gladding-McBean's Lincoln plant. He would later be instrumental in the founding of two Southern California tile businesses, California Clay Products (Calco) and the Malibu Potteries.

After graduation from Huntington Park High School in 1931 Brad enrolled in an evening painting class at USC. This was the only formal art training he received prior to employment as a modeler for the Philips Bronze and Brass Company of Los Angeles in the mid thirties. There, the young Keeler created numerous figures while perfecting his natural skill as a clay modeler.

In 1939 a small ceramics studio was established in the garage of the family residence in Glendale. Because the naturalistic, hand-decorated birds Keeler created were such an immediate success, he leased about 5,000 square feet of workspace in Evan K. Shaw's American Pottery in Los Angeles. Shaw was so impressed by Brad's work that he added Keeler's birds to the line of ceramic giftware he represented to the trade. Altogether more than fifty bird models were produced at the Shaw location including several popular flamingos.

Manufacturing of the entire assortment was carried out by Keeler's own crew of about sixty workers. Decoration was performed in two stages. First, the appropriate colors were applied to the bisque ware by means of an airbrush. Then hand-painted details, such as beaks and eyes, were added before an overall transparent glaze was sprayed on. The wide variety of birds modeled by Keeler included seagulls, blue jays, swans, ducks, chickens, herons, cockatoos, pheasants, canaries, parrots and parakeets. Most were designed as male-female sets, with two birds occasionally incorporated into a single unit.

Brad Keeler relocated his thriving business in 1946 after a fire destroyed the American Pottery plant. A completely new 15,000 square foot factory was erected at 2936 Delay Drive in Los Angeles (near Glendale) on land owned by Keeler's father. One large continuous tunnel kiln and a number of smaller batch-type kilns for experimental work were installed in the new facility. Before the move took place, Brad began modeling the characters which comprised Evan K. Shaw's exclusive line of Walt Disney figurines. These were produced and distributed by Shaw's own company. Many new items were added to Brad Keeler's line by enlisting the services of free-lance designers. Fred Kaye was the most favored designer and he modeled a number of additional birds, including what was called the "Exotic Series," as well as a variety of animals.

In 1946, Keeler, assisted by glaze technician Andrew Malinovsky, Jr., developed a brilliant red glaze (using cadmium and selenium oxides) which he called Ming Dragon Blood. This was one of the first true reds to be successfully adapted to commercial production. An extensive collection of Chinese Modern housewares was created to utilize the red glaze, which was sometimes combined with high-gloss black. The very successful Ming line included vases, ginger jars, low bowls, candle holders, planters, cigarette boxes and ashtrays. In order to fully capitalize on the Ming Dragon Blood glaze, a line of buffet serving dishes was produced featuring lobster handles. Other Keeler ware consisted of plain and decorated vases, bowls and tea sets.

Representation of the Brad Keeler Artwares line was transferred to the China Dry Goods Company of San Francisco and Paul Straub of New York in the late forties. Although Japanese imports posed a serious threat to the business, Brad Keeler was constructing an even larger factory in San Juan Capistrano in 1952 when a heart attack claimed his life at age thirty-nine. The Keeler company, which employed about two hundred people at the time, did not survive the loss and the new plant was sold in 1953.

Brad Keeler's early (American Pottery) bird figurines were marked in two ways with an incised (in-mold) "Brad Keeler" (1) plus a model number, and with an American Pottery paper label. After 1946, when the Keeler plant was occupied, a new paper label was used (2) in conjunction with the original recessed mark. Stamped marks were used on small items or the work of outside designers (3)

(1)

B.B.K.
Made In
U.S.A.

(2)

(3)

Brad Keeler. Archival photo.

William Manker

California's ceramic heritage has been enriched by the contributions of a number of exceptional potter-instructors. William Manker is among those who helped shape the course of commercial studio pottery in Southern California.

A California native (born in Upland in 1902), Manker began his ceramics career in 1926 when he secured a position with the Batchelder-Wilson Tile Company in Los Angeles. He had been part of the inaugural student body at the Chouinard School of Art at the time, but eagerness for practical experience led him to accept an apprenticeship under Ernest A. Batchelder.

A young man with a keen interest in color and design, Manker found a creative outlet in the tile business where he advanced to the position of Batchelder's design assistant, a post he held until the plant closed in 1932. Undaunted by the economic uncertainties of the Depression, William Manker opened a studio in Pasadena the following year. Although just a one-man operation at first, his skillfully crafted earthenware vessels, celebrating the classic simplicity of Chinese ceramics, attracted the attention of Pasadena art dealer Grace Nicholson. Her prestigious gallery gave Manker his first commercial account and recognition. Due to this swift success, former associate Batchelder became interested in the enterprise. Through his efforts an exhibition was mounted at a local college with the intent of attracting financing for a Batchelder-Manker partnership. The attempt, although unsuccessful, prompted Batchelder to organize a competitive business in 1936.

Continuing to prosper, William Manker Ceramics was relocated in 1935 to larger quarters in the Padua Hills fine arts complex north of Claremont, where Manker had already accepted a teaching position at Scripps College. The business greatly expanded after Manker's line began to be featured in fine department stores throughout the country. Among the notable outlets were: Bullock's Wilshire in Los Angeles, Gump's in San Francisco, J. L. Hudson in New York, and Maison Blanche in New Orleans. Manker's elegant vases and bowls were especially favored by those interested in flower arranging, a popular Depression-era diversion.

All of the vessel shapes were designed and modeled by Manker personally. The exceptional glazes he achieved and used as their only embellishment was a high point of the work. Usually a contrasting color was sprayed over the base color, later blending with it in the kiln. Two different colors (one outside, the other inside) were frequently employed with equally striking results. In addition to vases and bowls, the items produced at Padua Hills included cigarette boxes, ashtrays, candle holders, lamp bases, and a short set of tableware shaped like a stylized leaf. The latter was produced only during 1947-48.

In 1952 William Manker made a career change, assigning management of the pottery business to his son Courtney. By then he had resigned his teaching post at Scripps College (and at the Claremont Graduate School). During his tenure at Scripps he was responsible for founding the college's ceramics department and for initiating its popular ceramic annual, one of the first such exhibitions held on the West Coast. Also during this period, he was active in pottery organizations, like the American Ceramic Society, and exhibited non-production pieces in major shows around the country. Many ceramic artists received support and encouragement from Manker through the years. Among the more prominent were Kay Finch, Howard Pierce, Jean Ames, and Betty Davenport Ford.

By the late fifties the cost of labor had risen to the extent that the pottery was no longer viable and it was closed. At its height, just after World War II, about fourteen workers had been employed. Following a distinguished career in ceramics, William Manker became a successful interior color consultant. He was on the staff of *House Beautiful* for many years and more recently has been an independent design consultant.

William Manker's work of the early thirties was hand incised (1). After the move to Padua Hills the familiar ink-stamped mark (2) was adopted. During the war a new stamped mark was used to stress that the product was made in California, USA (3). After 1952, when son Courtney took over the business, the stamped mark was changed a final time (4). A paper label (5) was also used at Padua Hills.

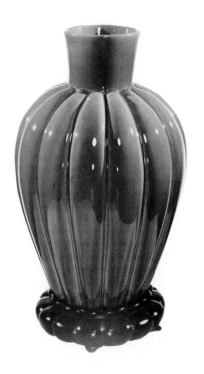

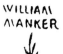

WILLIAM
MANKER

WILLIAM
MANKER

(1)

(2)

MANKER CERAMICS
CALIFORNIA
USA

(3)

William Manker
CALIFORNIA
U.S.A

(4)

(5)

*Lobed vase, 14", by William
Manker, pictured on teakwood
stand.*

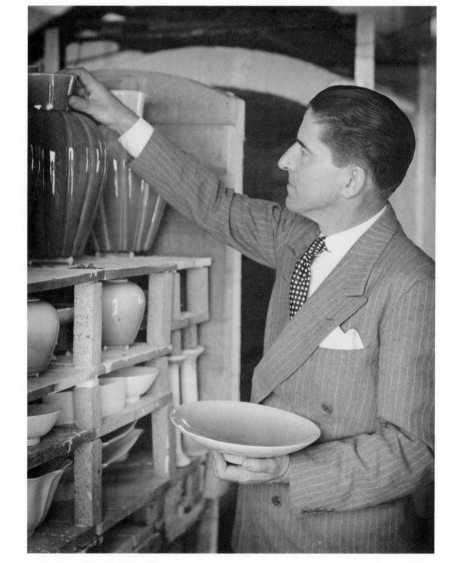

*William Manker inspecting ware in his
Claremont studio, c. 1947. Archival photo.*

Metlox

The history of Metlox Potteries is like no other in California. Proutyline Products, the business which preceded it, was founded in 1921 by T.C. Prouty and his son Willis. Organized as a California corporation, it specialized in the development and marketing of their numerous inventions.

Willis O. Prouty, who was born in Michigan in 1888, invented and patented at age 18 a tachometer used on aircraft during World War I. After moving to Southern California in 1919, he tested various local clays to determine their suitability for ceramic production. Finding that talc obtained from Death Valley was superior to ordinary clay, a tile body comprised of this material was formulated and patented in 1920. In 1922 a two-story tile plant was erected at 719 Pier Avenue in Hermosa Beach, the first manufacturing facility of the Proutyline Products Company. A year later, Prouty invented and installed a tunnel kiln especially suited for tile production. A patent was obtained for this kiln which utilized setters instead of saggers for maximum efficiency. The trade name Hermosa Tile was used to distinguish both decorative and standard wall and floor tile. The Hermosa Beach facility was sold to the American Encaustic Tiling Company of Ohio in 1926.

Metlox (a contraction of metallic oxide) was established by the Proutys in 1927 in a modern all-steel factory constructed on a four-acre tract at 1200 Morningside Drive in downtown Manhattan Beach. Initially outdoor ceramic signs were produced at the new plant. These molded electrical advertising signs were devised for maximum day and night visibility and to withstand all types of weather conditions. Neon tubing was effectively used in one of the company's most impressive installations, the newly constructed Pantages Theatre in Hollywood (1928). Unfortunately Metlox's innovative sign business dwindled with the onset of the Depression. Following the death of T. C. Prouty in 1931, the younger Prouty reorganized and converted the Manhattan Beach plant to dinnerware production.

In 1932 the first line of Metlox dishes, designated California Pottery, was produced in bright colored glazes similar to those popularized by Bauer. The initial set was followed in 1934 by a complete line of table and kitchen ware called Poppytrail. This package was even simpler in design than Prouty's first, and was offered in fifteen different colors during an eight year production. The "Poppytrail" designation was adopted as the company trade name in 1936 in order to emphasize California, the poppy being the state flower. Talc, the major component of the Metlox body, was mined in California, as were most of the metallic oxides that comprised the glazes.

From 1935 to 1938 Prouty's pottery produced an exclusive line of pastel-colored tableware and kitchen articles for Sears & Roebuck called Mission Bell. Yorkshire dinnerware, introduced about the same time and in the same glazes, was a swirled design adapted from Gladding-McBean's Coronado line. The most striking and unusual set of dishes of this period was Pintoria. Based on an English Staffordshire design, its markedly geometric shapes (wide-bordered rectangular plates and bowls with circular depressions) were in production for only a few years (c.1937-39).

A talented sculptor by the name of Carl Romanelli was the first artware designer hired by Metlox. Soon after joining the business in the late thirties, he initiated the popular Metlox Miniatures, a collection of small-scale animal figurines and novelty items. Romanelli was also responsible for one of the company's most memorable artware lines. Called Modern Masterpieces, the series included figures, figural vases, busts, wallpockets, bookends, and vases with figures in relief. Most pieces bore the signature (in-mold) of "C. Romanelli" and many of the designs were patented.

During World War II, pottery manufacturing continued on a very limited basis as Metlox converted to 90% defense work. Full-scale production resumed after the war with the introduction of the company's first decorated dinnerware line. Evan K. Shaw was the person most instrumental in steering Metlox onto this successful new course. Shaw, whose American Pottery in Los Angeles had recently been destroyed by fire, purchased the business from Willis O. Prouty in

1946. California Ivy, introduced the same year, was the first in a long succession of popular hand-painted patterns developed under the Shaw ownership. Others included California Provincial (1950), Homestead Provincial (1950), Red Rooster (1955), California Strawberry (1961), Sculptured Grape (1963), and Della Robbia (1965).

The fifties, a prosperous period for the business (with over 500 employed) yielded dynamic dinnerware lines Navajo, Aztec, California Mobile, California Free Form and California Contempora. The shapes and decorative patterns for these were developed by art directors Bob Allen and Mel Shaw.

In 1958 Metlox purchased the trade name and selected dinnerware molds from Vernon Kilns after the latter ceased operations. A few of Vernon's best-selling lines were used to establish a separate Vernon Ware branch, which was headed by Doug Bothwell. Metlox's Vernon Ware division eventually rivaled the Poppytrail division in the number of shapes and patterns of dinnerware produced.

Artware, another Evan K. Shaw specialty, flourished in the fifties and sixties at Metlox. A line of contemporary vessels in earthy matte glazes, designed by well-known California ceramist Harrison McIntosh, was produced in the mid fifties. Concurrent was a series called American Royal Horses: finely detailed, hand-painted figurines of various equine breeds. This was complemented by Nostalgia, an offering of scale-model antique carriages and related articles inspired by Shaw's personal collection of actual carriages.

Shaw's ill-fated American Pottery was licensed to manufacture ceramic figurines based on the Walt Disney cartoon characters in 1943. The Metlox purchase in 1946 enabled him to continue production of this very successful line until 1956. Most of the famous Disney figurines were reproduced in both regular and miniature scale by the Metlox staff.

Poppets by Poppytrail, an extensive collection of doll-like stoneware flower holders and planters created by Helen Slater, was marketed in the sixties and seventies. Colorstax, a revival of dinnerware in solid colored glazes (1978) and Helen McIntosh's charming and novel cookie jars were best-sellers for the company in its last decade.

Kenneth Avery became president of Metlox Manufacturing Inc. following the death of Evan K. Shaw in 1980. In 1988 Shaw's daughter Melinda Avery became the guiding force. Metlox, the last survivor of the original "Big 5" manufacturers, ceased operations in 1989.

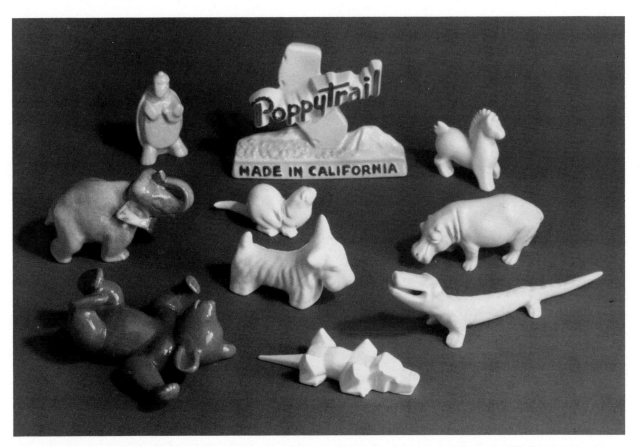

A collection of "Metlox Miniatures" of the late thirties: (clockwise from top) "Poppytrail" dealer sign, horse, hippo, crocodile, cubistic dog, reclining bear, elephant, standing turtle, seal, scottie dog.

There are nearly as many Metlox marks and labels as there are lines. The earliest mark was "California Pottery" (1) impressed in-mold on the first line of dinnerware produced in 1932. Beginning in 1934 the impressed "Poppytrail By Metlox" mark (2) came into use, followed slightly later by "Poppytrail Made in California, U.S.A." (3), which was used on dinnerware, and artware alike. "Mission Bell" (4) was impressed on a variety of ware made for Sears between 1935 and 1938. The "C. Romanelli" (5) designation was impressed on most of the artware created by Carl Romanelli in the late thirties and early forties. The Metlox Miniatures generally bore paper labels. The earliest one was shaped like an "M." Evan K. Shaw's Disney line carried an oval paper label reading "Walt Disney Productions/Evan K. Shaw Company Los Angeles" with the name of the depicted character in the center. In the fifties the familiar ink-stamped logo with the word "Poppytrail" superimposed over an outline of the State of California (6) was adopted. The circular backstamp "Poppytrail by Metlox/ Made in California" (7) was also used in the fifties (and sixties), along with a similar "Vernon Ware by Metlox/Made in California" version. Two Vernon Ware backstamps that identify specific patterns are shown (8) & (9). Many other such marks were used on both Poppytrail and Vernon Ware dinnerware patterns. Metlox manufactured dishes especially for Sears again in the fifties, with Sears' "Harmony House" logo plus "Made in California" stamped on the ware (10). Artware of the sixties and seventies bore the paper labels shown (11) & (12). A special circular paper label was used on the Poppets by Poppytrail series. Individual name tags have been found on some models.

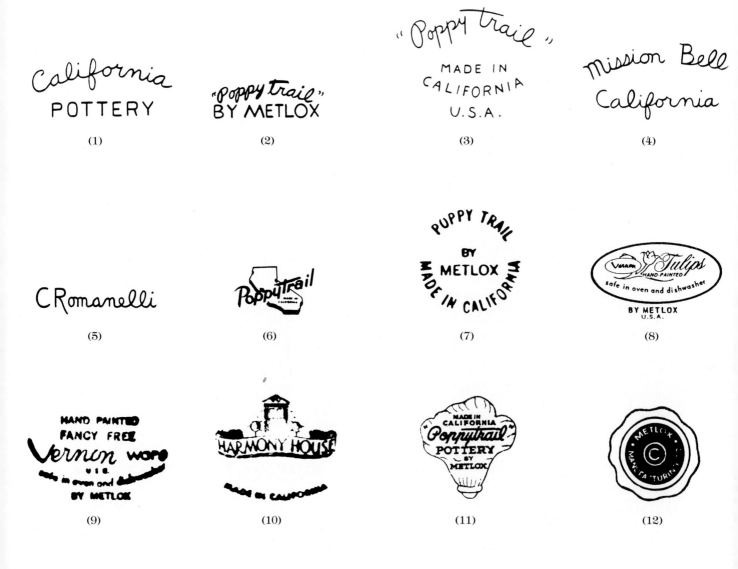

(1)

(2)

(3)

(4)

(5)

(6)

(7)

(8)

(9)

(10)

(11)

(12)

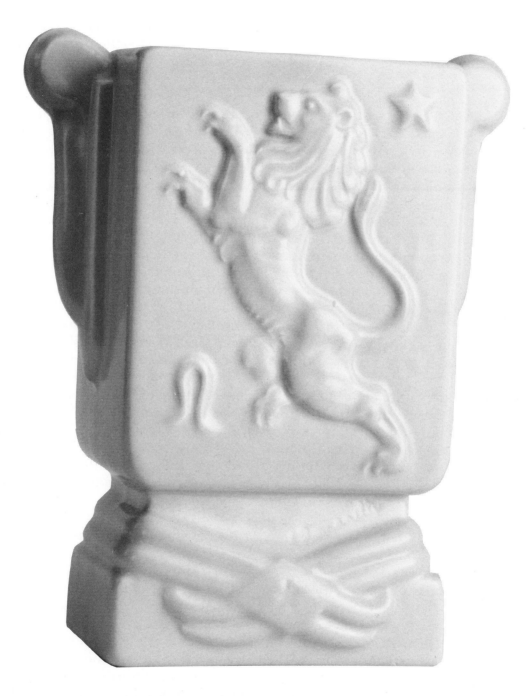

Leo Vase, 8", from the "Zodiac" series designed by Carl Romanelli for Metlox, c. 1939. A vase for each astrological sign was produced.

Pacific

The Pacific Clay Products Company came into existence when William Lacy consolidated several local potteries in the early twenties. Included in this union were some of the oldest ceramic companies in California. Lacy's principal plant was situated in the Lincoln Heights district of Los Angeles, at 306 West Avenue 26. The Los Angeles Stoneware Company was the original business at this location and was built in 1890 to make kitchen stoneware, ollas and similar ware. It was the first plant in Southern California to manufacture these products and one of the first to make clay products of any kind in the state. Architectural terra cotta, brick and roofing tile were among the varied items produced there after the name change and formation of the consolidated Pacific Company.

Pacific's stoneware line was a quality product which enjoyed an excellent reputation throughout the Southwest during the twenties. The clays used in its production, and later pottery, were obtained from California deposits owned by the company. Among the numerous stoneware staples that Pacific provided were: butter jars, yellowware mixing bowls, and bean pots. Representative samples were displayed in the showroom of the Lincoln Heights plant where visitors were "always cordially welcome."

Harold Johnson joined the business in 1917 and before leaving in 1928 modeled several garden pots and vases which were added to the stoneware line. His distinctive polychrome glazes were used to good effect on a variety of articles pictured in Pacific's stoneware catalogs of the late twenties. Hired as technician after Johnson's departure was Frank McCann. In the capacity of ceramic engineer, McCann was responsible for developing the firm's earthenware (pottery) body and glazes during the next decade.

Like so many other manufacturers in the area, Pacific Clay Products prospered during the course of the twenties building boom. When the boom ended in the early thirties the outlook was rather dismal. The new and promising colored ware of the nearby Bauer Pottery offered the best solution to the Depression slump and Pacific was one of the first companies to follow their lead. In 1932 a rival set of dishes called Hostess Ware was introduced. More than a quickie imitation of Bauer's prototype, Pacific's line was quite distinctive. The glazes, for example, varied considerably in density and tone. The seven original colors were: Apache red, Pacific blue, Sierra white, lemon yellow, jade green, delphinium blue and desert brown.

Quality consciousness embraced most aspects of production, but McCann's glazes and the exceptional Art Deco styling of Matthew J. Lattie are what ultimately set Pacific's tableware apart. In the pottery line's earliest price list, over ninety separate items were offered. Many more would appear during the ten years it was made. As an alternative to the unadorned shapes, art director Lattie and his crew devised a series of simple underglaze decorations such as contrasting colored bands, spirals and crosshatching. These individual patterns, which were available between 1933 and 1939, could be purchased in complete sets.

In 1937 a lighter weight, pastel colored tableware was introduced. Unlike its predecessor, Coralitos was designed by Lattie for the consumer seeking a more conventional product. A similar set of dishes called Arcadia was produced about the same time.

Matthew J. Lattie, who joined the business in 1924, headed Pacific's art department from the time it was established in 1930. Lattie and his small team of designers created an extensive artware collection to complement the company's tableware lines. The variety of decorative articles included vases, planters, candle holders, figurines, flower bowls and frogs. Some of this ware was also hand decorated. Large architectural vases, sand jars, flower pots and bird baths rounded out the distinguished but short-lived Pacific Pottery line.

In 1942 the Lincoln Heights plant was committed to full-time defense work and all pottery manufacture came to an end. The Pacific Clay Products Company presently operates out of its Corona plant, specializing in roof tile.

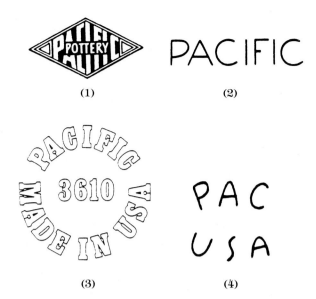

(1)

PACIFIC

(2)

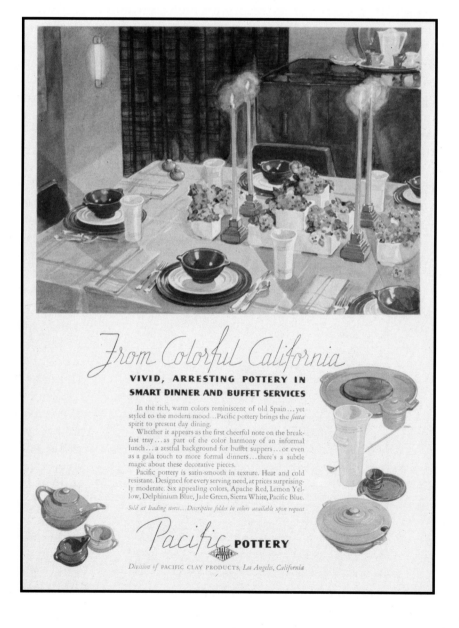

(3)

P A C
U S A

(4)

In the twenties the company adopted a logo consisting of the name Pacific enclosed in a diamond shaped outline. In the thirties this logo was modified and the paper label shown (1) was used extensively. Many articles found unmarked today once carried this identification. The earliest pottery backstamp used was the impressed (in-mold) "Pacific" (2) in block letters. In the late thirties a raised circular mark (3) was developed for use on tableware and artware alike. Some Pacific ware, perhaps premiums, bore only the bottom half of this mark, minus the company name. Small items may be found today with the abbreviated "PAC-USA" (4) in-mold mark. Additionally, stamped marks devised for specific lines were used.

Pacific advertised extensively in the late thirties in an effort to broaden its consumer acceptance. This full-page, full-color ad appeared in the April 1935 issue of House and Garden.

Howard Pierce

Howard Pierce has been and continues to be one of the most original of the Southern California ceramists working commercially. Born in Chicago, Illinois in 1912, Pierce attended the University of Illinois and the Chicago Art Institute before moving to California in 1935. Locating in Claremont, he enrolled at Pomona College for further art instruction. In 1936 a miniature fawn which Pierce had modeled was purchased by William Manker and added to the line of ceramics the latter produced in Claremont. A job offer from Manker was also accepted at this time, an association which continued for three years.

Gaining a thorough education in ceramic production in Manker's plant, along with the motivation to start his own business, Howard Pierce established a studio in nearby La Verne in 1941. So not to create direct competition for his former employer, he began producing small animal figures in pewter. In 1945, after a three year hiatus in defense work in Long Beach, Howard returned to Claremont and the ceramics business by leasing a small building on 6th Street and outfitting it with

Howard Pierce at work in his Claremont studio, c. 1952. Archival photo.

one gas-fired kiln. With assistance from his wife Ellen, whom he had married in 1941, Howard began production of a very contemporary line of figurines in a porcelain material known as nepheline syenite (to which was added china clay from Florida and ball clay from Kentucky and Tennessee.) He formulated the clay body and glazes, did the modeling, made the molds, and supervised every step of production, most of which he performed himself. A local florist provided the business with its initial account. Good public response led to additional accounts and in 1950 the N.S. Gustin Company became Howard Pierce's national sales representative. During the fifties, which was the peak period, two ten-foot gas-fired kilns were added to the Claremont facility along with extra help.

Pierce's distinctively styled porcelain sculptures of animal, bird and human subjects retailed in the finest gift shops and department stores in the country. Most items were designed and sold in sets of two or three, a feature which enhanced their decorative and sales appeal. The earliest glaze used was a satin-matte white. Soon after, a satin-matte brown on white combination was added and it became the favored finish for almost fifteen years. Other satin colors of this period included black on white, all black, and all gray. Standard high-gloss colors were brown agate, slate grey, and sandstone. Many experimental or special colors and combinations have been produced over the years and continue to be a salient aspect of the work. Both body and glaze are matured in a single firing at 2150°F.

In 1956 Pierce developed his own version of Wedgwood's Jasperware in which the raised cameos were cast as an integral part of each of the various objects. Background colors were brown, green and blue. Limited public acceptance resulted in a brief production. Somewhat more successful was a separate line of high-glazed vases and lamps with open centers containing miniature animals and plant forms in white porcelain bisque.

The business returned to a more relaxed pace after the Gustin representation ended in 1966. With their extra help no longer needed, the Pierces

carried on as they had in the pre-fifties period until 1968, when they moved to Joshua Tree (a desert community near Palm Springs) and semi-retirement. Howard Pierce's current production is limited and sold through a select number of outlets. He creates new designs and glazes on a continuous basis.

Howard Pierce continues to use the same stamped mark of his full name in block letters which has been used throughout most of his ceramics career. During the fifties "Howard Pierce Porcelain" or "Pierce Porcelain" was used to call attention to this high-grade material. Pierce's incised signature (full name or last name) appears on numerous items, with "Claremont, Calif." occasionally added during the years the business remained there. Smaller items in a set were often left unmarked.

HOWARD PIERCE

PIErcE

HOWARD PIERCE PORCELAIN

Noward PIErcE Claremont Calif.

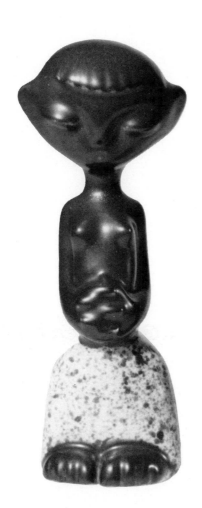 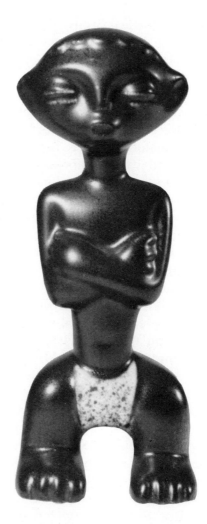

Howard Pierce native pair: woman, 7", man, 7½", brown on white, c. 1957.

Roselane

The Roselane Pottery was a husband and wife operation owned by William "Doc" Fields and his wife Georgia. Roselane was established at the Fields' residence in Pasadena with the firing of the first kiln in February 1938.

Although Doc Fields was basically untrained in ceramic production, the business overcame many obstacles and by 1939 was selling its attractive figurines to local florists. At first Doc sculpted all of the models while Georgia took charge of production (with the help of a part-time technician.)

With continued good fortune the business outgrew its first location and was moved in 1940 to a newly constructed factory at 249 Mary Street in Pasadena. By the mid forties twenty-five people were employed. Joining the firm as salesman was Doc Fields' brother Robert. Roselane was displaying its line at this time at the semi-annual gift shows in Los Angeles and San Francisco and shipping to all parts of the country plus Alaska and South America.

The most extensive offering of the forties was Chinese Modern and included vases, bowls, figurines, candle holders and wallpockets produced in various high-gloss colors and combinations such as black and white, cherry and dove gray, citron yellow and sage green, and bitter green and cocoa. From c. 1945 to 1952 a successful buffet serving line called Aqua Marine was manufactured. It featured a stylized sgraffito-like outline of swirling black fish against an aqua or pink background. In the mid fifties Mr. Fields designed a striking series of small abstract ceramic sculptures of animals which were mounted on walnut bases. Unfortunately these were deemed too advanced by the gift buyers and had to be modified with attached eyes to make them appear more naturalistic.

The impending construction of the #210 freeway through Pasadena forced Roselane's relocation to 5107 Calmview Avenue in Baldwin Park in 1968, where it remained until 1974. Begun in the fifties, the very popular Sparklers series in airbrush decorated semi-porcelain was continued in the new location. The line featured stylized, sometimes whimsical figurines of animals and birds, each complete with colored rhinestone (later plastic) eyes.

After the death of William Fields in 1973, Mrs. Fields sold the business to Prather Engineering Corporation and operations were moved to Long Beach. Roselane production ceased entirely in 1977.

In addition to the items already mentioned, Roselane produced flower bowls, vases, ashtrays, covered boxes, and other decorative housewares, much of which reflected fifties-modern design.

Roselane employed a variety of incised (in-mold) and stamped marks, a sampling of which is shown. Prior to the move to Baldwin Park, the word "Roselane" was sometimes followed by "Pasadena, Calif." rather than simply "Calif." Paper labels were also used.

Hedi Schoop

Hedi Schoop's trend-setting career in clay came about after her dislocation from formative theatrical pursuits in Europe. Born in Switzerland in 1906, Ms. Schoop received a wide-ranging education in the arts (including painting, sculpture, architecture and fashion design) at Vienna's Kunstgewerbeschule and Berlin's Reimann Institute, before joining her dancer sister Trudi Schoop on the German stage in the early thirties. But any thoughts of a professional career in the theatre were cut short by the existent political turmoil.

Fleeing Nazi Germany with her husband, the well-known composer Frederick Hollander, Hedi Schoop emigrated to the States and settled in Hollywood in 1933. In 1938 a group of hand-painted plaster of Paris dolls which she outfitted in contemporary fashions was "discovered" by the Barker Brothers department store in Los Angeles. Advised to adapt her designs to the more durable ceramic medium, Hedi immediately established a workshop in a rented building near her home. The unexpected success of her deftly painted slip-cast figures necessitated construction of a much larger facility in 1940.

The Hedi Schoop plant, located at 10852 Burbank Boulevard in North Hollywood, was financed by Hedi's mother and contained two general-purpose gas-fired kilns and a smaller electric kiln for overglaze gold and platinum decoration. Beginning with a crew of about twenty, the workforce of the business had more than doubled by the end of World War II. Several European actors, dancers and musicians, their careers also interrupted by Hitler's rise to power, found temporary employment in this country as Ms. Schoop's decorators. Most of these refugees were friends or acquaintances prior to the war. One of them, Sylvester Schaffers, a leading German painter, was allowed to initiate hand-painted pictorial motifs for plates and ashtrays in addition to his regular decorating duties.

With few exceptions, the figurines produced were personally designed and modeled by Hedi Schoop, and ranged from European and Asian couples in native attire to American debutantes and Hawaiian hula dancers. Many of the figures doubled as flower containers, a concept which Hedi Schoop popularized. Another innovation was her development of sharply incised texture on areas of the green ware prior to decoration and firing. Besides her animated human figures, Hedi produced animals (as figurines, flower holders and candle holders), vases, wall plaques, planters, candlesticks, covered boxes and ashtrays. Often entire lines would be created with all the above listed articles included in a single coordinated decorative scheme or motif.

The company was incorporated as Hedi Schoop Art Creations in 1942, just as California's giftware business was beginning to intensify. The post-war years were the most productive, with an average of 30,000 hand-painted items turned out annually. To keep pace with the latest development in home entertainment, Hedi Schoop began a charming series of TV lamps in the mid fifties. Unfortunately this line was cut short by a disastrous fire that leveled her plant in 1958.

Rather than rebuild, Ms. Schoop opted to withdraw from full-time production and lent her design skills to a few local firms on a free-lance basis. She retired from the pottery business permanently in the early sixties and has been active since then as a painter.

Hedi Schoop was one of the most imitated of the California giftware artists. One of her former associates, Katherine Schueftan (operating under the fictitious name Kim Ward) produced such obvious copies that a successful industry supported lawsuit resulted in 1942. Two former employees, Max and Yona Lippin, established a separate and highly derivative business in the forties known as Yona Ceramics. These unauthorized Hedi Schoop spin-offs were only the beginning of what ultimately became an endemic California trend.

A variety of marks were used. These included both stamped and incised versions of Hedi Schoop's signature. The words "Hollywood, Cal." or just "California" were added in some instances. Unmarked examples would be very uncommon.

Hedi Schoop
HOLLYWOOD CAL.

Hedi
Schoop

HEDI SCHOOP
CALIFORNIA

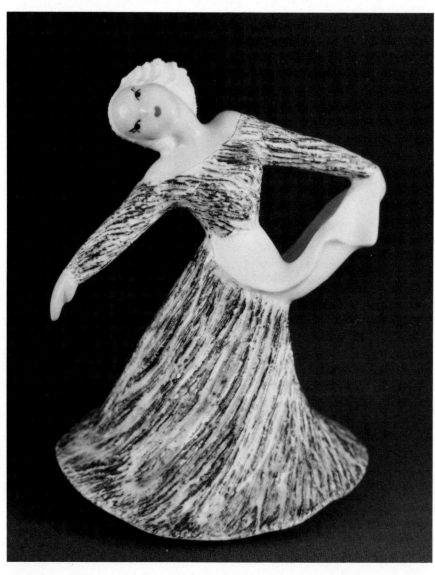

Hedi Schoop Tiny, 7", from "Tiny & Teeny" set of flower girls of the late forties. Stamped mark.

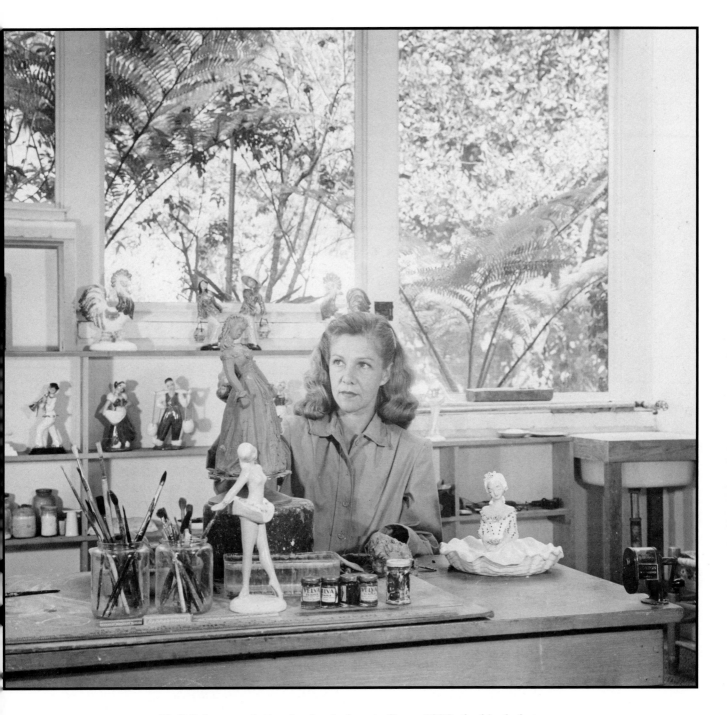

Hedi Schoop sculpting in clay in her studio, c. 1948. Archival photo.

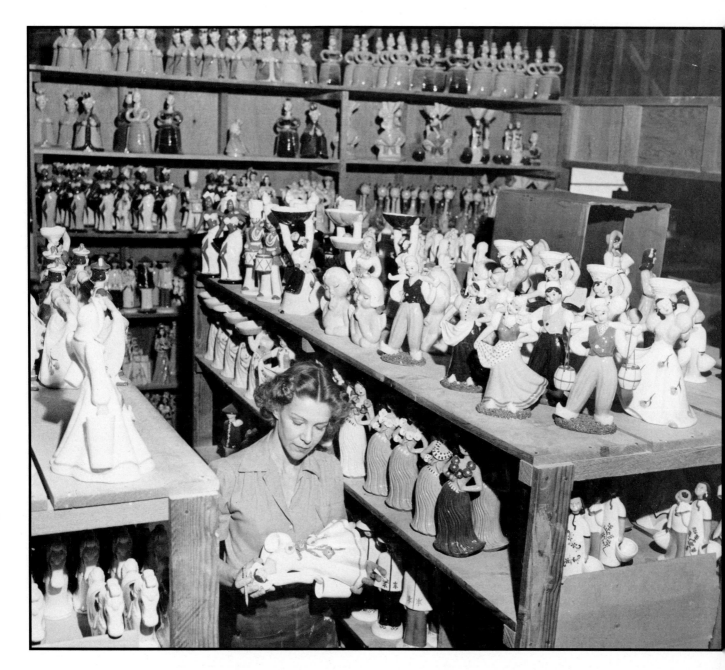

Hedi Schoop inspecting ware in her plant. Mid Forties. Archival photo.

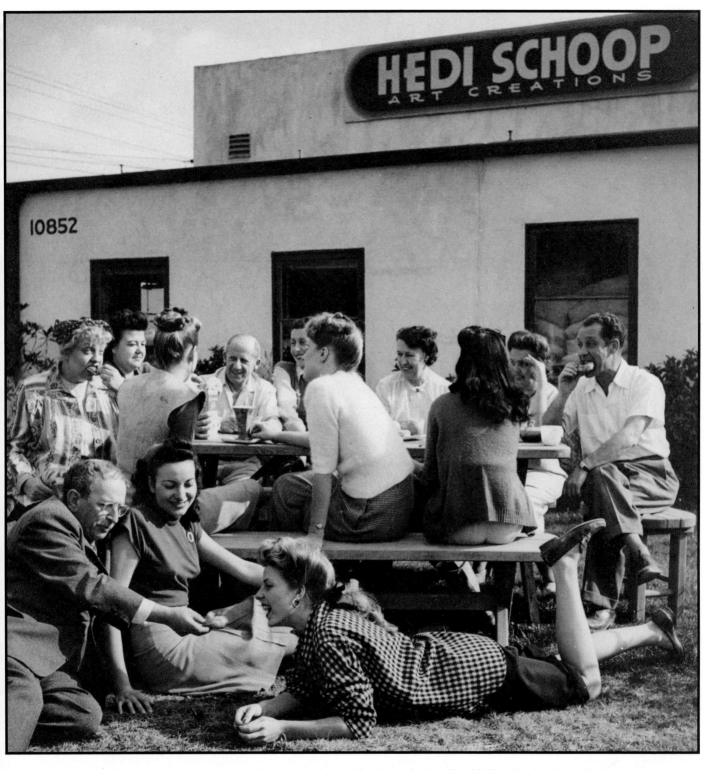

Hedi Schoop crew enjoying a lunch break outside plant during World War II. Archival photo.

Twin Winton

Twin Winton Ceramics was started by twin brothers Don and Ross Winton in Pasadena in 1936. The Winton twins were born in Canada in 1919. The family moved to Pasadena in the late twenties, with Don, Ross and older brother Bruce attending high school and junior college there.

The Depression and its attendant hardships prompted the establishment of the business which had its beginnings in a rented cottage at Busch Gardens in Pasadena. Initially Twin Winton was known as Burke-Winton, a partnership between the twins and Helen Burke, who hand-decorated and sold the ware in a display room attached to the pottery Don was responsible for modeling the stock-in-trade: small slip-cast figurines which drew inspiration from Walt Disney's cartoon characters. Ross made all of the molds and helped manage the financial affairs. The enchanting series of animals that Don Winton created and Helen Burke decorated proved to be a big hit with locals and tourists alike.

Twins Ross and Don Winton, late 1950's. Archival photo.

In 1939 the youthful Winton brothers withdrew from the partnership with Burke and leased a modest workshop of their own in Tujunga, just north of Pasadena. Continuing along the same lines as before, the Wintons soon outgrew the Tujunga shop and moved back to Pasadena (on Hill Street near Washington) in 1942. Don and Ross enlisted for military service the following year and all operations were suspended for the duration of World War II.

In 1946 the Twin Winton business was re-established in a 2,000 square foot factory on Mission Street in South Pasadena. Older brother Bruce joined forces with Don and Ross (and about eight others) at this time, eventually becoming their business manager.

The very successful Hillbilly line (inspired by the Paul Webb cartoon series) was introduced in 1947. This consisted of pitcher and mug sets, pretzel bowls, salt & pepper shakers, lamps, ashtrays, and other novelty items. The various articles featured humorous hand-painted figures of the Ozark mountain boys set against a simulated woodgrain effect under glaze.

The popularity of the Hillbilly line made a larger factory with additional workers necessary, so the Wintons relocated to Pasadena once again (1190 North Fair Oaks).

Don and Ross remained in the new facility only two years. In 1952 they sold their interest in Twin Winton to Bruce and began designing for various local firms on a free-lance basis.

Bruce Winton, as sole owner, moved the pottery to El Monte (11654 McBean Drive). At the new location, in 1953, the popular series of cookie jars in woodtone finish was begun with a winsome squirrel that Don designed and modeled. Produced in a brown-stained bisque with colored glaze accents, the cookie jar line ultimately included over fifty figural models. Don Winton, working in a free-lance capacity, designed the entire collection and the matching salt & pepper sets and related household accessories such as spoon rests, wallpockets, planters, ice buckets, napkin holders and lamps.

In 1964 Twin Winton made its final move to the plant that Brad Keeler had built in San Juan Capistrano in the early fifties. The business remained active there, with about eighty employees, until its sale in 1975. Don continues to design and model ware for various concerns, and creates portrait busts and statuary commissions at his Corona del Mar studio. Bruce is now retired; Ross died in 1980.

The earliest marks used were the slip-painted "Burke Winton" (1), sometimes abbreviated "B-W," and the impressed "Burke Winton" (2). A number of variations on the painted (3) and incised in-mold (4) marks as shown appeared on the ware until 1952. After this date the incised in-mold "Twin Winton Calif. USA" mark (5), with some variations, was used to identify the product.

BURKE WINTON

(1)

(2)

TWIN WINTON

(3)

Twin-Winton
Pasadena

(4)

TWIN WINTON
CALIF USA

(5)

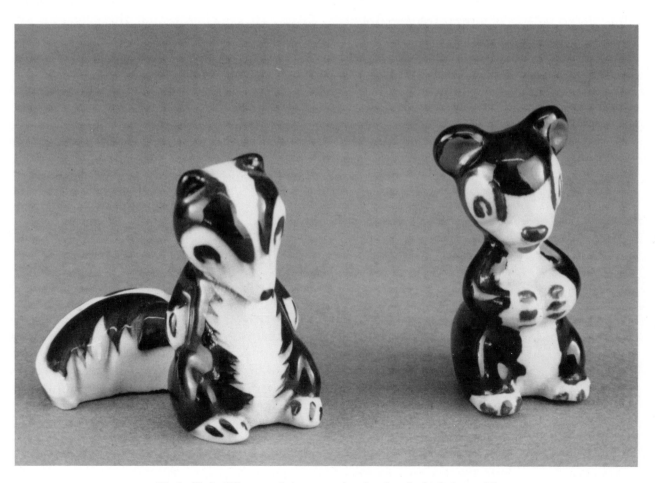

Early Twin Winton miniature animals: skunk, 2½", bear, 2".

Vernon

Vernon Potteries, which became known as Vernon Kilns, was an industry leader. Especially noteworthy was the company's creative association with various well-known artists.

In 1930 Faye G. Bennison, an Iowa-born entrepreneur, purchased the Poxon China Company located at 2300 East 52nd Street in Vernon. Apparently fearless in the face of the Great Depression, Bennison added nearly one hundred new workers to the payroll almost immediately. By establishing Vernon with a farsighted policy, he eventually transformed a struggling concern into one of the most successful in California.

For a short time the new company utilized the existing stock of Poxon green ware. But in 1934, the first in a long succession of original dinnerware designs was introduced. Known as Coronado, it was a premium line manufactured in the standard array of California colors. A factor which set it apart from the colored pottery of most other Los Angeles firms was its light weight.

Capitalizing on this initial success, a more stylish and extensive line of solid-colored ware called Early California was introduced in 1935. Early California's sales appeal was strong and enduring, with some items still in production as late as the fifties. Modern California followed in 1938 in satiny pastel colored glazes. With extensive national advertising, it and other Vernon lines of dinnerware achieved widespread consumer acceptance.

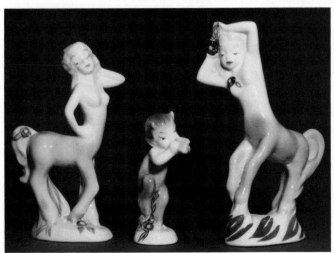

Vernon Kilns figurines from Walt Disney's Fantasia series of 1940: Centaurette #18, 7½", Pan, 4¾", Centaurette #22, 8". Stamped "Disney" marks.

In the mid thirties the Vernon company established an art department headed by Gale Turnbull. First to join in the new venture was artist Harry Bird. Using his unique patented process called Inlaid Glaze, Bird decorated various sizes of plates which were obtained from the dinnerware section. For awhile, entire sets of dishes were decorated and backstamped with the Bird trademark.

From 1937 to 1939 noted ceramists May and Vieve Hamilton designed and modeled an exceptional body of artware for Vernon, including figures, busts, vases, bowls and candle holders. They also created two original dinnerware designs, Rhythmic and Rippled, in characteristic art moderne style. Jane Bennison, the owner's daughter and a USC graduate, made a significant contribution to the art line also.

Dinnerware, however, outsold decorative pottery at this time by a wide margin, and in 1939 Faye Bennison made the decision to discontinue the latter. He concluded that the economic realities did not lend support to the less marketable artware. Instead, the business invested all its energies into transfer-printed dinnerware, with art director Turnbull commissioning recognized artists to design the decorative schemes.

In his annual convention report, of January 1939, President of the United States Potters Association, Frederick H. Rhead commented on this development:

"One of our group, Vernon Potteries of Los Angeles, has made a most interesting experiment in this direction (under glaze printing). With Gale Turnbull as Art Director they turn up at this year's Pittsburgh Show with two tableware decorations by Rockwell Kent and two more by Don Blanding. Three of the patterns are underglaze prints in one color, the fourth, also underglaze, is in outline and beautifully hand-tinted by well-trained art students. It is enough to state without reservation that it is the greatest and most inspiring development since the production of Wedgwood's Queensware and the old Staffordshire underglaze prints. It is so far above anything

that has been done in any country by any potter since that time that comparison would be idiotic."[1]

Don Blanding, known as the "Hawaiian poet," was the first artist commissioned, in 1938. Four tropical motifs similar to those he used to illustrate his popular books were produced. The number was eventually expanded to ten with the use of different color prints and corresponding pattern names. The most popular was Lei Lani, one of the company's best sellers.

Rockwell Kent, the famous painter, illustrator, author and lecturer, contributed three patterns: Salamina, Our America (encompassing thirty separate pictorial designs), and Moby Dick. The latter was somewhat successful, but Kent's designs were basically overlooked by an apathetic public. Kent placed the blame on Turnbull's Ultra California shapes, which hosted the patterns; the "upside down" handles eliciting the most criticism.

In 1940, operating under the name Vernon Kilns, the firm signed a contract with Walt Disney resulting in a number of dinnerware patterns inspired by the film *Fantasia*. Various figurines from *Fantasia*, *Dumbo*, and *The Reluctant Dragon* were also produced under license from the Disney Studios. The figurines required considerable hand painting, and because of this extra expense were made for a short time only. Vases and bowls with figures in high relief were also produced from Walt Disney's own models.

Acclaimed ceramic designer Royal Hickman worked briefly for Vernon Kilns in the late forties and fifties, designing three dinnerware shapes: Melinda, San Mario, and Lotus. The war years saw the business barely able to meet the demand for its popular dishes. The hand-painted patterns Organdie and Brown Eyed Susan, which Gale Turnbull created, were very well received during this period. Numerous variations on Organdie's simple brown and yellow plaid were marketed in later years.

In 1947 a devastating fire leveled the thirty-year-old wood and sheet-metal Vernon plant. Bennison, at the urging of his employees and associates, erected a new 130,000 square foot factory of steel-reinforced concrete, which was a model of efficiency with tunnel kilns replacing the old beehives.

Vernon's continued success was greatly enhanced by the transfer-printed specialty ware it originated in the late thirties. Manufactured in regular stock patterns and on special order, these colorful plates commemorated famous and not-so-famous people, places and events. Most of the artists on salary created designs for the specialty ware – including Orpha Klinker, Paul Davidson, Bill Cavett, Mary Petty, Margaret Pearson Joyner, and Ralph Schepe.

Elliott House replaced Gale Turnbull as art director in the early fifties and was responsible for Anytime, one of Vernon's last dinnerware shapes (introduced in 1955). Nine different patterns utilized this shape, the most unusual being Imperial. Other notable designs of the fifties were Sharon Merrill's Chatelaine and Jean Ames' Sun Garden, both produced in 1953.

As the decade progressed Vernon Kilns felt the combined effects of mounting labor costs and increased competition from abroad. Despite valiant efforts by an efficient sales department and advertising agent, Vernon succumbed in 1958. Faye G. Bennison had already retired as president of the firm in 1955. Bennison died in 1974 at the age of ninety-one. After purchasing the molds, Metlox continued production of some of Vernon's bestselling dinnerware lines in its newly established Vernon Ware division. Vernon Kilns created an individual backstamp for nearly every design it produced. It is not possible to show them all; only a sampling is included here. The stamped mark with mission bells (1) was used on decorated Poxon stock in the early thirties. "Vernon Kilns Made in U.S.A. California" (2) was stamped on early colored ware such as mixing bowls. The "Early California" backstamp (3) is shown. Similar Modern California and Ultra California marks were used. "Authentic Vernonware Made in U.S.A." (4) came into general use during World War II. The fifties had its version (5) of this all-purpose mark. The trademarks of the various artists and ceramists associated with the company include: Bird Pottery" (6), "May and Vieve Hamilton" (7), "Jane F. Bennison" (8), "Gale Turnbull" (9), "Don Blanding" (10), "Rockwell Kent" (11), and "Walt Disney" (12) & (13). Lines of the forties and fifties with individual backstamps included: "Winchester 73" (14), which was later changed to Frontier Days, "Chatelaine" (15), "Imperial" (16), and "Tickled Pink" (17). There were many others.

[1] M. Nelson, *Versatile Vernon Kilns (Book II)*, pg. 25.

(1)

(2)

(3)

(4)

(5)

(6)

(7)

(8)

(9)

(10)

(11)

Designed by
WALT DISNEY
Copyright 1940
V E R N O N K I L N S
Made in U. S. A.

(12)

NUTCRACKER
Designed by
WALT DISNEY
Copyright 1940
Vernon Kilns
Made in U.S.A.

(13)

(14)

(15)

made in
california

(16)

TICKLED PINK
dishwasher
and
oven proof

(17)

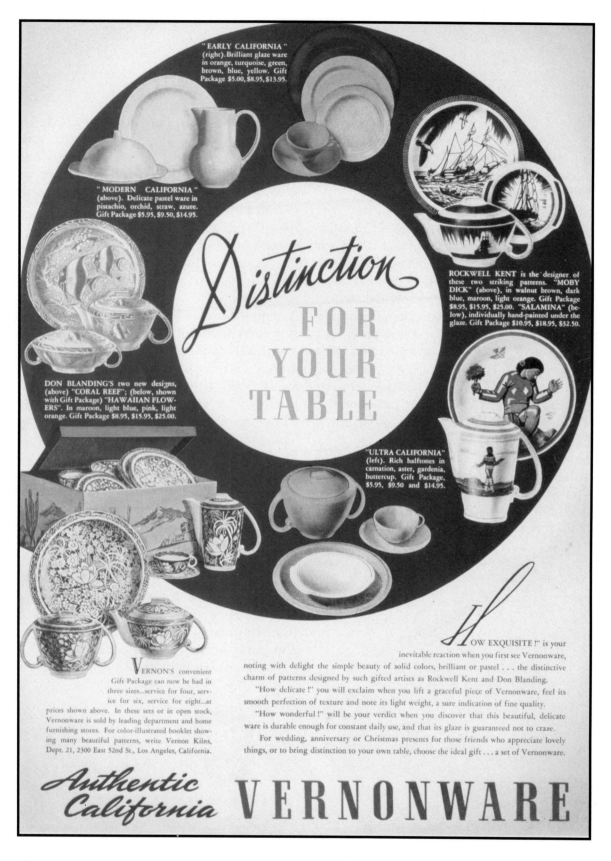

One example of the many full-page advertisements Vernon placed in prominent periodicals in the late thirties. This one appeared in the November 1939 issue of House Beautiful.

Wallace China

The Wallace China Company was founded in 1931 for the purpose of making vitrified heavy-grade hotel china. The Wallace plant covered an area of about 60,000 square feet and was located at 5600 Desoto Avenue in Huntington Park.

With a beginning crew of over two hundred, the new company produced both plain and transfer-printed dinnerware for institutional use. Patterns tended toward time-honored English Staffordshire designs at first. Various decal decorations were also offered in the early years, along with a selection of airbrush-stencil patterns. The popular Willow design (in blue, green, brown and red) was produced in great quantities in the thirties and forties, as was a line of dishes in solid colors.

George Poxon was hired by Wallace shortly after selling his own china business in Vernon. A number of his Poxon China designs were adapted for use by the firm.

In 1943 the M.C. Wentz Company of Pasadena commissioned Wallace China to produce a special line of hotel-grade "Barbecue Ware" which was incorporated into their exclusive Westward Ho package of western theme housewares. Well-known western artist Till Goodan created three separate patterns: Rodeo, Boots & Saddle, and Pioneer Trails. A three-piece Little Buckaroo Chuck set was also made for children. The Westward Ho series was very popular (and widely imitated) and resulted in two more Goodan designs, El Rancho and Longhorn, which were added to Wallace's own restaurant stock.

Numerous hotels and restaurants in California and throughout the western states enlisted the services of the company for special dinnerware designs. Shadowleaf, designed for a Los Angeles restaurant chain, was so well-liked that it was eventually made available to the general public as an open stock pattern.

In 1959 the greatly expanded Wallace China business became a West Coast subsidiary of the Shenango China Company of East Liverpool, Ohio. The company was liquidated in 1964.

A variety of backstamps was used by the Wallace China Company through the years. The earliest stamp featured the words "Wallace China" in an oval, with "Los Angeles, Calif." below. Somewhat later a circular stamp that included these words was added. The trade name "Desert Ware" appeared on numerous patterns of the thirties, forties and fifties. One of the Westward Ho backstamps is shown (for the Rodeo Pattern) along with the Westward Ho paper label. A new modernized logo featuring a stylized "W" was adopted by Wallace in the early sixties. It was incorporated into their subsequent backstamps.

"Eaton's Rancho" dinnerplate, 10½", by Wallace China, from full line produced for the noted Southern California restaurant. Stamped mark.

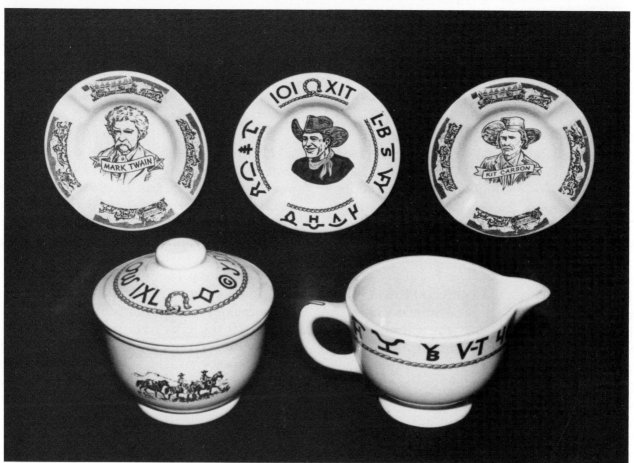

"Westward Ho" items made by Wallace China: "Mark Twain" ashtray, cowboy ashtray, "Kit Carson" ashtray, "Rodeo" pattern large covered sugar bowl and cream pitcher. Stamped marks.

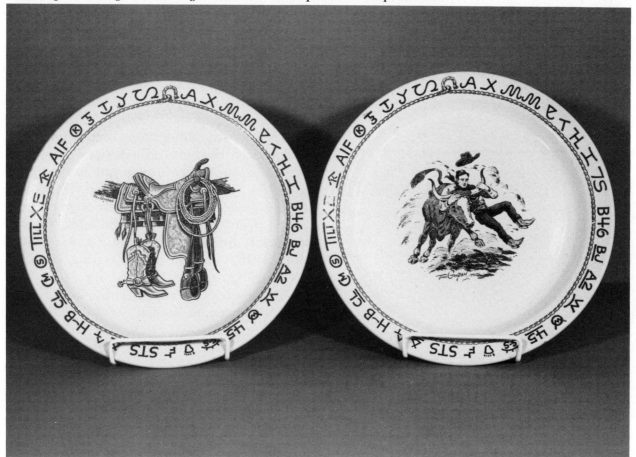

Wallace China "Boots & Saddle" and "Rodeo" pattern 13" chop plates. Artwork by Till Goodan. Stamped marks.

Will-George/The Claysmiths

Many of the smaller Southern California potteries were family owned and operated. The Climes family business, originally known as Will-George, was a typical example. Started "on a shoestring" in the family garage by two art-minded brothers, with financial backing it blossomed into one of the state's hallmark companies in terms of design and technical proficiency.

George Climes was the motivator behind Will-George. He was born in Ohio, three years after his brother Will, in 1909. After the Climes family moved to Los Angeles in the late twenties, George worked for the Catalina pottery on Catalina Island. There he learned the pottery trade, especially glaze chemistry, as an assistant to ceramic engineer Virgil Haldeman. Will, after a year or two of study at the Chicago Art Institute, returned to Southern California and joined his brother for a short time on the island.

Back in Los Angeles, the Will-George business began officially in 1934 in Will Climes' garage. Will designed, modeled and decorated the various figurines that were initially produced. George formulated the clay body and glazes and made molds, Will's wife Frances helped out with the finishing, and a third brother Lloyd joined them (in 1937) as salesman.

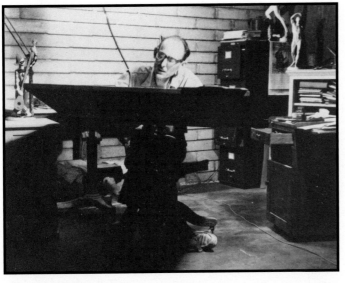

Will Climes of Will-George at work in his studio in the fifties. Archival photo.

The first real success came with a charming artist and model set of figurines produced in a combination of bisque and glazed slip decoration. In 1938 the company received a much needed boost when entertainer Edgar Bergen, who was an avid ceramics collector, discovered the Climes family. So impressed was Bergen that he immediately invested in their business. With his backing and influence, improvements in production were implemented and new markets were opened up.

In 1940 the operation was moved to a much better facility equipped with two kilns at 2966 East Colorado Boulevard in Pasadena. At this time a corporation was formed with Bergen as the major stockholder. New items in the Will-George line were introduced with increasing frequency as imports disappeared during the war.

Will Climes' colorful exquisitely crafted figurines of birds were produced at this time with a supplemental work force that included five full-time decorators. Many of the figurines required complex eight-piece molds and as many as six separate firings. Due to this extreme attention to detail, and its added cost factor, Will-George creations were not inexpensive and were carried by the more exclusive gift shops and department stores.

Howard Ball was hired as a modeler in 1945 and worked a short time before establishing a competitive business. His designs included a large pair of great danes and a smaller set of cocker spaniels. Will Climes, in addition to birds, sculpted a number of human figures in a style akin to the Royal Doulton works of England. George also modeled during the busy war years, contributing one of the company's best-selling lines with his elegant flamingos.

After the war, and a split with Bergen, the business became known as The Claysmiths and was relocated to 400 South San Gabriel Boulevard in San Gabriel. The San Gabriel plant was very large and equipped with a continuous tunnel kiln in addition to two periodic kilns.

In its final decade the output of the pottery included a series of Oriental figures and figural flower holders with matching bowls. A line of lamps was also produced. The post-war flood of Italian imports was largely to blame for declining sales during the last few years of the business, which was liquidated in 1956. Will Climes died in 1960 while employed as a designer for Hagen-Renaker. George worked for the Redondo Tile Company of Torrance from 1956 to 1959, and for Gladding-McBean as a lab technician from 1959 until his death in 1966.

A variety of incised and stamped marks was used over the years. The one most often seen is the stamped "Will-George Pasadena." A paper label has also been noted. The "Claysmiths" designation was apparently never used on the ware.

Will-George
PASADENA

Will-George
MADE IN AMERICA

Will-George

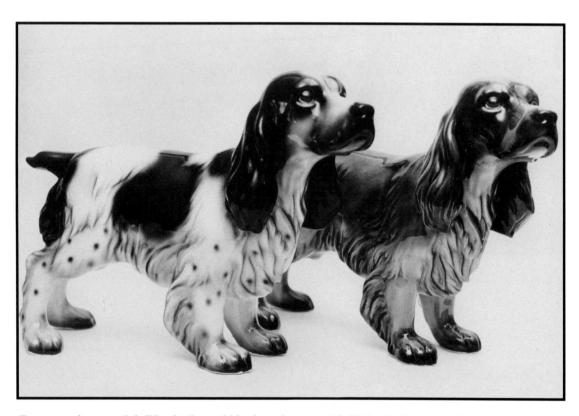

Brown cocker spaniel, 7" x 9½", and black cocker spaniel, 7½" x 9½" were produced during World War II by Will-George. Archival photo.

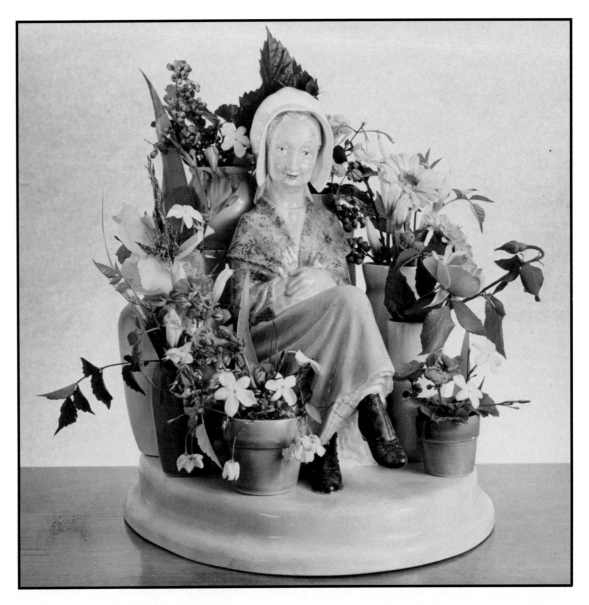

Will-George's novel "Flower Vendor," 10", included eight separate flower containers. Archival photo.

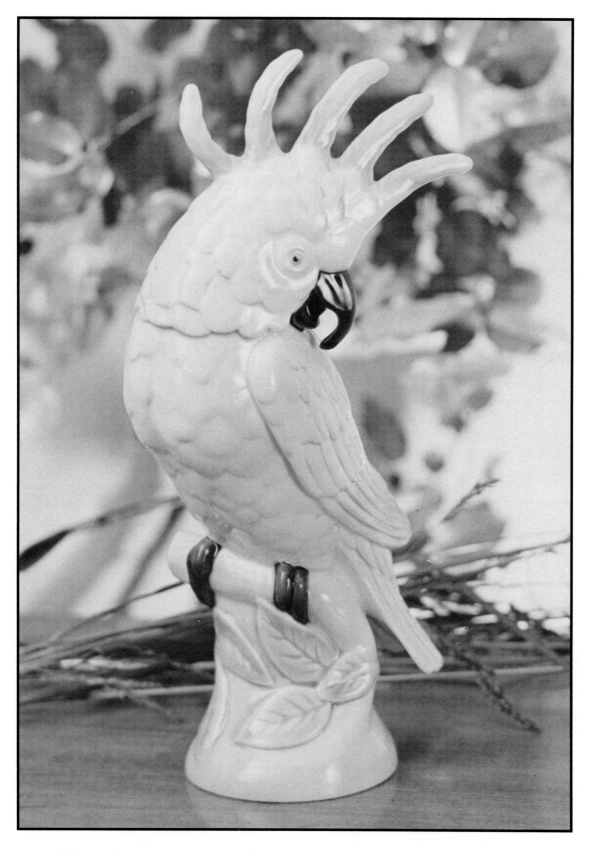

This small pink cockatoo by Will-George dates from the late forties. Archival photo.

Winfield

The Winfield Pottery of Pasadena was founded by Lesley Winfield Sample in 1929. Sample was born in England in 1897 where he received a wide-ranging education, including instruction in ceramics. He immigrated to the United States in the twenties, locating in Southern California. The original site of the Winfield Pottery was the Cloisters of El Padre, a Spanish-style structure financed and built by Sample at 1432 North Foothill (now Altadena Drive) on the northeastern fringe of Pasadena in 1929. The business began as a studio and "School of Clayworking," a service he rendered during evening hours. Despite limited experience in ceramic production, Sample managed to turn out an exceptional line of cast porcelain vases and bowls, many of which were modeled on the same principles as classical Greek vessels. One small muffle kiln capable of firing up to 1,950 °F was utilized in a one-fire process wherein body and glaze matured simultaneously.

Lesley Sample's glazes were particularly noteworthy and included both opaque and transparent types (including crystallines) in a wide range of colors. Experiments in glaze application were carried out, with many subtle and unusual effects achieved.

In order to expand productivity, the Winfield Pottery was moved a short distance in 1935 to 1635 North Foothill where it occupied an authentic California adobe. Designer Margaret Mears Gabriel joined Sample at the new location and fashioned some utilitarian items that were favorably received in the shops that already handled the artware. This aspect of production was greatly expanded over the next few years, with two complete dinnerware designs and about ten decorative patterns introduced between 1936 and 1941.

Initially a set of couple-style dishes was made. This was followed in 1937 by the first square-shaped dinnerware made in this country. Most of the pieces in the line were square (with softly rounded corners) and required unorthodox production methods and molds. The numerous hand-painted patterns created by Gabriel to embellish her shapes included Bamboo, introduced in 1937; Tulip, Avocado, and Geranium of 1938; and Citrus of 1939. Bamboo was by far the most successful design and remained in production until the business closed. Some of the simple but attractive color combinations marketed in dinnerware were Yellow-Sage, Pink-Grape, Turquoise-White, Chartreuse-Olive Rim, and Linen-Pine.

With the passing of founder Lesley Sample in 1939, Margaret and her husband Arthur C. Gabriel became the owners of Winfield. In 1941 they constructed a new 12,000 square foot factory at 150 West Union Street in Pasadena equipped with three large periodic kilns. More dinnerware patterns were initiated at this time, including Yellow Flower, Weed, Acorn, and Fallow. Tyrus Wong, a talented Chinese-American artist, created a number of dinnerware patterns in the late forties and early fifties. In addition, he personally decorated many large plates with graceful Oriental motifs.

Other Winfield artware consisted of glazed vases, candle holders, planters and low flower bowls. More than four hundred separate articles comprised the Winfield line at this time, three hundred of

Workers bringing a new supply of clay into the Winfield factory on Union in Pasadena, c. 1959. Archival photo.

California Pottery

which were designed for use in food preparation and dining.

In 1946 an unusual arrangement was worked out with American Ceramic Products of Santa Monica, enabling them to assist the Pasadena plant with a huge backlog of dinnerware orders accrued during the war. The trade name "Winfield China" (along with the manufacturing rights) was licensed to the Santa Monica business, with the Winfield Pottery adopting the trademark "Gabriel Porcelain" to distinguish its product. Overwhelming war-time demand had severely disrupted the owners' original marketing philosophy. What they originally intended to produce was hand-crafted casual china of high quality for the discriminating buyer, and as such catered to exclusive outlets in the West such as Gump's, Neiman-Marcus, and Joseph Magnin. Their larger accounts were therefore assigned to American Ceramic Products, which expanded the line even further into the lucrative direct sales market.

The Winfield business was incorporated in 1947 following the retirement of owners Arthur and Margaret Gabriel. Investors in the closed corporation were son-in-law Boucher Snyder, nephew Nathan Mears, and Douglas Gabriel, Margaret's step-son. The latter became the sole owner when the other partners withdrew in the mid fifties.

Winfield's business slowed considerably after the reappearance of imported china, and a continued sluggish trend led to the closing of the Pasadena plant in 1962. At most, just fifty people had been employed. China clay from England (combined with certain domestic materials) was used in production. Over the years a number of custom-designed dinnerware sets were made for well-known personalities including Bing Crosby, Boris Karloff, Pearl Buck, the Duke and Duchess of Windsor, and Mr. and Mrs. Franklin D. Roosevelt.

Winfield obviously took pride in its product and diligently marked it. Unmarked pieces are extremely uncommon. The early studio production of Lesley Sample was impressed "Winfield Pasadena" (1). Very early work was sometimes dated, and the initials "L.S." have been noted on rare occasions. Other impressed marks used on Winfield tableware and artware in the early years are shown (2) & (3). The block lettered designations were superseded by hand-incised versions (in various script handwriting styles) circa 1941 (4). After 1947 the words "Gabriel Pasadena" were incised in script (5). In addition, a shape number was nearly always incised on Winfield ware. The American Ceramic Products Company used "Winfield," "Winfield Ware," and "Winfield China" printed in ink or recessed in-mold.

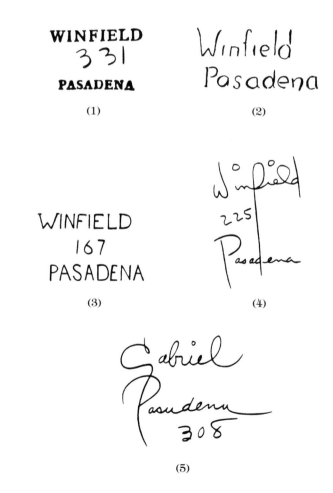

WINFIELD
3 3 1
PASADENA

(1)

Winfield
Pasadena

(2)

WINFIELD
167
PASADENA

(3)

Winfield
225
Pasadena

(4)

Gabriel
Pasadena
308

(5)

Winfield decorator painting "Citrus" pattern on round dinner plate, c. late fifites. Archival photo.

Additional Companies

Listed here are more than fifty additional Southern California potteries that are worth considering. There are many others which could be listed, but these are the most interesting to the author, and examples of the ware can be identified with relative ease.

Companies are listed alphabetically by business name or the last name of the artist-owner. The location (or locations) is given if known. Trade names, which might be more familiar, are provided in parenthesis. Companies whose principal output was tile have not been considered here.

American Pottery – Los Angeles
Arcadia Ceramics
Architectural Pottery – Manhattan Beach
Ball Artware – Inglewood
Bellaire, Marc – Los Angeles
Brahm, Johannes – Los Angeles, Reseda
Callender, Jane – Los Angeles
Cemar – Los Angeles
Clay Sketches – Pasadena
Coors, H.F. – Inglewood
Deforest of California – Duarte
De Lee Art – Los Angeles
Doranne of California
Flintridge China – Pasadena
Freeman-Leidy – Laguna Beach
Gilner – Culver City
Guppy – Los Angeles
Hamilton Studio – Huntington Park
Hollydale – Los Angeles
Jackson, Vee – Pasadena
Jaru Art Products – Culver City
Johnson, Harold – Glendale, Burbank
Josef Originals – Monrovia
Kaye of Hollywood – North Hollywood
Kellems – Pasadena
Kindell, Dorothy – Laguna Beach, Corona del Mar
La Cañada – Newhall
Lane – Van Nuys
Lerner, Claire – Los Angeles

Los Angeles Potteries – Lynwood
Madeline Originals – Pasadena
Maddux – Los Angeles
Manley, Jean – Pasadena
Maxwell, Robert – Venice
Meyers (California Rainbow) – Los Angeles
McAfee Artware – San Gabriel
McCarty Brothers – Sierra Madre
Miramar of California – Los Angeles
Nichols, Betty Lou – La Habra
Pacific Pottery Products – Long Beach
Padre – Los Angeles
Poxon – Vernon
Robertson – Los Angeles, Hollywood
Santa Anita – Los Angeles
Shirey, Esther – Encino
Simmons, Robert – Los Angeles
S-Quire Ceramics – Los Angeles
Thompson, Joy – Pasadena
Treasure Craft (Pottery Craft) – Compton
Tudor – Los Angeles
Vohann of California – Capistrano Beach
West Coast – Burbank
Weil/aka California Figurine Company – Los Angeles
Werner, Vally – Los Angeles
White, Eugene – Bell
Willis, Barbara – North Hollywood
Ynez – Inglewood
Yona Ceramics – Los Angeles

American Pottery Bambi figurine, 8½", from the Disney movie "Bambi." Mid forties.

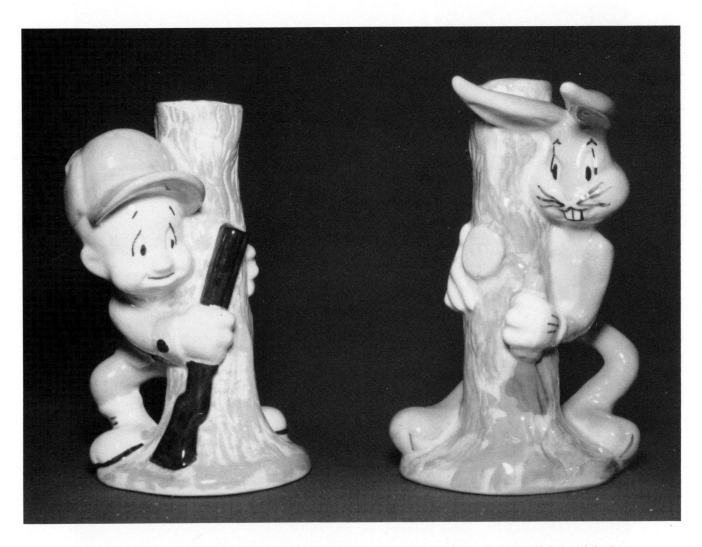

American Pottery Elmer Fudd, 6¾", and Bugs Bunny, 7", figurine-flower holders of the mid forties.

American Ceramic Products

La Mirada Pottery candle holder, 1½" x 4", vase, 4½", stylized Oriental man, 9½", and vase, 4½" of the late thirties.

La Mirada Pottery water buffalo planter, 7" x 10", mandarin figure, 12", Oriental child planter, 7½". Early forties.

La Mirada Pottery fish wall pocket, chartreuse crackle glaze.

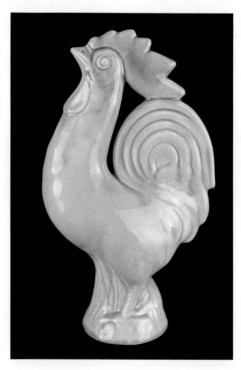

La Mirada Pottery cock, 12½", light turquoise-maroon crackle glaze, in-mold mark, c. 1946.

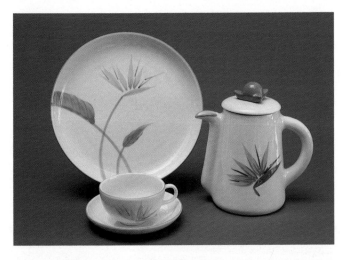

Winfield China "Bird of Paradise" dinner plate, 10", cup & saucer, coffee pot.

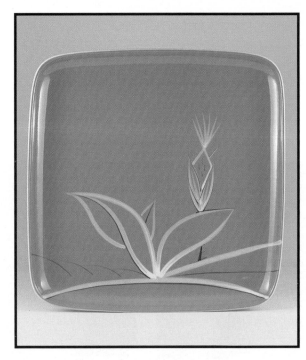

Winfield China "Desert Dawn" 14" chop plate.

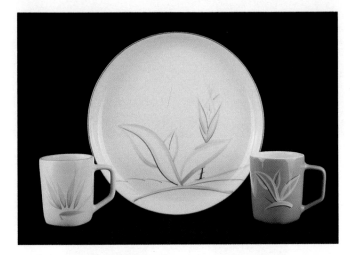

Winfield China "Bird of Paradise" mug, "Dragon Flower" dinner plate, 10", "Desert Dawn" mug. Stamped marks.

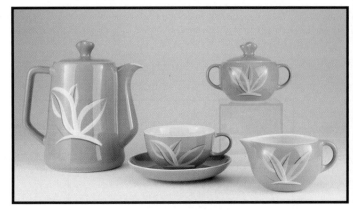

Winfield China "Desert Dawn" coffee pot, cup & saucer, covered sugar, creamer. Stamped marks.

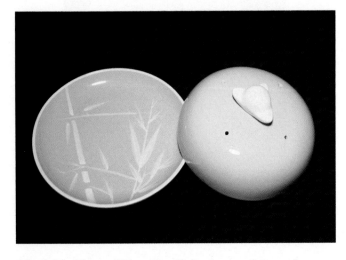

Winfield China "Blue Pacific" cheese dish and cover. Stamped mark.

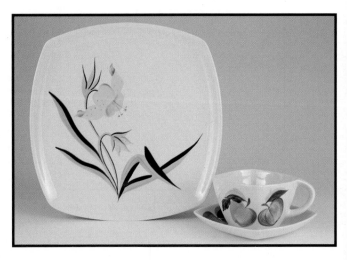

La Mirada Ware "Daffodil" dinner plate, 10", "Apple" cup & saucer (author's names). Stamped marks.

Batchelder

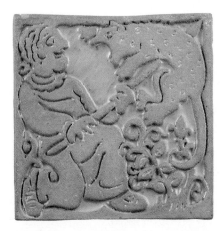

Partially glazed tile, 4", depicting medieval hunt. Impressed "Batchelder Los Angeles," c. 1928.

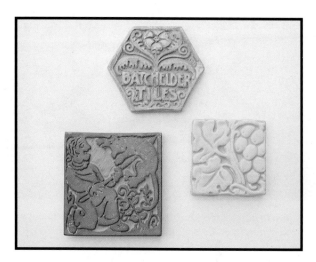

Unglazed (engobe) hexagonal tile, 3½", advertising "Batchelder Tiles," medieval hunting scene tile, 4", patina glazed grapevine tile, 3".

Unglazed (engobe) conventionalized bud with leaves tile, 3", impressed "Batchelder Los Angeles."

Unglazed (engobe) peacock tile, 6". "Batchelder Los Angeles" impressed mark.

Unglazed (engobe) medieval landscape tile, 4", impressed "Batchelder Los Angeles."

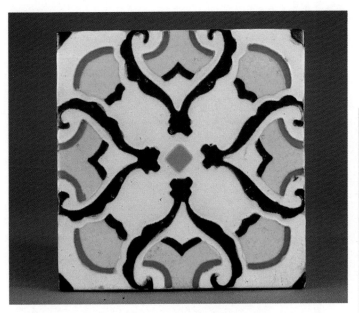

Satin matte glazed Hispanic tile, 6", "Batchelder Los Angeles" impressed mark, c. 1928.

Batchelder Ceramics: (back row) vase, 6", vase, 9½", vase, 7"; (front row) bowl, 3", vase 4¾" x 5½". Incised marks.

Batchelder Ceramics oblong vase, 6¼" x 8", low bowl, 1½" x 7". Incised marks.

Batchelder Ceramics vase, 6", flared bowl, 3¼" x 7½". Incised marks.

Bauer

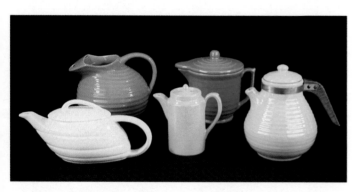

Bauer (back row) "Ring" ball jug, "Ring" covered beater pitcher; (front row) "Gloss Pastel Kitchenware" (aka the Aladdin) 4 cup teapot, "Plain" individual coffee pot, "Ring" 6 cup teapot with wood handle.

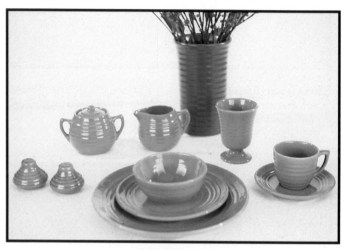

"Ring" cylinder vase, 8", salt & pepper shakers, covered sugar, creamer, goblet, coffee cup & saucer, dinner plate, 10½", salad plate, 7½", cereal bowl.

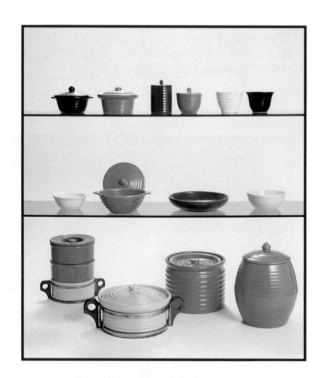

"Ring ware": (row 1) covered baking dish, 4", individual casserole, cigarette jar, mustard jar, "Hi-Fire" style custard cup, standard custard cup; (row 2) berry dish, lug soup, 5½", with cover, soup plate, 7½", cereal bowl; (row 3) refrigerator stack set in rack, 7½" casserole in rack, #3 spice jar, cookie jar.

C.L. McClanahan photo.

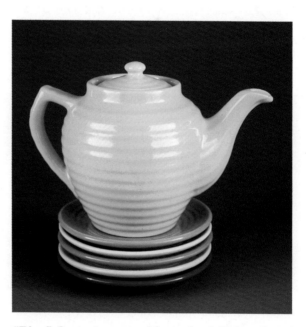

"Ring" 6 cup tea pot with stack of 6" bread and butter plates. In-mold marks.

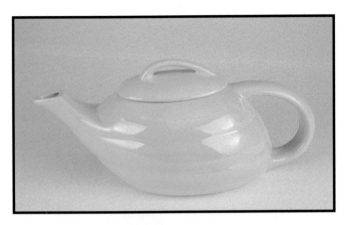

This classic teapot design was part of the "Gloss Pastel Kitchenware" line of the forties. Larger 8 cup size in yellow. In-mold mark.

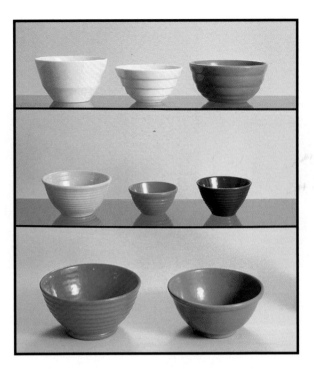

A variety of Bauer mixing bowls: (row 1) #24 Tracy Irwin design, #24 premium line, #18, "Gloss Pastel Kitchenware; (row 2) #24 "Ring", #26 "Hi-Fire", Bauer look alike; (row 3) #9 early "Ring" and "Plain" designs. C.L. McClanahan photo.

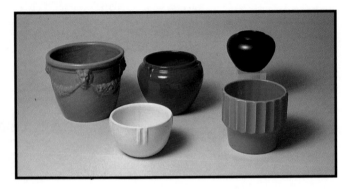

Decorative pots: (back row) 10" lion pot, 8" hanging basket, 6" Indian bowl of the fifties; (front row) 7" Indian bowl of the thirties, 8" Biltmore jar. C.L. McClanahan photo.

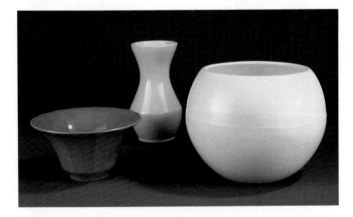

"Hi-Fire" 5" deep flower bowl, handmade vase by Fred Johnson, 5½", rose bowl, 5½ x 6½".

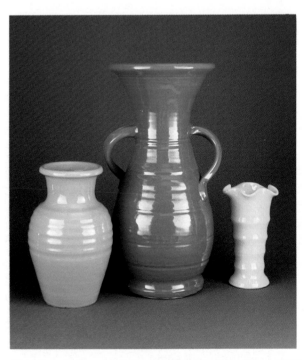

Handmade floral artware by Mat Carlton. Vase, 9½", handled vase, 17", ruffled vase, 7½".

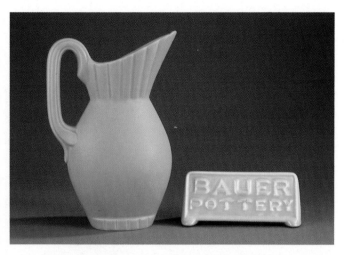

"Cal. Art" ewer, 10", with Bauer dealer sign.

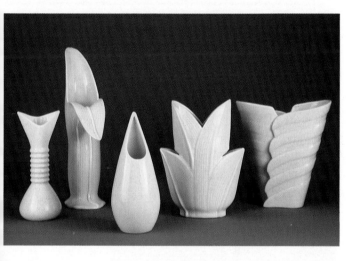

Bauer floral artware of the fifties designed by Tracy Irwin: vase #506, 8", vase #678, 13", vase #505, 8", vase #684, 8½", vase #502, 8".

The majestic #100 oil jar, 22" size, in orange red. C.L. McClanahan photo.

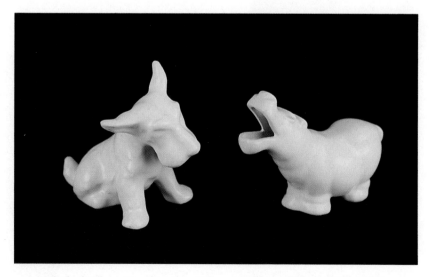

"Cal. Art" matte glazed scottie and hippo. Hippo: 3¼" x 4½".

Sascha Brastoff

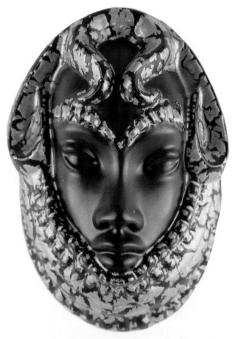

Native Wall mask, 9½", one of a series,
signed "Sascha B."

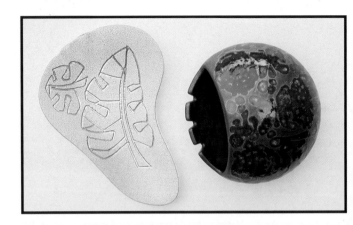

Freeform ashtray, 8½" and round domed ashtray, 3¼" x 5½".
Signed "Sascha B."

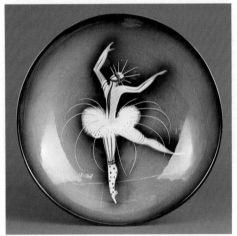

Three-footed
bowl, 2¼" x 10",
signed "Sascha
B."

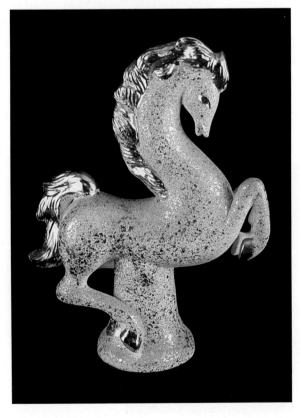

Horse figure, 10½", platinum on matte pink, signed
"Sascha B." c. 1957.

Sascha Brastoff vases:
abstract design, 12",
and "Alaska" Line,
13½", signed "Sascha
B."

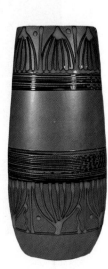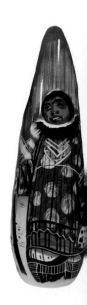

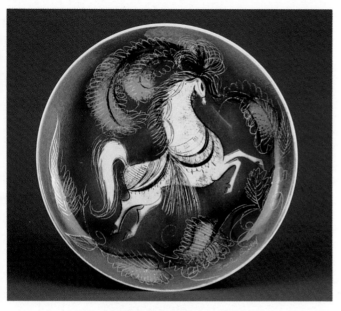

"Star Steed" plate, 10½", hand decorated by Sascha Brastoff. Signed "Sascha Brastoff," c. 1959.

Poodle, a favorite Brastoff subject, 7" x 9", satin-matte crackle glaze, signed "Sascha B."

"Winrock" porcelain dinner plate, 11", "Night Song" porcelain salad plate, 9", and cereal bowl, 6". "Sascha Brastoff Fine China" stamped marks.

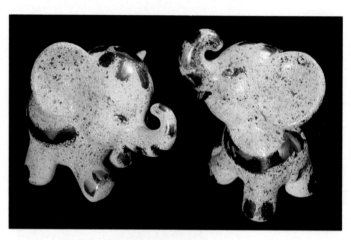

Circus elephant set: (left) 7½" (right) 8". Platinum on matte light blue, signed "Sascha B."

Enamel ware ashtrays: artichoke shape, 5½" and leaf shape, 6¼". Both signed "Sascha B."

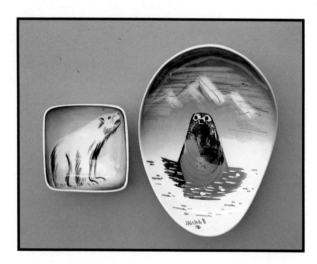

Sascha Brastoff's extensive "Alaska" line included this square dish, 3½", and oblong footed dish, 2¼" x 7½". Both pieces signed "Sascha B."

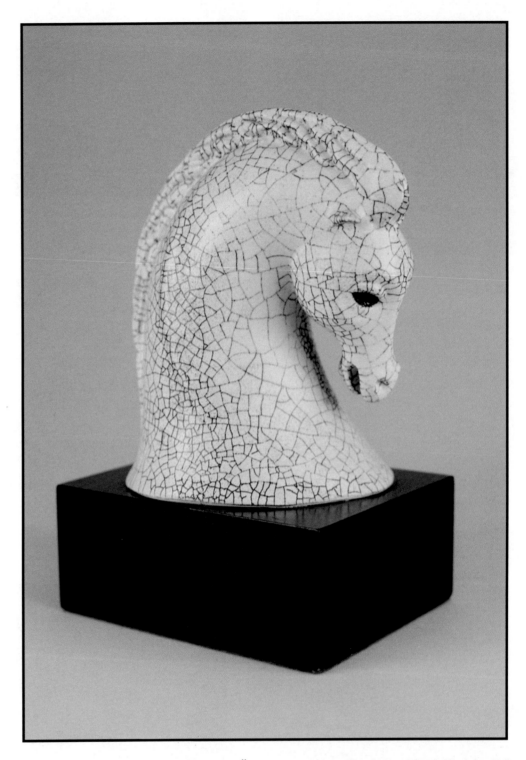

Horse head sculpture on wood base, 7½″, satin-matte crackle glaze, signed "Sascha B."

Brayton Laguna

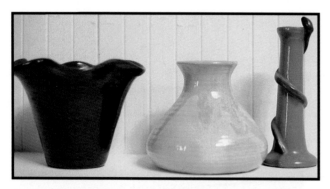

Early handmade decorative pottery by Durlin Brayton: flower pot, vase, 5½", bud vase with entwined snake, 8". Incised marks.

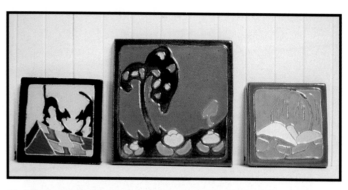

Handmade tiles by D. Brayton: cats on roof, 4½", fanciful tree, 6½", mushrooms, 4½". Incised marks, c. 1928.

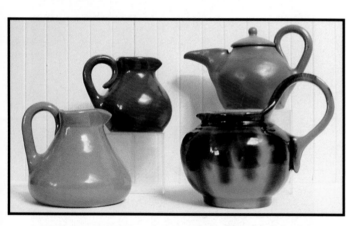

Durlin Brayton's line of handmade colored pottery included: pitcher, 5", teapot, 5½", pitcher, 5½", loop-handled pitcher, 7¼". Incised marks.

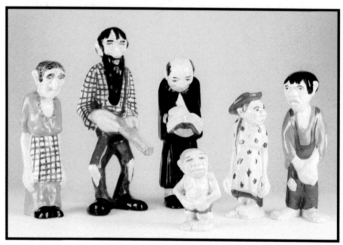

Popular "Hillbilly Shotgun Wedding" set designed by Andy Anderson, c. 1938. Shotgun man: 9". Stamped marks.

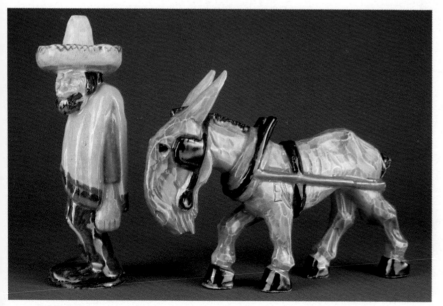

Mexican Man, 9", and mule, 7¼" x 10", designed by A. Anderson.

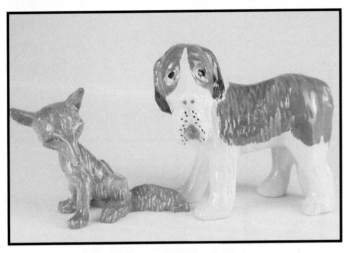

Fox (from "English hunter with fox and hounds" set) and St. Bernard figurines by Andy Anderson. Late thirties.

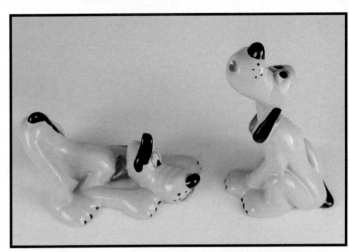

Brayton Laguna's Walt Disney line of figurines included: sniffing Pluto 3¼" x 6", and howling Pluto, 6".

From the two Brayton Laguna childhood series: (left) Chinese boy & girl by Frances Robinson; (right) black children (single figure) by L.A. Dowd. Early forties.

Frances Robinsons's childhood series included: Pedro, 6½", and Rosita, 5½". Stamped marks.

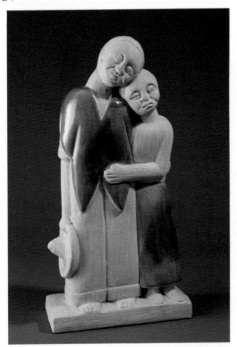

Mexican peasant couple figure, 12½", textured bisque with high glaze. In-mold mark.

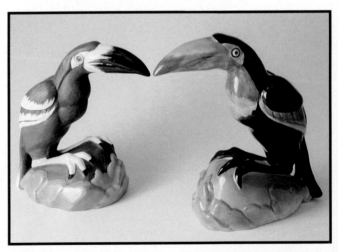

Toucan, 9", with different finishes: (left) woodtone with high glaze, (right) polychrome high glaze. In-mold marks, fifties/sixties.

California Pottery

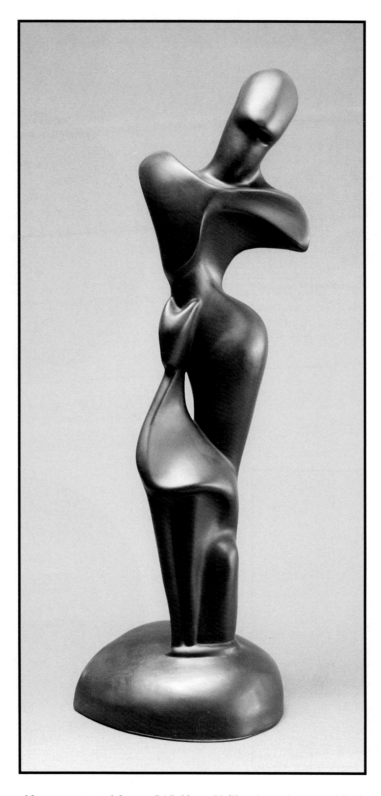

Abstract man with cat, 21" (from M/F set), satin-matte black, in-mold mark, c. 1957.

Catalina

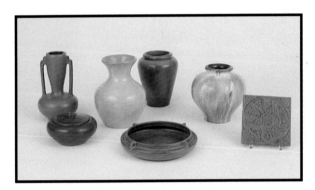

Artware of the early thirties: (back row) handled vase, 8½", vase, 9", vase, 7½", vase, 7¼"; (front row) covered dish, bowl, 2" x 8", tea tile, 6". C. L. McClanahan photo.

Plate, 11½", with hand-painted scene of old Mexico, impressed mark, c. 1932.

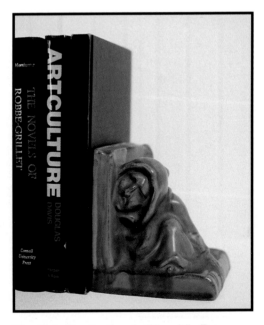

Monk design bookend, 5" x 4", Descanso green glaze, c. 1932.

"Submarine Garden" decorative plate, 14". Impressed mark.

Decorative plate, 11", Moorish design, c. 1932.

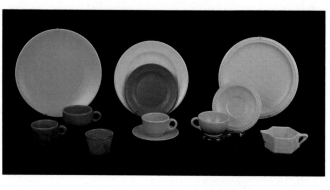

Dinnerware designs: (back row) coupe design plate, 11¼", wide shoulder design dinner plate, 10" and salad plate, 7½", "Rope" design dinner plate, 10½"; (front) punch cup, coffee-tea cup, refrigerator jar, cup & saucer, "Rope" design cup & saucer, hexagonal design creamer. C.L. McClanahan photo.

This tile plaque depicting green macaws is inset in the exterior wall of a Spanish style building in Avalon.

Catalina Glazes: tumbler in Monterey brown, demitasse cup in pearly white, coffee mug in Catalina blue, pitcher in Toyon red.

Rolled edge design tray, 14½", turquoise glaze, in forged iron handle, c. 1934.

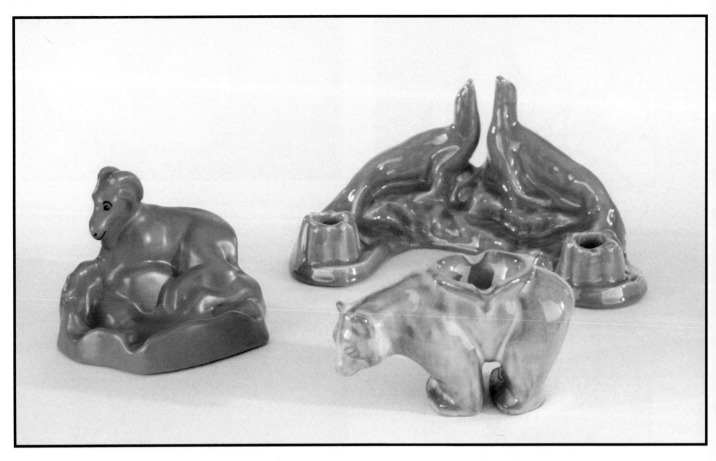

Catalina Island souvenir items: goat ashtray, 4", seal candelabra, 5" x 10½", bear ashtray, 3¼"x5½".

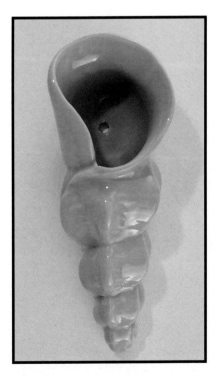

Seashell wallpocket in turquoise. Incised mark.

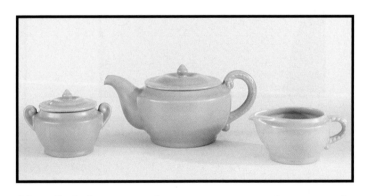

"Rope" design covered sugar, teapot and creamer in powder blue matte glaze, c. 1936.

California Pottery

Cleminsons

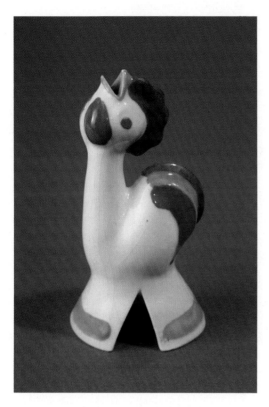

The popular Cleminsons pie bird, 4½", Betty Cleminson's initials in-mold.

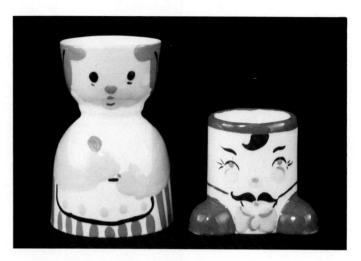

Two early egg cup designs for children.

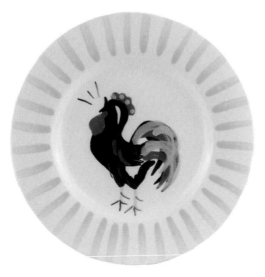

Plate, 9½", decorated with crowing rooster.

Jumbo size cup & saucer, stamped marks.

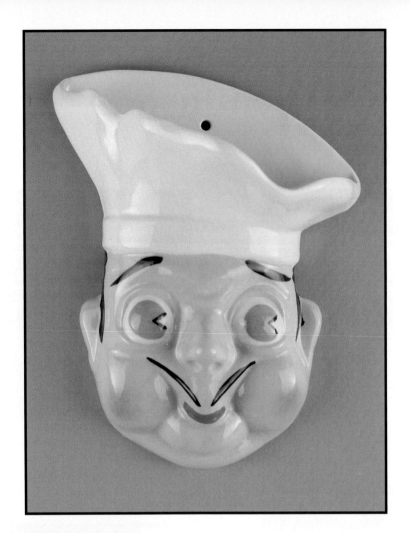

Above: Chef design wallpocket, 7¼", stamped mark.

Left: Spoon rest, 8½".

Kay Finch

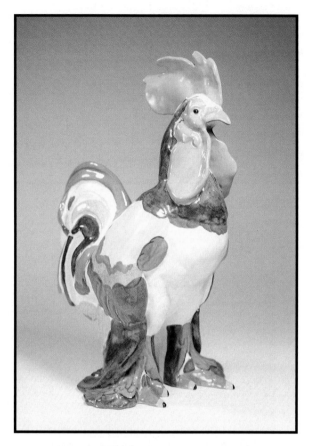

Chanticleer, 10¾", in-mold mark.

Seashell low flower bowl, 2" x 12¾" with fish, 3¼" x 7", incised marks.

Cottontail, 2½", c. 1946.

Santa Claus tumbler or vase, 4¼", stamped mark.

Pair of circus monkeys, 4", c. 1948.

Yorky Pup, 6¾". (Yorky pup on page 101 completes the set.)

English village bank, 5½", dated "1944."

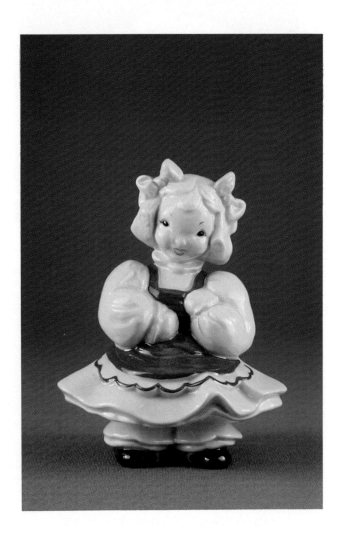

Above: One of a series of dog head ashtrays. Stamped mark.

Left: Girl figurine, 5¼".

California Pottery

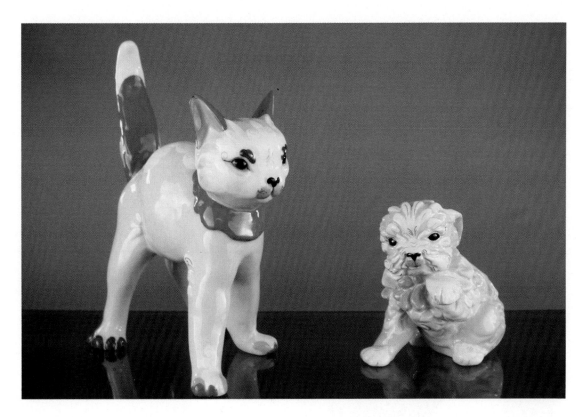

Hannibal, the angry cat, 10¼", and Yorky pup, 5".

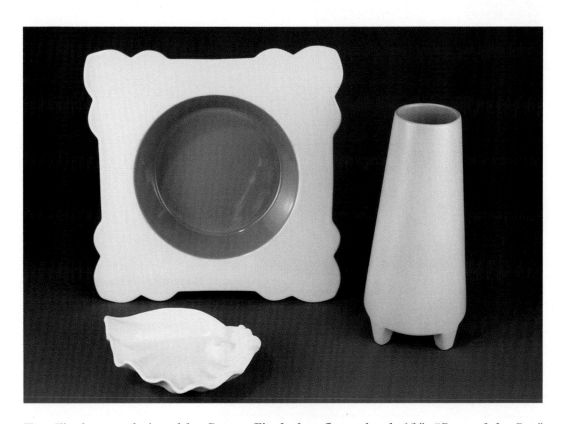

Kay Finch ware designed by George Finch: low flower bowl, 12", "Song of the Sea" ashtray, 5" x 7", Footed vase, 9". Incised marks.

Florence

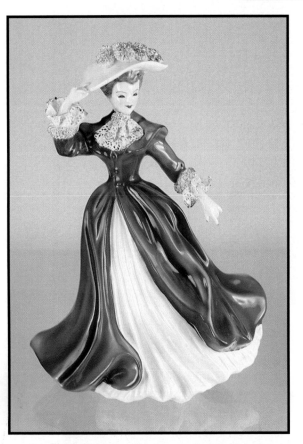

Cynthia figurine, 9¼", lace and fur trim, 22K gold. Stamped mark with "Cynthia" in-mold.

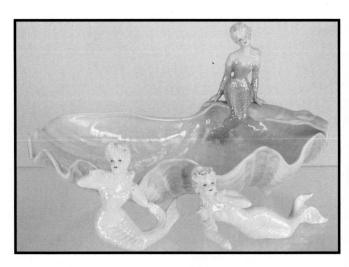

Merrymaids and matching shell bowl: (clockwise from top) Jane 7", Rosie 3½" x 7", Betty 4½", bowl 3¼" x 15¾".

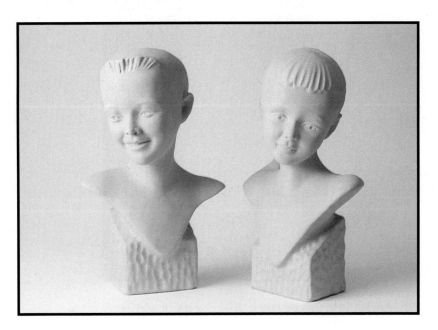

Boy and Girl busts in bisque finish. Boy, 9¾", girl, 9½". Mid fifties.

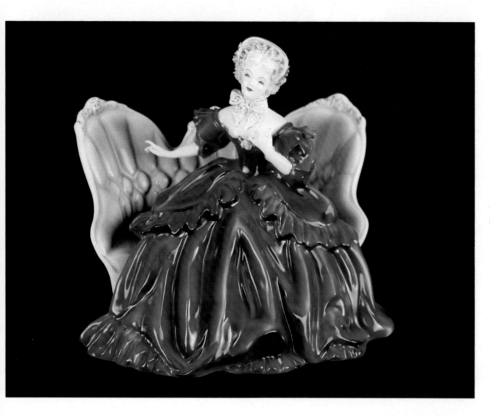

Victoria on divan (attached), 7" x 8¼", ribbon, roses, and lace trim, 22K gold. Stamped mark with "Victoria" in-mold.

Florence ceramic royalty: Louis XVI figurine, 10", lace and fur trim, 22K gold, and Marie Antoinette figurine, 10", ruffled bodice, hair ornamentation, roses and lace trim, 22K gold. Stamped marks.

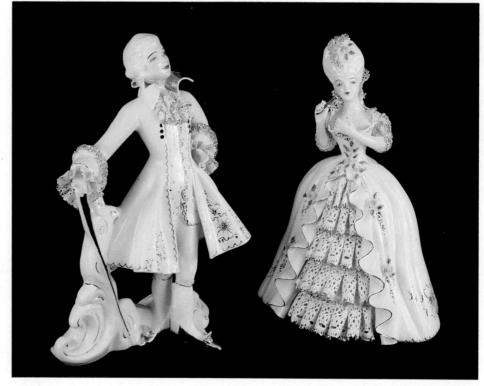

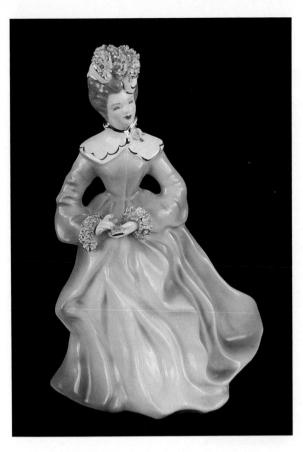

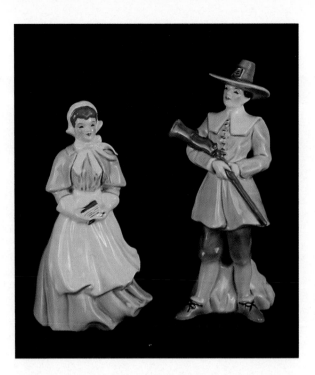

Priscilla figurine, 7¾", and John Alden figurine, 9¼", minimal gold. Stamped marks.

Shirley figurine, 8", hand-applied compact, rose and fur trim, 22K gold. Stamped mark.

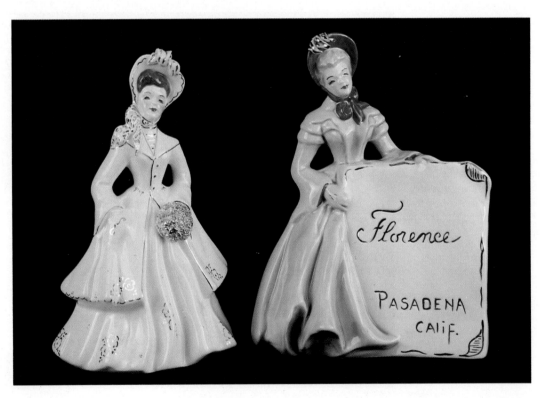

Kay figurine, 6", fur trim, 22 K gold, and Florence dealer sign, 6¼" x 5", 22K gold, stamped mark.

California Pottery

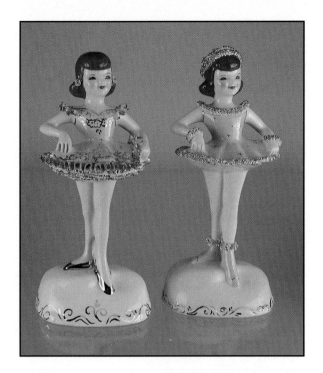

Ballerina variations: (left) 7", lace trim, 22K gold, (right) 7¼", fur trim, 22K gold. Stamped marks.

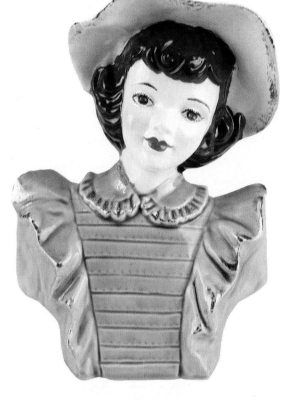

Violet wallpocket, 7", 22K gold, stamped marks.

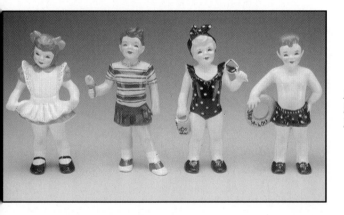

Florence figurines of children: (left) girl holding skirt and boy holding ice cream cone; (right) seashore girl and seashore boy. Circa 1951. Tony Cuñha photo.

Less elaborate figurine-flower holders: girl holding skirt, 7", book girl (June), 6¼", girl holding parasol, 8¼".

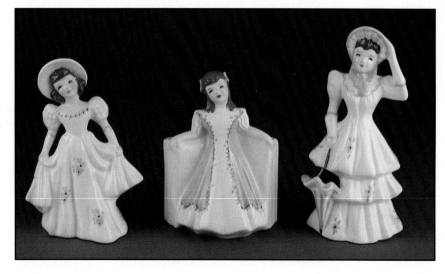

Freeman-McFarlin

Giraffes by Maynard Anthony Freeman: upright male, 21", female, 11". Woodtone with white crackle high glaze, in-mold marks.

Mermaid holding shell dish, pink-tinted bisque with high glaze, c. 1957.

Elephant planter, 7" x 9", stoneware, in-mold "Anthony" mark. Sixties/seventies.

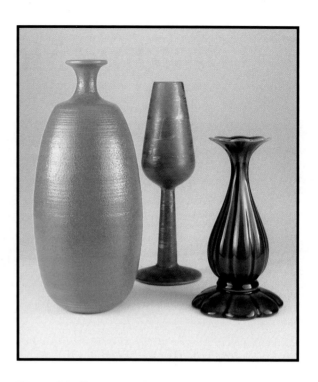

Vase, 11¼", stemmed vase, 10¾", bud vase, 8",
designed by Maynard Anthony Freeman. In-
mold marks and paper labels.

Pair of amorous cats: male, 12½", female, 11¾",
woodtone, in-mold "Anthony" marks.

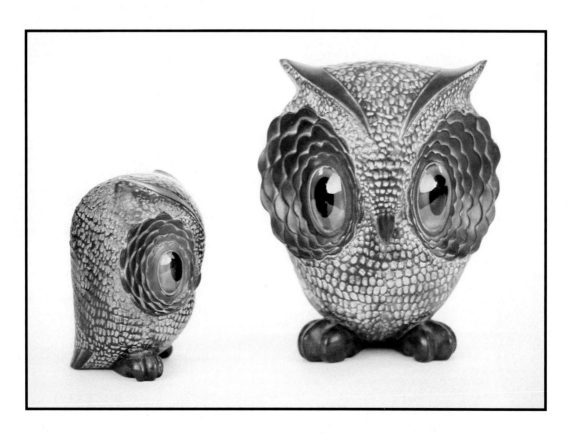

Freeman-McFarlin owls: small owl, 6", large owl, 9". Sixties/seventies.

Gladding-McBean/Franciscan

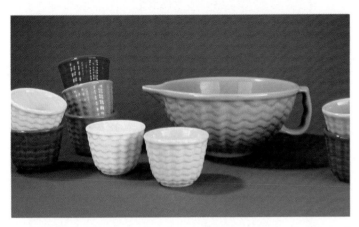

"Cocinero" kitchenware of the thirties: batter bowl and custard cups in distinctive scalloped design.

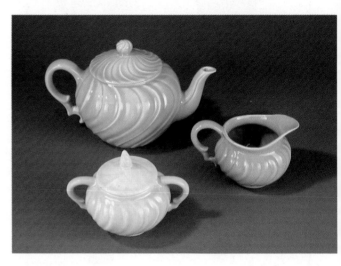

Gladding-McBean's "Coronado" dinnerware line included this tea pot, covered sugar and creamer.

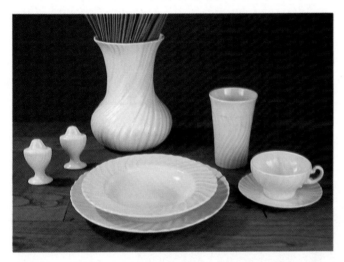

"Coronado" placesetting: service plate, 10½", rim soup, cup & saucer, tumbler, salt & pepper shakers, and vase, 8½".

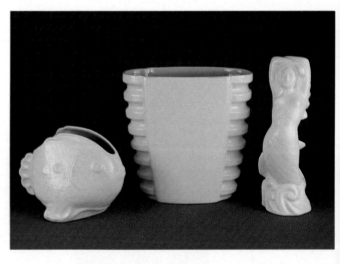

Gladding-McBean's "Catalina Pottery": fish vase, 5", vase (from original Island mold), 8", mermaid figurine, 9". Late thirties.

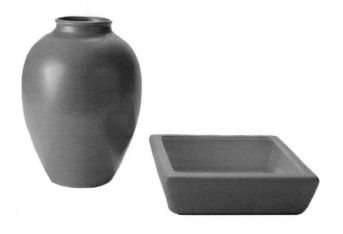

"Catalina Pottery" line vase #C381, 8", in periwinkle blue, and low bowl #C282, 2" x 7½".

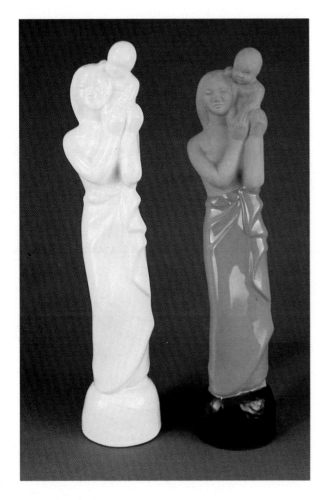

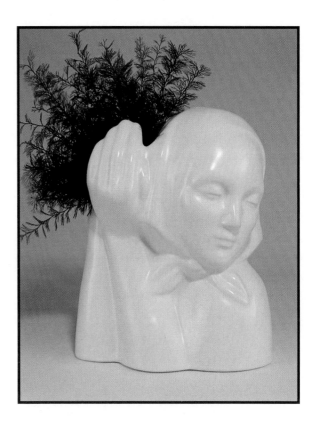

Popular peasant woman vase, 6¾", designed by Dorr Bothwell, was part of the "Catalina Pottery" package of the late thirties/early forties.

Dorr Bothwell designed these 13" Samoan women with child figures, c. 1937. Figure on left in satin white glaze; figure on right in terra cotta finish.

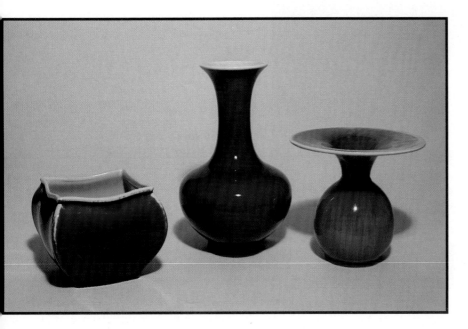

The celebrated ox-blood glazed artware: square vase, 4½", vase 9½", trumpet shaped vase, 6", stamped "Catalina Pottery" or "GMcB" marks.

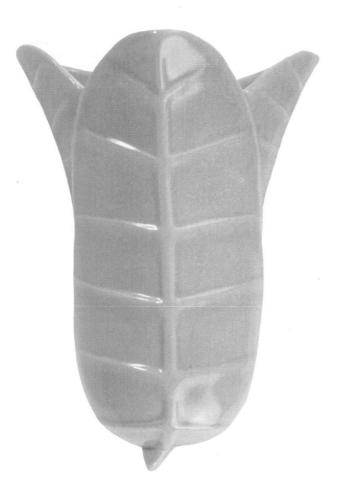

Ashtray, 4½", advertising the "Franciscan Pottery" trademark of 1937. In 1938 the mark was changed to the more-familiar "Franciscan Ware."

Leaf-shaped wallpocket, 7¾", in satin green, from the extensive "Catalina Pottery" line.

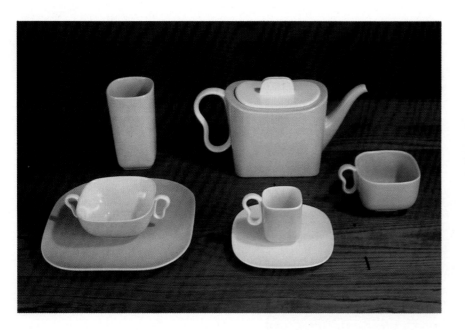

The highly acclaimed "Metropolitan" dinnerware: dinner plate, 10", cream soup, after dinner coffee cup & saucer, and teapot, along with later "Tiempo" line tumbler and tea cup.

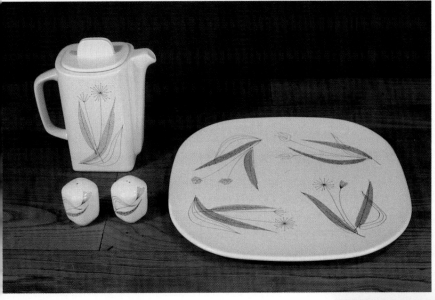

"Trio" was another variation on the "Metropolitan" design. Coffee pot, shakers, and dinner plate from the line produced between 1954 and 1957.

"Franciscan Fine China" patterns: "Debut" teapot, "Mesa" coupe soup bowl, "Westwood" fruit bowl, "Brentwood" oval vegetable bowl, and "Cherokee Rose" sauce boat.

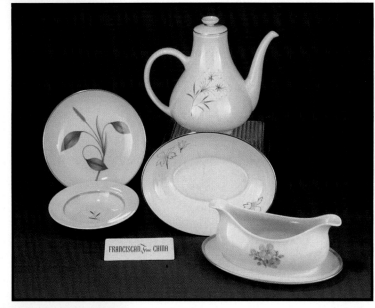

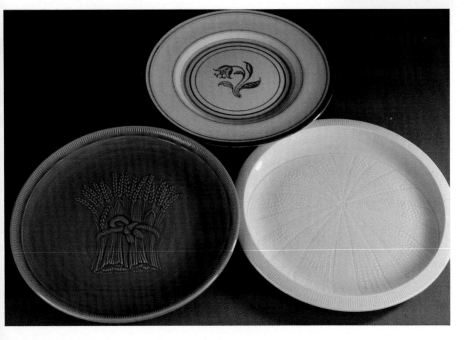

"Franciscan" dinnerware contrasts: "Padua" (top) was the first hand-decorated earthenware pattern. "Wheat" (left) and "Sea Sculptures" (right) were later embossed patterns of the type offered prior to the closing of the Los Angeles plant.

Hagan—Renaker

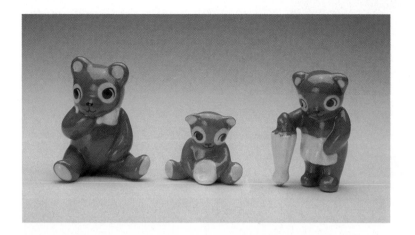

*The Three Bears, c. 1950. Papa bear measures 2".
Tony Cuña photo.*

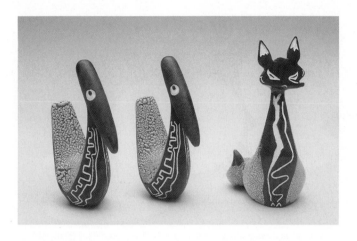

*"Black Bisque" line items: dodo birds (left) and flat face fox
(right). Fox measures just under 4". Black toned bisque
with turquoise high glaze. Tony Cuña photo.*

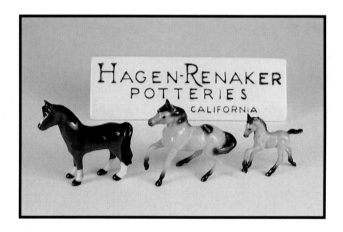

*Hagen–Renaker dealer sign along with early (Monrovia)
horse (left) and current horses (right).*

*Designers workshop Arabian stallion, 9" x 11¼", and colt,
6¾" x 6¼". Modeled by Maureen Love Calvert.*

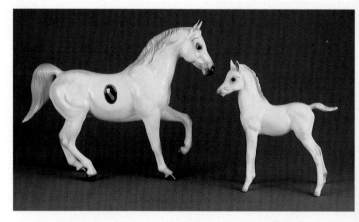

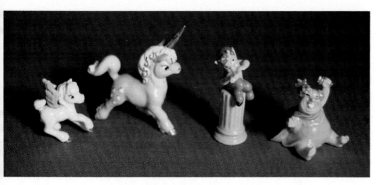

Walt Disney line items from the movie "Fantasia": baby Pegasus, unicorn, Pan on Greek column (2 pieces), and Bacchus. Fifties series.

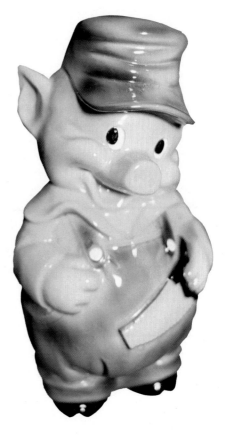

Pig Bank, 6¾", from the Disney film "The Three Little Pigs." Fifties series.

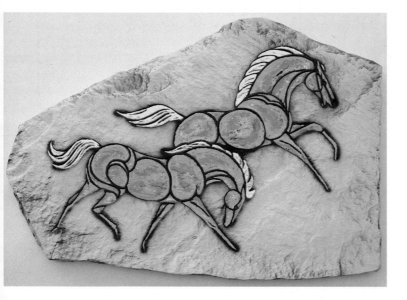

Wall plaque, 15" x 22", of prancing horses was produced in 1960. Paper label.

From the Designers Workshop: Pasha, the baby elephant, 3½", (label reads: "Designers Workshop/Pasha/1955"), and Miss Pepper, reclining Morgan foal, 2¾" x 4½", c. 1959.

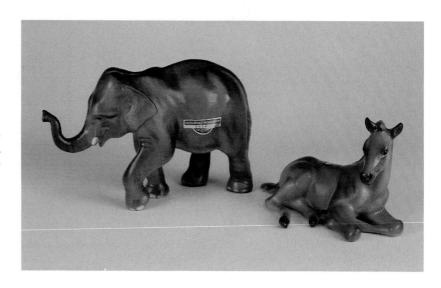

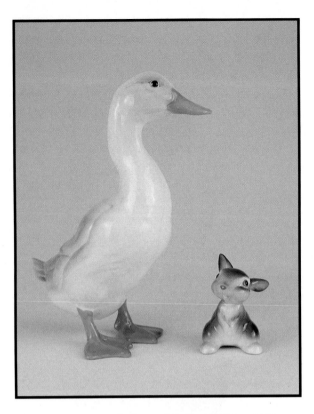

Standing goose, 6½", and baby rabbit, 2¼", are Designers workshop models produced in recent years.

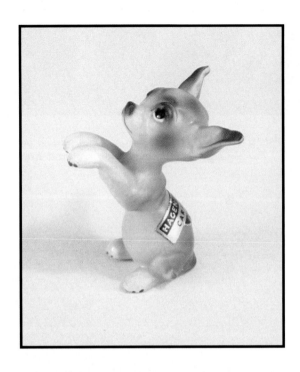

The "Pedigree Dogs" line by Tom Masterson included Carmencita, begging chihuahua puppy, 2". Label reads: "Hagen–Renaker/Carmencita/ 1953."

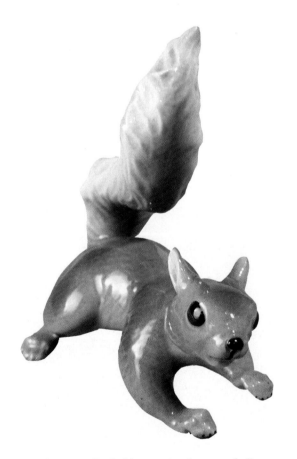

Designers Workship squirrel named Peggy, 4¼" x 4".

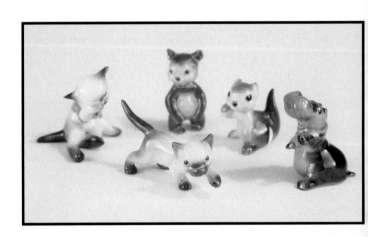

Group of Hagen–Renaker minis: (all current) kitten who lost her mittens, creeping siamese kitten, baby bear, chipmunk, hippo. All under 2".

Haldeman

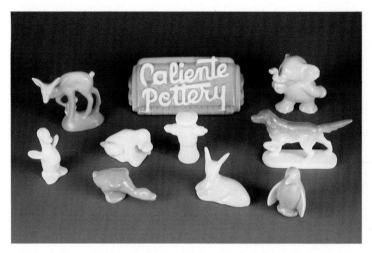

The Caliente clay menagerie: (row 1) deer, 5", Caliente Pottery dealer sign, 3¼" x 9½", comic elephant, 5"; (row 2) duck, 4", sad hound, 2¼" x 4", with fire hydrant, 3½", pointer, 4" x 6¾"; (row 3) goose, 1¾" x 4½", seated deer, 3¼", penguin, 3¼". Late thirties/early forties.

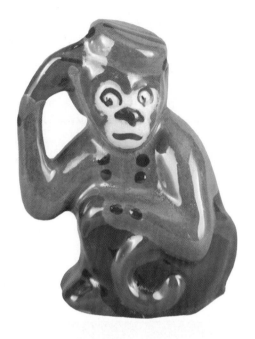

Caliente monkey, 2¾", dressed as a bellhop. Unusual hand decoration, c. 1943.

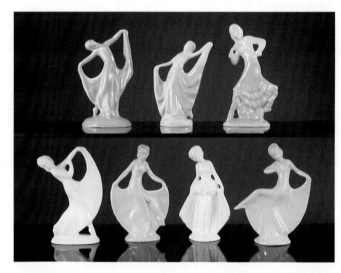

Caliente dancing ladies of the late thirties: (row 1) lady #408, 6½", lady #412, 6", lady #402, 7"; (row 2) lady #401, 7", lady #403, 6½", lady #405, 6½", lady #407, 7". Impressed marks.

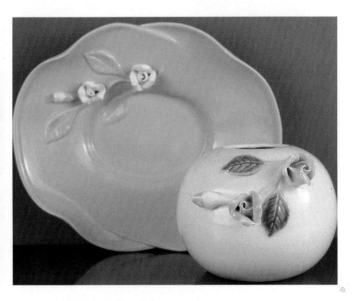

Artware with applied hand-made roses: low flower bowl, 9½" x 11¼", rose bowl, 4¾". Mid forties.

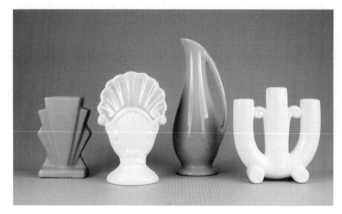

Floral Artware: vase, 5¾", vase, 7½", ewer, 10", triple bud vase, 6½".

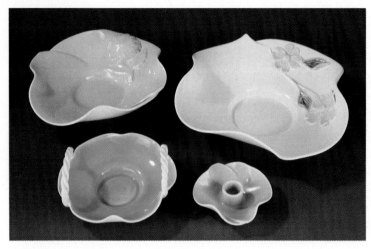

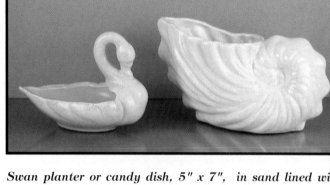

Decorative Caliente Pottery: (row 1) low flower bowl with applied dahlia and leaves, 3" x 10", low flower bowl with applied dogwood and leaves, 3½" x 11¾"; (row 2) low bowl with hand-coiled handles, 3" x 6¾", candle holder, 1½" x 4½". Incised marks.

Swan planter or candy dish, 5" x 7", in sand lined wit turquoise, and shell planter, 5" x 9½", in pink. Incised mark

Chinese style flared bowl, 3½" x 10", in one of Haldeman's blended glazes.

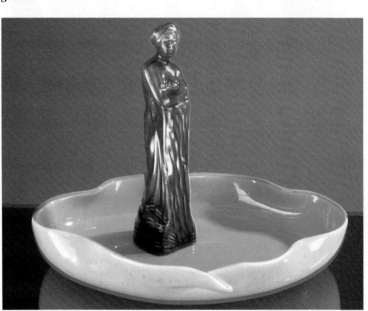

Unusual slave woman at block figure, 7", with low bowl, 1½" x 10".

Wallpocket, 6½", in satin white glaze. Incised mark.

Brad Keeler

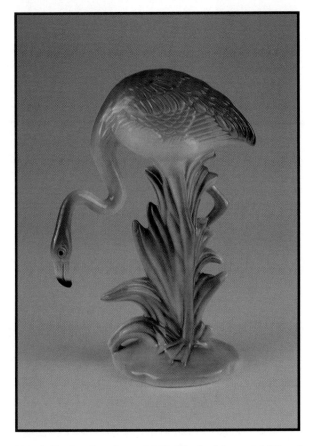

Brad Keeler flamingo, 7½". Marked in-mold "Brad Keeler #3."

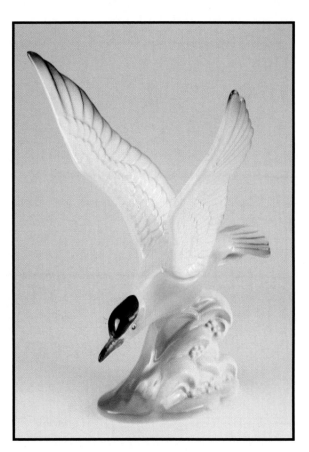

This seagull by Brad Keeler measures 10½". Marked in-mold "Brad Keeler #29."

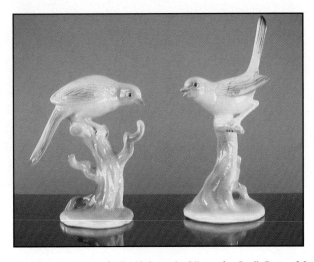

Canary set: female (tail down), 6", male, 8¼". In-mold marks.

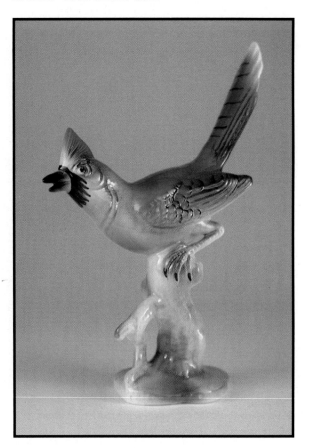

Naturalistic blue jay, 9¼". Marked in-mold "Brad Keeler #735."

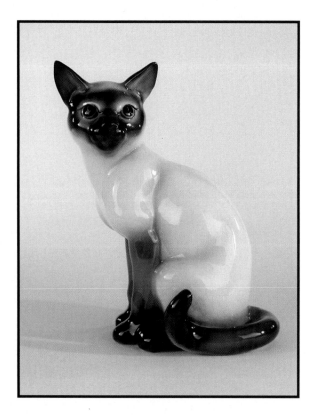

Siamese cat with printed mark "Brad Keeler #798."

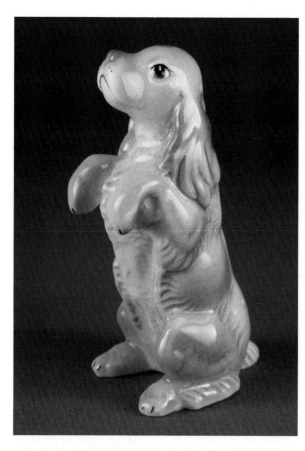

Begging cocker spaniel pup, 6". Marked in-mold "Brad Keeler #735."

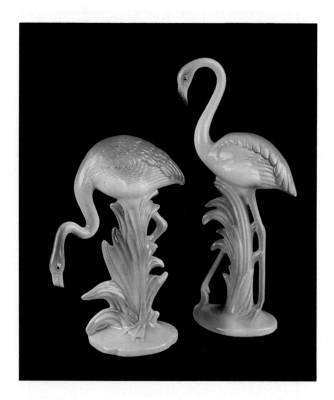

Pair of graceful flamingos: female (head down), 7¼", and male, 9½". In-mold marks.

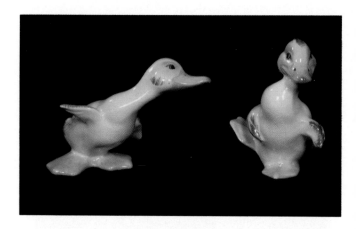

Pair of small-scale ducks. Stamped marks.

William Manker

Exceptional floral artware: rectangular vase, 7½" x 6", square vase, 7¼" x 3½", fluted vase, 6".

William Manker vase, 7¼", with characteristic drip glaze. Early stamped mark.

William Manker artware: small egg shape bowl, 3¼", cylinder vase, 8", tall cylinder vase, 14", stilted vase, 5½".

Covered jar, 6", in citron green. Early stamped mark.

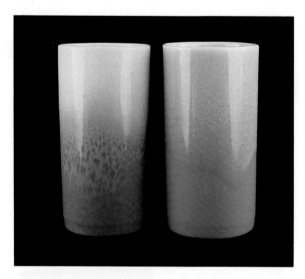

Artfully blended glazes on 8" cylinder vases: (left) citron green and dove grey, (right) powder blue and light rose. Early stamped marks.

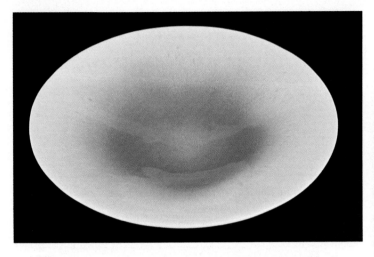

Low flower-arranging bowl, 16½", in burgundy and pale turquoise. Stamped "Manker Ceramics" mark.

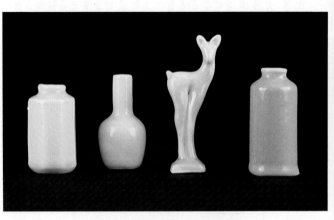

Miniatures by Manker: six sided vase, 2¼", vase, 2½", fawn figurine (modeled by Howard Pierce), 4", vase, 2¾".

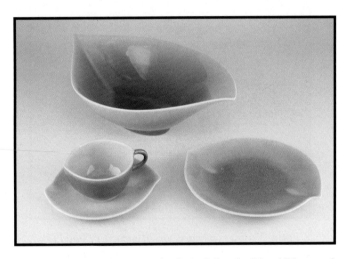

Leaf shaped luncheon set included: bowl, 4" x 15", cup & saucer, and plate, 7½", c. 1947.

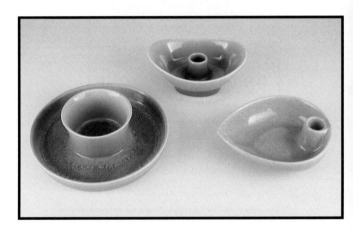

Candle holders: Christmas design, 2¼" x 7½", oblong design, 2½" x 6", leaf design candle and flower holder, 2" x 6".

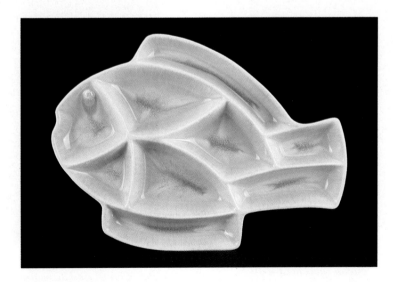

Fish design condiment tray, 11¾" x 16¾". Stamped "William Manker/California/U.S.A."

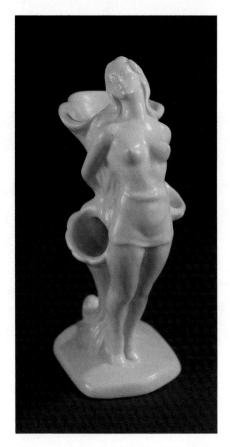

These cubistic dog figurines, 5", are from the extensive "Metlox Miniatures" line. Late thirties.

Figurine-flower holder, 8¾", designed by Carl Romanelli. Satin ivory glaze, c. 1940.

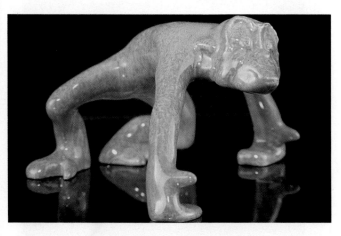

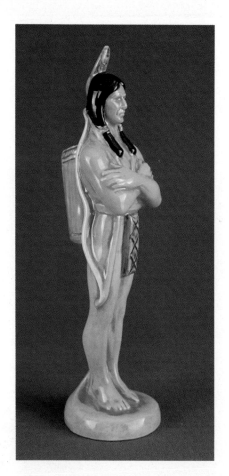

"Metlox Miniatures" monkey on all fours, 4½", in turquoise-rust glaze, c. 1939.

Indian Brave, 9", from sculptor Carl Romanelli's "Modern Masterpieces" series of the late thirties/early forties. In-mold mark.

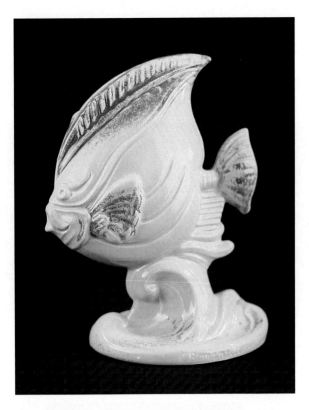

Distinctive "Pintoria" dinnerware of the late thirties in whi[te] gloss: service bowl, dinner plate, small bowl, bread plate. In-mo[ld] marks.

Angel Fish vase, 8½", was a patented design by Carl Romanelli, c. 1940. In-mold markings include "C. Romanelli."

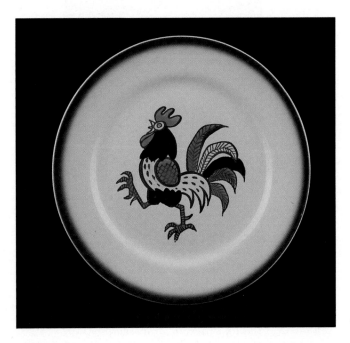

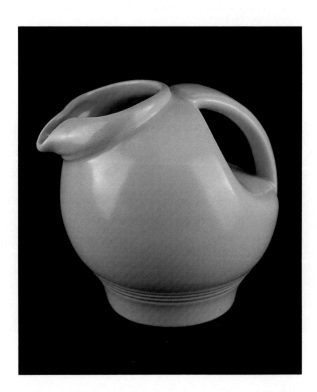

Poppytrail ice-lip jug in satin peach, c. 1939.

"Red Rooster Provincial" dinner plate, 10". Stamped mark.

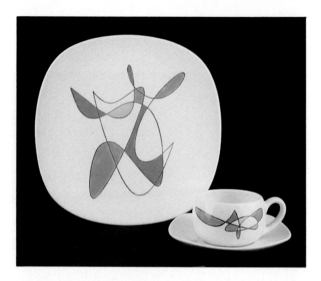

"California Mobile" dinner plate, 10", and cup and saucer. Stamped mark.

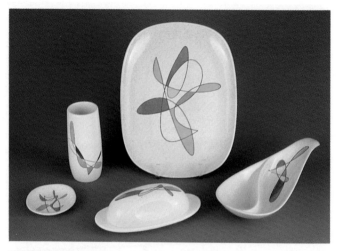

Ultra-modern fifties styling by Metlox designers Bob Allen and Mel Shaw: (row 1) "California Contempora" tumbler, "California Free Form" platter; (row 2) "California Mobile" coaster, covered butter dish and twin vegetable dish. Stamped marks.

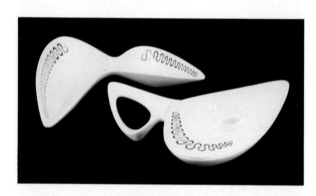

"California Aztec" jawbone (relish dish) and covered vegetable. Stamped mark.

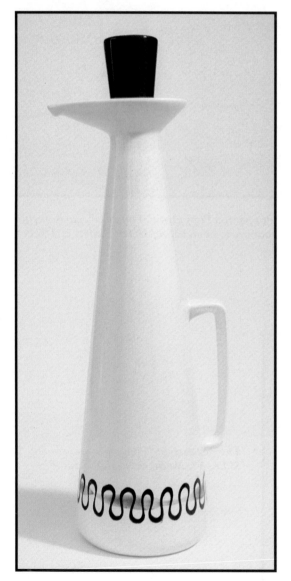

The "California Aztec" dinnerware line included this unusually tall coffee pot, c. 1960.

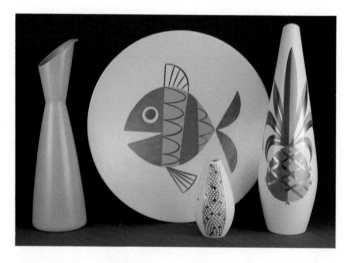

Poppytrail artware circa 1957: "California Contemporary" hour glass ewer, 15", "Tropicana" (fish motif) low bowl, 12", Mosaic" bud vase, 6", "Tropicana" (pineapple motif) teardrop vase, 17".

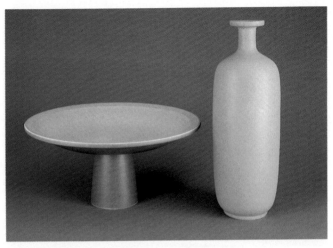

The "Ceramic Art Traditions" line designed by ceramist Harrison McIntosh included this compote, 4½" x 12", and bottle vase, 12½". Speckled matte glazes, c. 1956.

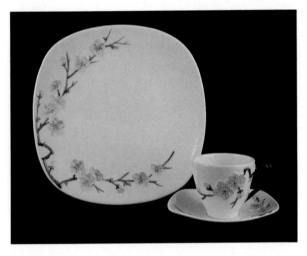

"Peach Blossom" dinner plate and "Golden Blossom" cup & saucer. Early sixties, stamped marks.

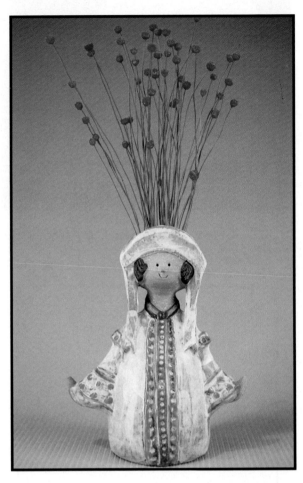

"Poppets by Poppytrail" Tina, 8½", partially glazed stoneware, modeled by Helen Slater, c. 1970.

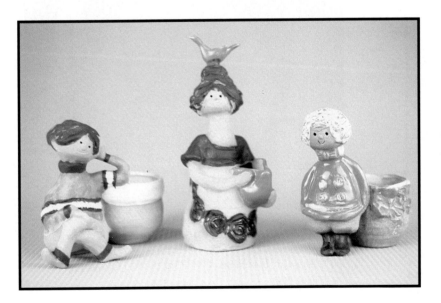

The extensive "Poppets" assortment included: Mike, 5", Nellie, 8¾", and Sam. 6".

Pacific

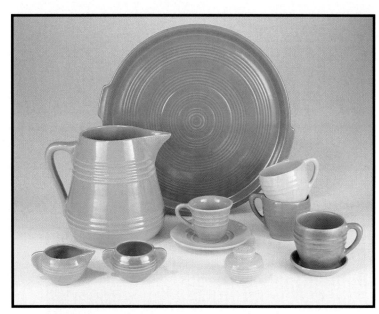

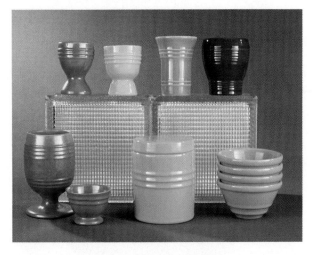

Pacific ware: (row 1) early design egg cup, later design egg cup, 4" tumbler, tumbler (has matching pitcher); (row 2) goblet, cocktail cup, covered jar, 5", early design custard cups. In-mold marks.

Pacific rivalled Bauer's "Ring" line with what was initially called "Hostess Ware": (clockwise) tray, 15", 2 quart pitcher, coffee/tea cup & saucer, large coffee cups, coaster, 4", shaker, small open sugar & creamer.

The clip-on wood handles on these kitchen items were patented. Baking dish, 8¾", and pie plate, 11", in delphinium blue, baking dish, 6¼", in jade green, pie plate, 11", in Pacific blue. Early in-mold "Pacific" marks.

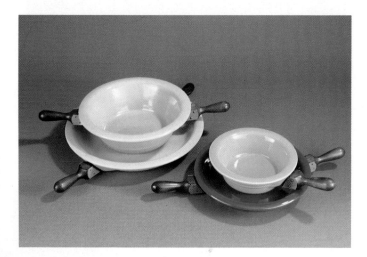

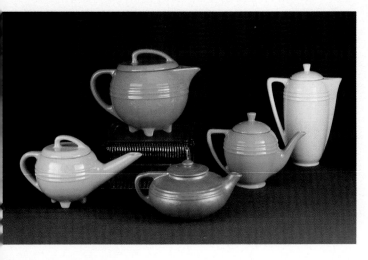

Streamlining with style from Pacific: (row 1) early footed design teapot in apricot, later design teapot in jade green, after-dinner coffee pot in Sierra white; (row 2) footed teapot with long spout in lemon yellow, low individual teapot in Apache red. In-mold marks.

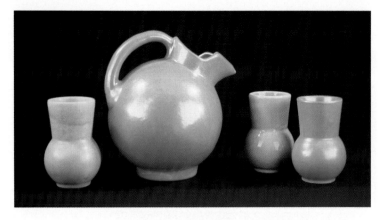

Early ball jug with matching 5" tumblers.

Some of the many hand-painted patterns available on Pacific ware in the mid thirties: (front to back) "Spiral" salad plate, "Plaid" dinner plate, "Wave" dinner plate, "Spoke" dinner plate. (Author's names.)

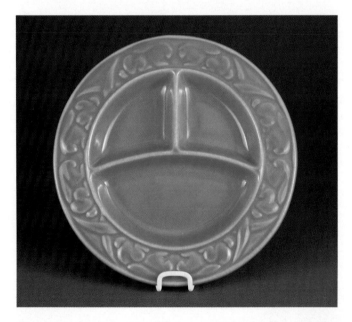

Divided baby plate, 9", with bunny design border, c. 1934.

Floral artware of the early thirties: handled low vase, 5", vase, 11½", vase, 8¼", vase, 7".

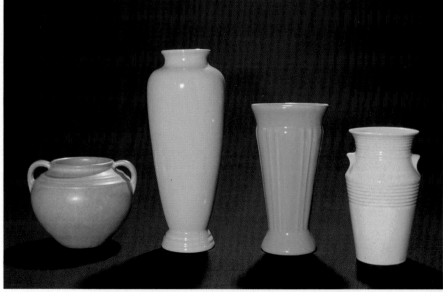

California Pottery

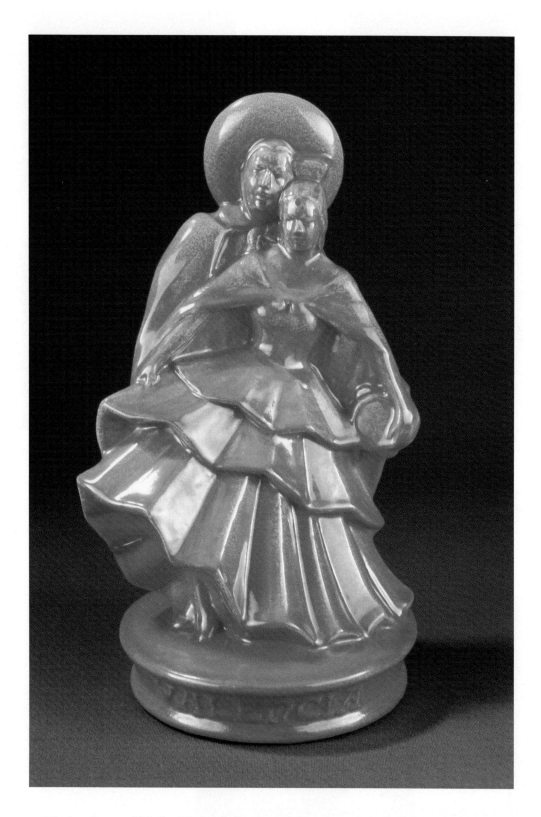

Display figure, 12", for "Valencia" oranges. Apache red glaze of the early thirties.

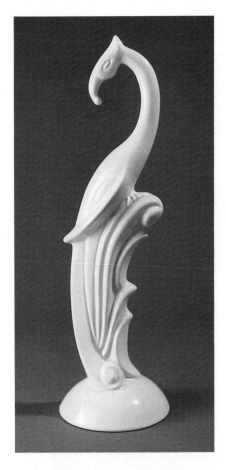

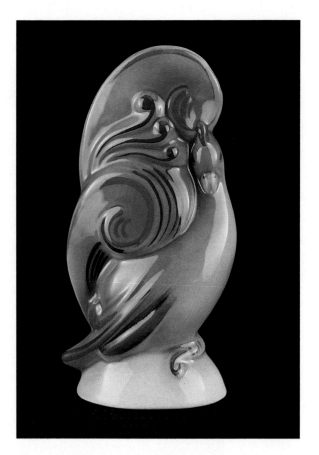

Large stylized bird figurine in satin white. Circular in-mold mark.

Hand-decorated bird motif vase, 8¼". Stamped mark, c. 1939.

Pacific artware: vase, 6¼", bust designed by Bernita Lundy, 7¾", bud vase, 7", vase, 7½".

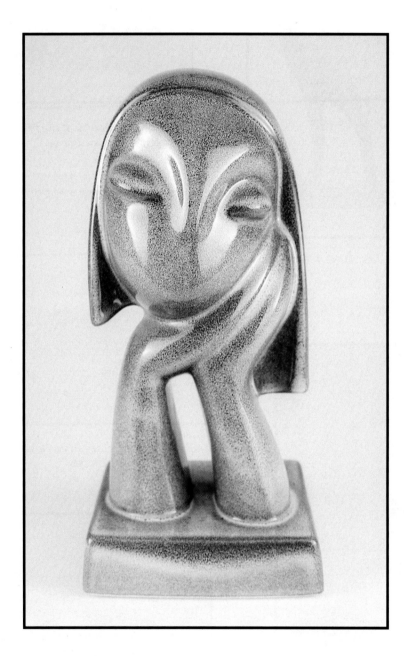

Limited production bust, 10½" brown agate, c. 1956. In-mold mark.

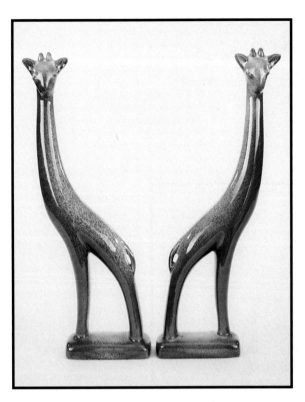

Pair of Howard Pierce giraffes, 10½", brown agate, in-mold marks. Mid fifties.

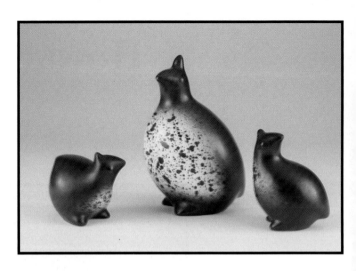

Popular quail family of the fifties period. Large quail, 5½". Stamped "Howard Pierce."

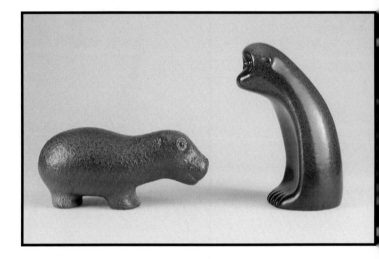

Animals with special glazes: hippo and monkey, each 6" and stamped "Howard Pierce."

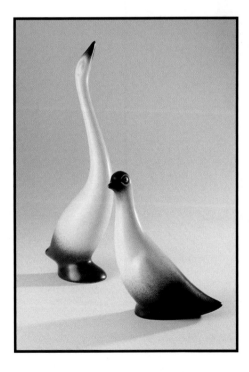

Howard Pierce water bird, 14", pigeon, 7½", (one of two.) Fifties period, stamped marks.

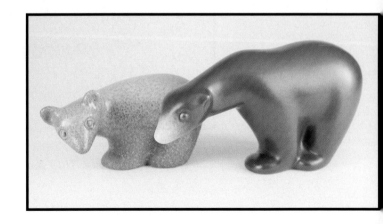

Different bear models of the fifties: bear (has matching cub), 6", special glaze, polar bear, 4½" brown on white.

California Pottery

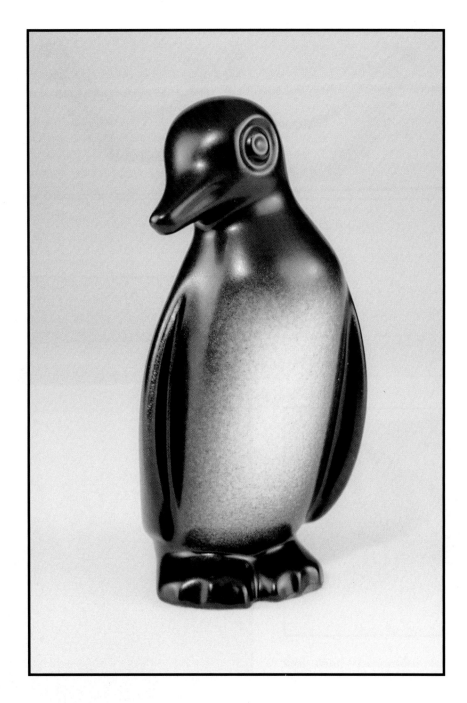

Penguin, 7", black on white, stamped "Howard Pierce," c. 1953.

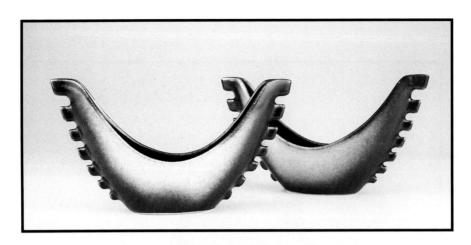

Pair of gondola bowls, 5" x 9½", brown on white.

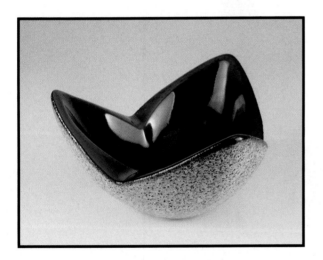

Howard Pierce high-style ashtray with light grey lava glaze outside and cobalt blue high glaze inside.

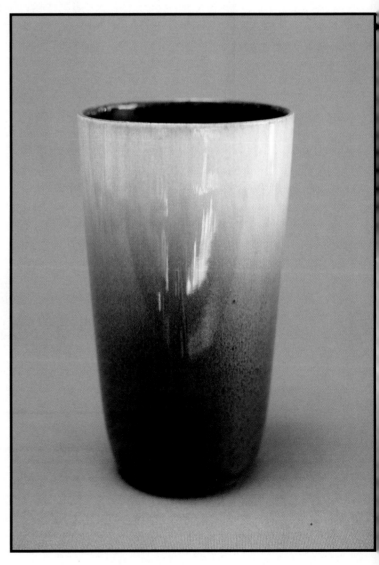

Vase, 7¼", mottled green high glaze, in-mold mark.

California Pottery

Roselane

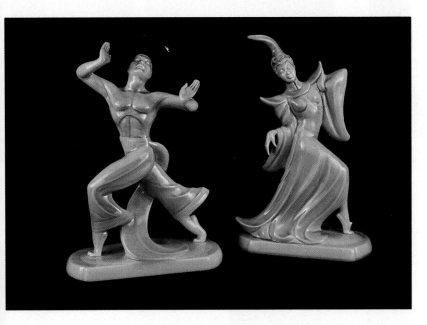

Pair of Roselane Bali dancers: male, 11", female, 11¼", in-mold marks.

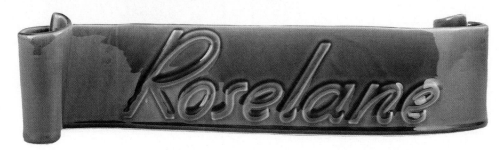

Roselane dealer sign, 3" x 12½", in deep aqua high glaze.

Modern elephant sculpture on wood base, 8", brown luster glaze. "Roselane" logo burned into bottom of wood base. Early fifties.

"Chinese Modern": vase, 8", vase with raised design, 9¾", vase with raised design, 8".

"Chinese Modern" housewares: square pedestal bowl, 2½" x 6¼", figurine, 6", vase, 6¼". Late forties.

Roselane stylized pheasants in Howard Pierce-like brown on white matte glaze: female (tail up), 7¾". Note ceramic seed pearl eyes.

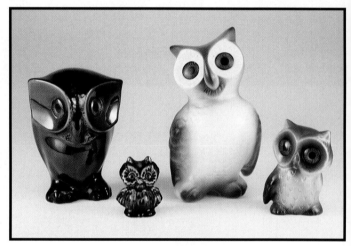

Popular "Sparkler" series owls with plastic eyes: modern owl, 5¼", baby owl, 2¼", large owl, 7", small owl, 3½". Sixties/seventies.

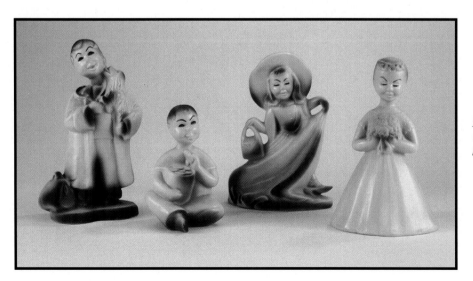

Roselane child figurines: boy with dog (5½"), sitting boy, girl with hat, girl with bouquet. In-mold "Roselane" marks.

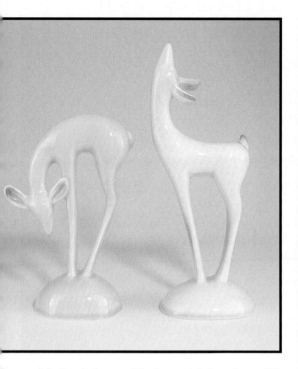

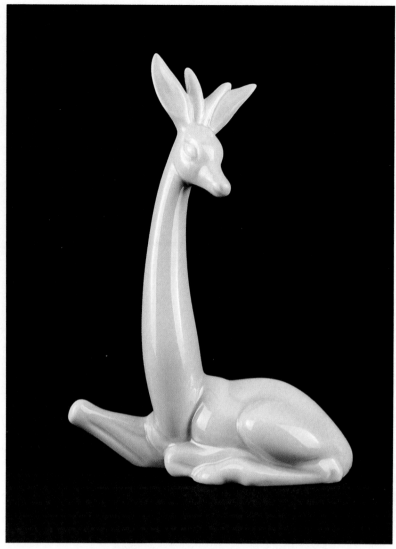

Deer with head down, 6", deer with head up, 8".
Late fifties/early sixties.

Giraffe figurine, 5½", light grey high glaze, c. 1960.

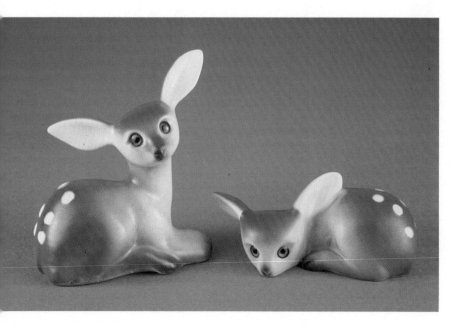

Small-scale "Sparkler" deer, 4" x 3½", with
fawn, satin-matte brown on white, plastic
eyes, c. 1965.

Hedi Schoop

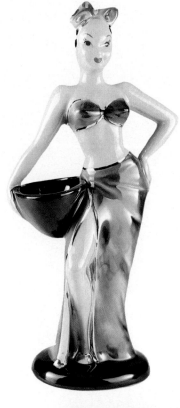

Josephine, 13", holds bowl suitable for small flowers or plants. Stamped mark, c. 1943.

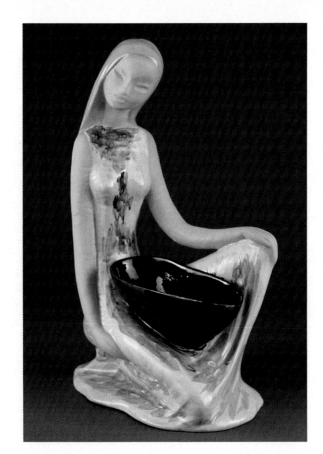

Hedi Schoop called this female figure holding bowl of 1949 "Repose." Tinted bisque with high glaze. Stamped mark.

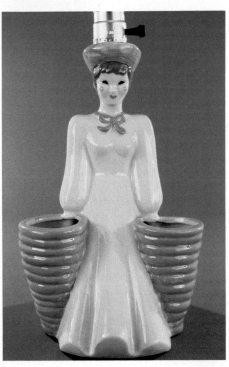

Hedi Schoop "Colbert" (modeled after Claudette Colbert) flower holder-lamp base, 11½", underglaze painted mark, c. 1940.

Mermaid candle holder, 13½". Stamped mark, c. 1950.

Figurine of clown playing cello, 12½", overglaze platinum, stamped mark, c. 1943.

Pair of Siamese dancers introduced in 1947: man, 14½", woman, 14". Tinted bisque with high glaze and overglaze gold. Stamped mark.

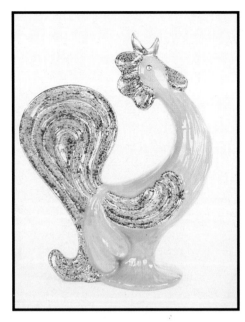

Crowing cock vase, 12", tinted clay body with transparent high glaze and overglaze gold, stamped mark, c. 1949.

King of Diamonds tray, in-mold mark.

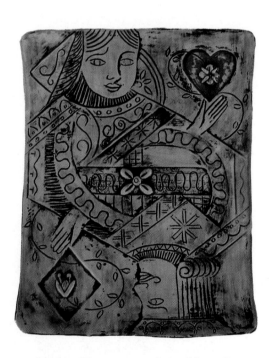

Queen of hearts tray, in-mold mark.

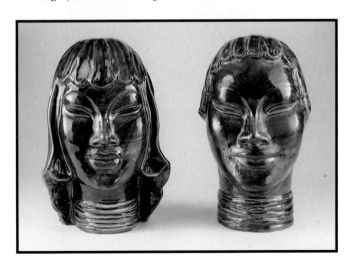

Male/Female pair of Chinese heads from the fifties.

Twin Winton

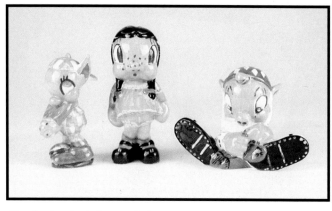

Early Burke-Winton figures: bashful boy elf, 3¼", little girl with pigtails, 4", sitting elf, 2¾", underglaze painted "Burke Winton" marks.

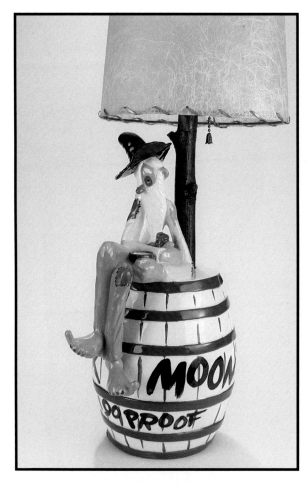

The "Hillbilly" line included this large table lamp, c. 1949.

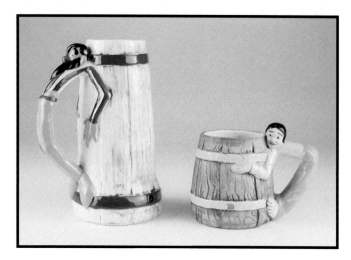

"Hillbilly" line tankard and early (partially unglazed) mug.

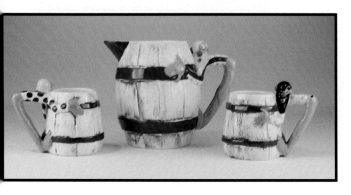

Figural-handled pitcher and mugs from the popular "Hillbilly" line of Twin Winton.

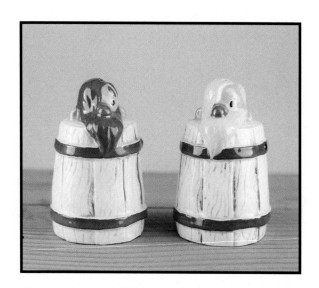

Twin Winton "Hillbilly" salt and pepper shakers.

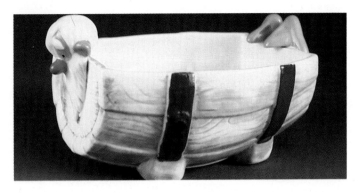

"Hillbilly" ice bucket. In-mold mark.

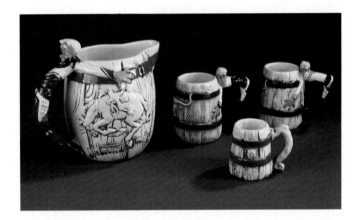

The "Open Range" line included this pitcher and mugs. Late forties.

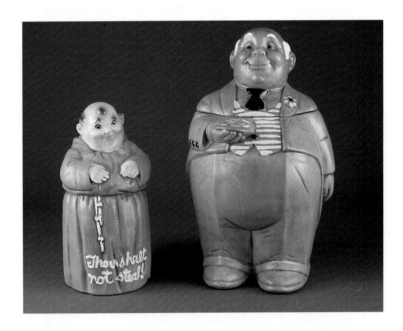

Friar bank and Butler cookie jar in woodtone finish. In-mold marks of the sixties/seventies period.

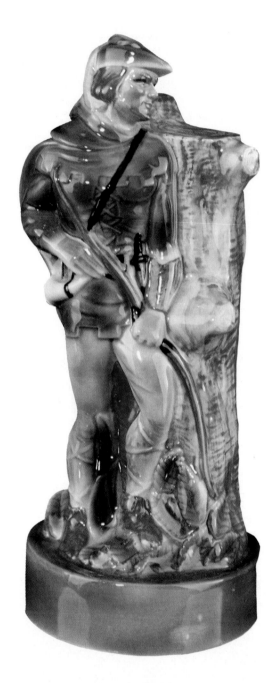

Robin Hood porcelain liquor decanter modeled by Don Winton and manufactured by Winfield.

Vernon

Jane Bennison designed this nesting set of "Ring Bowls": #1 blue, 11¾", #2 ivory, 10", #3 pink, 8". Stamped "Bennison" mark, c. 1935.

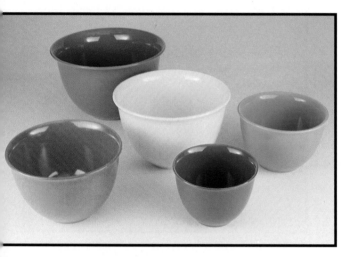

Early California" mixing bowl set in mixed high glaze colors.

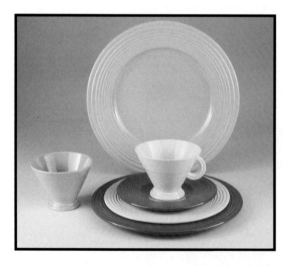

The "Rhythmic" dinnerware created by May and Vieve Hamilton: plate, 10½", tumbler, cup & saucer, plate, 7½", plate, 9½". Stamped "Hamilton" mark, c. 1935.

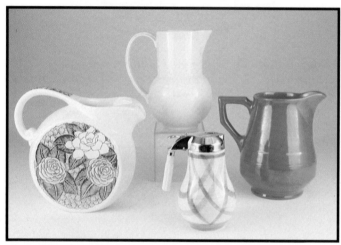

Pitchers by Vernon Kilns included: Don Blanding's "Ecstasy" pattern 2 quart disk pitcher, "Early California" 1 quart pitcher, "Early California" 3 pint jug, and "Calico" pattern syrup pitcher.

g cup lineup: "Modern California," "Early California," Iulti Flori" pattern by Harry Bird, and "Casa California" ttern by Gale Turnbull.

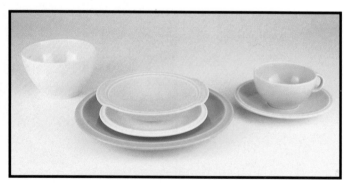

"Ultra California" dinnerware: 1 pint bowl in buttercup, luncheon plate, 9½", in aster, bread & butter plate, 6½", in gardenia, chowder bowl, 6", in carnation, cup & saucer in ice green.

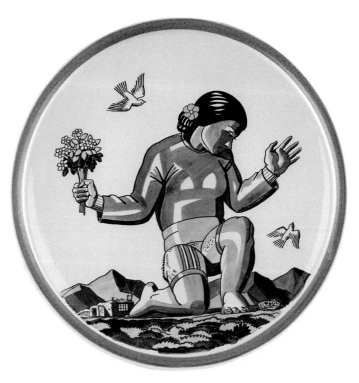

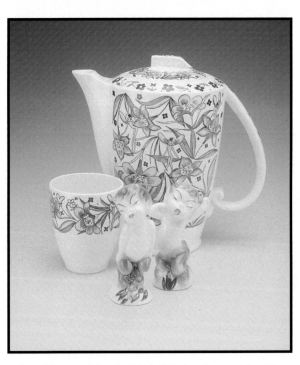

Rockwell Kent's "Salamina" dinnerware line of 1939 included this 17" chop plate, Enhanced transfer-printed design, stamped "Kent" mark.

Walt Disney lines of 1940 from the movie "Fantasia": "Nutcracker" 6 cup coffee pot and mug with 4½" satyr figurines. Stamped "Disney" marks. Tony Cuñha photo.

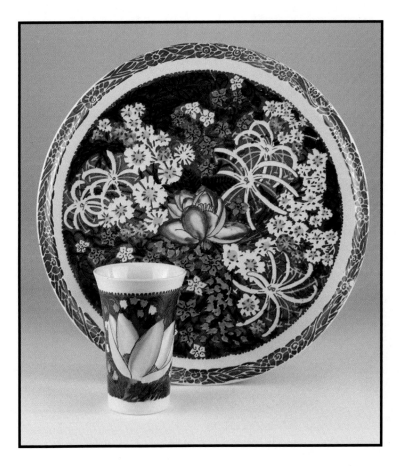

Don Blanding's "Lei Lani" 14" chop plate and "Hawaiian Flowers" ice tea tumbler. Enhanced transfer-printed designs, stamped "Blanding" marks.

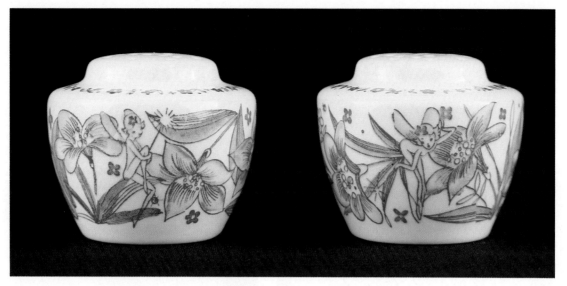

Disney's "Dewdrop Fairies" salt & pepper shakers of 1940.

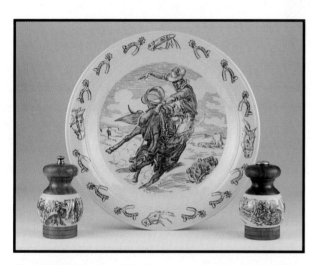

The "Winchester 73" dinnerware pattern designed by Paul Davidson included this 13" chop plate and large ceramic/wood shakers, c. 1950. Stamped mark.

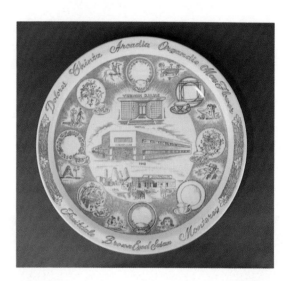

This 8½" plate commemorated the opening in 1948 of Vernon Kiln's newly rebuilt factory in Vernon. Artwork by L. Hicks.

Hollywood souvenir plate, 10½", by Vernon Kilns, c. 1940.

"Chatelaine" is what Sharon Merrill's dinnerware design of 1953 was called. Dinner plate, 10½", and tea cup & saucer in platinum.

Wallace China

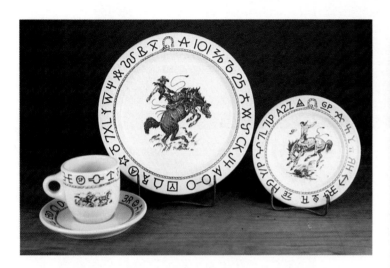

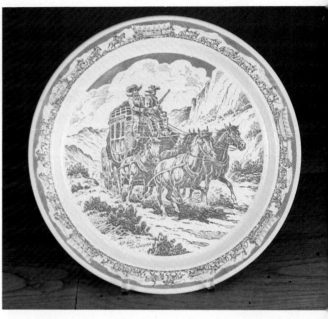

Popular "Rodeo" pattern by Till Goodan was part of the "Westward Ho" line produced by Wallace China: cup (7½ oz.) & saucer, dinner plate, 10¾", bread & butter plate, 7¼". Stamped marks.

"Pioneer Trails" 13" chop plate. Artwork by Till Goodan. Stamped mark with "Apple Valley Ranchos" added.

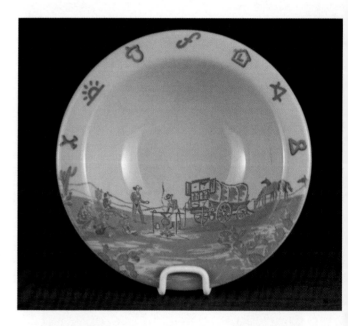

Wallace China hibiscus pattern dinner plate.

"Chuck Wagon" restaurant china bowl, 6¾". Stamped mark, dated 1955.

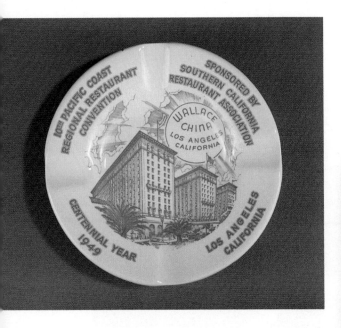

Commemorative ashtray picturing Los Angeles' Biltmore Hotel. Stamped mark, dated 1949.

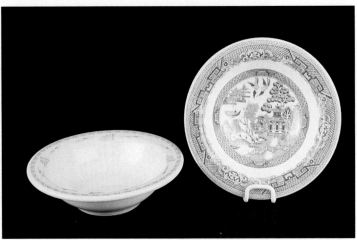

"Desert Ware" restaurant line bowls. Traditional "Blue Willow" pattern in brown on right. Stamped marks.

Plate displaying the colors available for pattern decoration. Stamped mark.

Ashtray with Christmas greetings from the Wallace China company. Stamped mark, c. 1950.

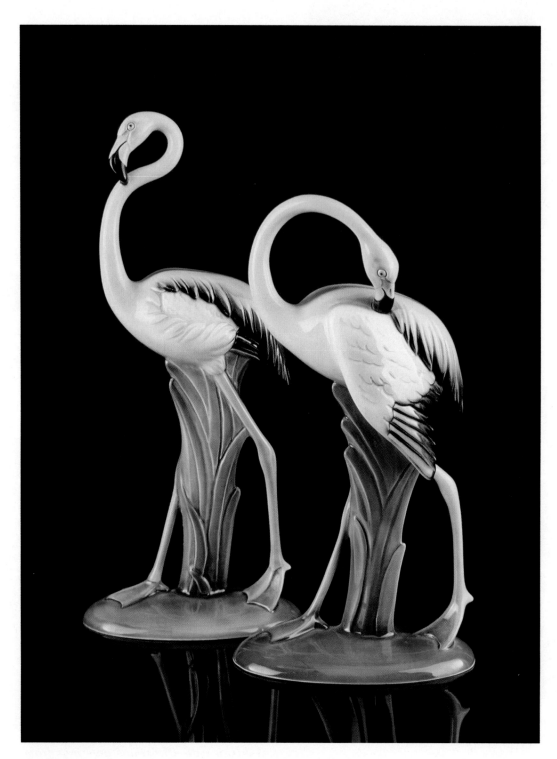

*Will-George's elegant, naturalistic flamingos: male, 11½", female (head in wing), 10".
Stamped marks. c. 1945.*

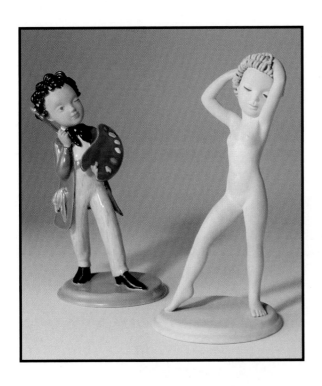

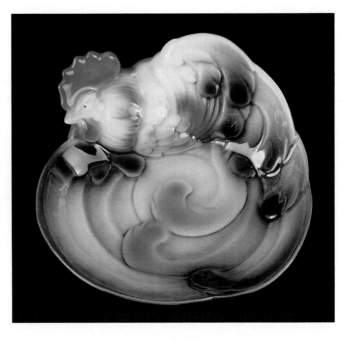

Child-like artist and model set of figurines. Incised marks, c. 1939.

Small rooster tray by Will-George. Stamped mark.

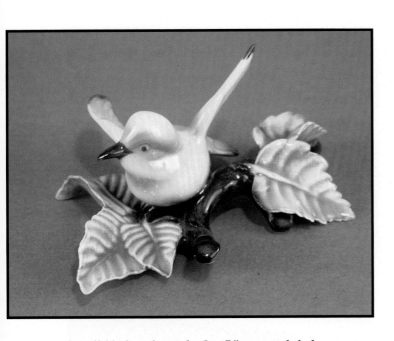

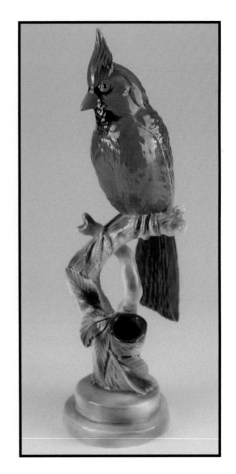

Small bird on branch, 2 x 5", paper label.

Cardinal on branch, 12", stamped mark.

Dachshund, 6½" x 9", stamped mark, c. 1945.

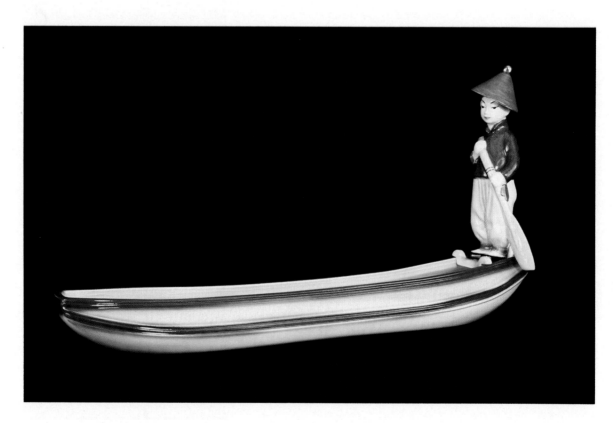

Long, low gondola-shaped flower bowl with detachable Chinese boy oarsman figure of the late forties. Stamped mark.

California Pottery

Winfield

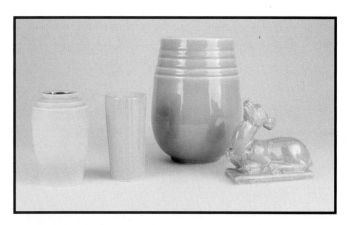

Winfield porcelain artware of the thirties: vase, 4¾", vase, 4¼", vase, 8½", deer, 4¼" x 4¾". Impressed "Winfield" marks.

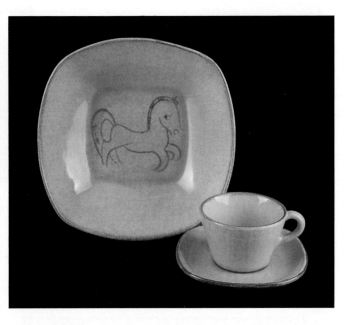

The "Primitive Pony" pattern: 9" square design serving bowl, cup & saucer. Incised "Gabriel" mark.

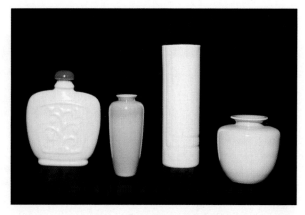

Early artware: bottle with stopper, 6¾", vase 5¼", cylinder vase, 8½" (from 3 piece stepped set), vase, 4". Impressed "Winfield" marks.

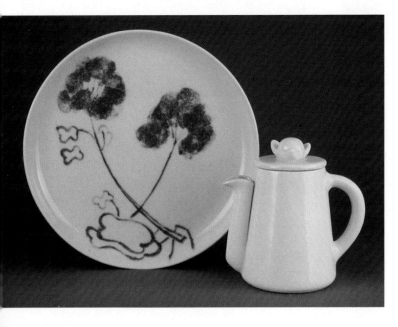

Round design dessert/breakfast plate, 8½", in hand-painted "Geranium" pattern along with undecorated individual coffee pot. Incised "Winfield" marks.

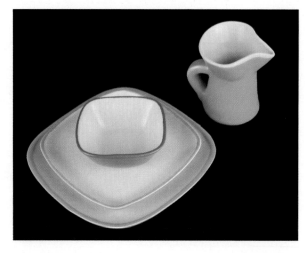

Winfield's square design dessert/breakfast plate, 9", salad plate, 7½", dessert bowl, 4¾", with small cream pitcher. Impressed "Winfield" marks.

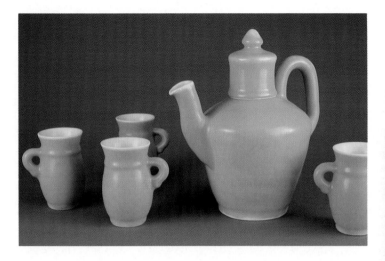

Early hot chocolate set included covered server and small handled mugs. Impressed "Winfield" marks.

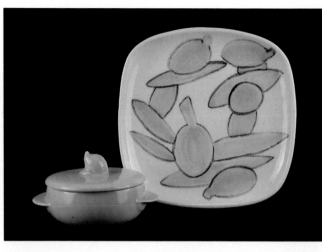

Individual casserole in chartreuse along with 9" square plate with hand-painted fruit pattern. Incised "Gabriel" marks.

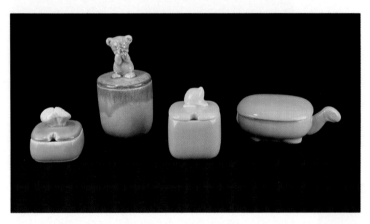

A few of the many Winfield accessories: covered mustard jar, covered honey jar (note bear knob), covered jam jar, and turtle shaped cigarette box. Various period marks.

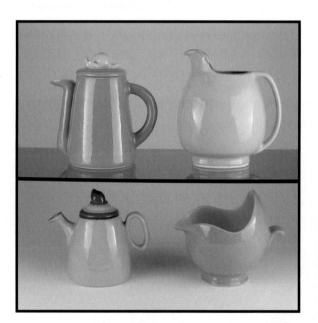

Winfield casual porcelain was offered in a variety of glaze color combinations: (row 1) coffee pot in yellow-sage, 1 quart pitcher in chartreuse-olive rim; (row 2) coffee/tea pot in azure-brown rim, scuttle in yellow-sage. Various marks.

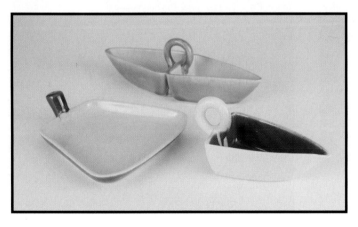

More accessory items: double boat-shaped relish, scoop, 7½", single boat-shaped relish. Various marks.

Additional Companies

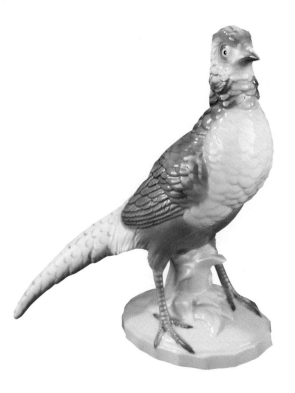

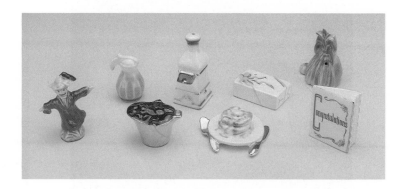

ARCADIA CERAMICS miniature novelty salt & pepper shaker sets. Try matching them up. All under 2". Tony Cünha photo.

BALL ARTWARE pheasant, 7½", stamped mark. Late forties.

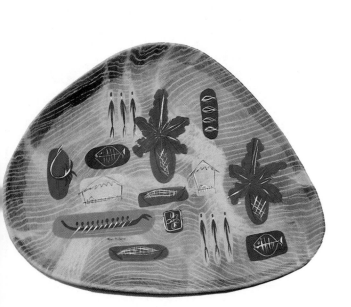

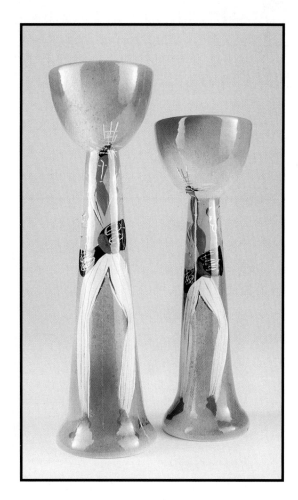

Large "Friendly Island" freeform tray by MARC BELLAIRE, a contemporary of Sascha Brastoff. Hand-painted decoration with overglaze gold, signed "Marc Bellaire." Mid fifties.

MARC BELLAIRE fifties period candlesticks. Candlestick on left is 10½". Both signed "Marc Bellaire."

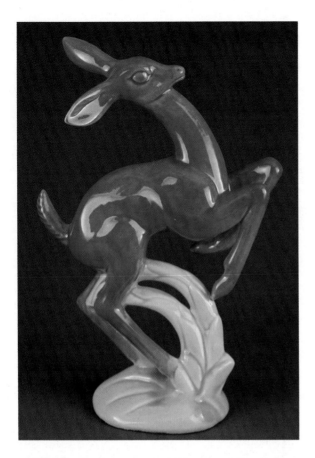

CEMAR deer figurine, 11¾", brown flocking on base. Late forties.

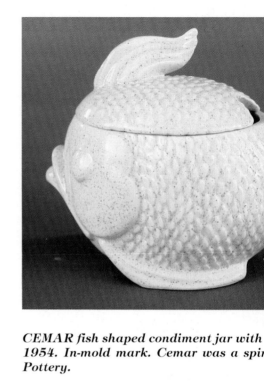

CEMAR fish shaped condiment jar with notched cover, 1954. In-mold mark. Cemar was a spinoff of the Bau Pottery.

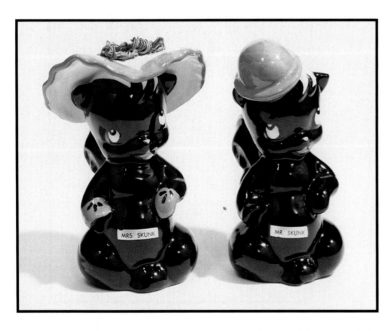

DE LEE ART hand-painted "Skunkettes": Mrs. Skunk on left, Mr. Skunk on right. Late forties.

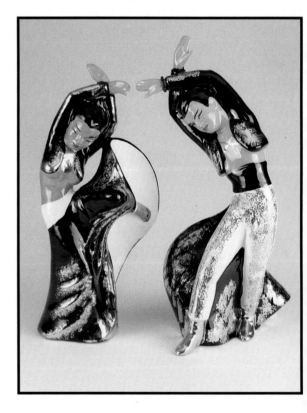

DE LEE ART Latino dancers of the early fifties: female, 11½", male 12½". Hand-painted decoration with overglaze gold, in-mold marks.

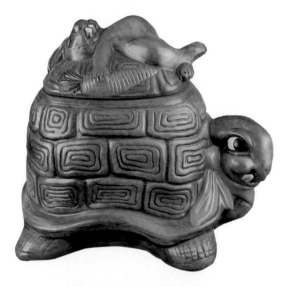

DORANNE OF CALIFORNIA tortoise & hare cookie jar. Endemic woodtone finish, c. 1970.

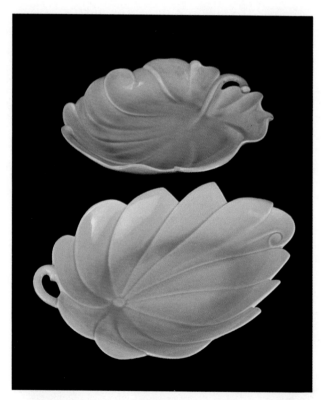

GUPPY'S "Island Ware" shaker, flared tumbler with hand-coiled base, and bamboo shaped tumbler or vase. Late forties.

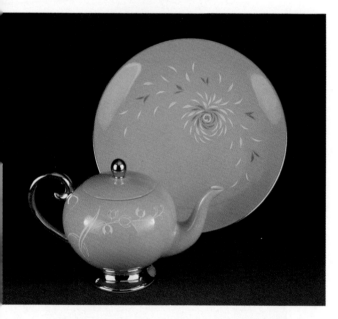

Examples of the fine china produced by FLINTRIDGE CHINA of Pasadena: dinner plate and tea pot with overglaze silver trim. Stamped marks.

Two examples of HAROLD JOHNSON'S elegant low flower bowls: (top) 13¾" x 12", (bottom) 14" x 10¼". Incised "Harold Johnson" in script, c. 1948.

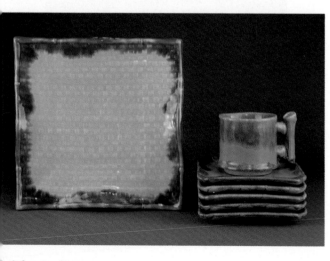

Exotic "Island Ware" of the forties by GUPPY: service plate, stacked saucers and cup. Painted marks.

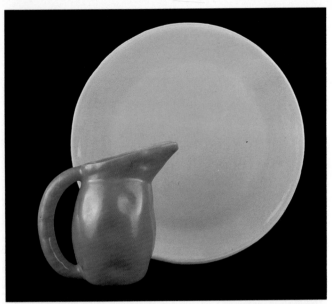

LA CAÑADA handmade dinner plate and small pitcher. Incised marks, c. 1935.

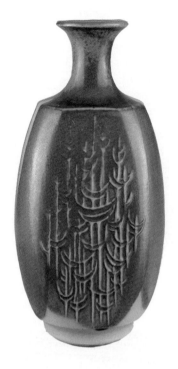

Stoneware vase circa 1960 by ROBERT MAXWELL. Paper label.

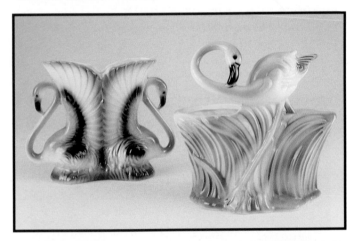

MADDUX'S flamingo line of the early fifties included this double flamingo vase, 5", and single flamingo planter, 6". In-mold marks.

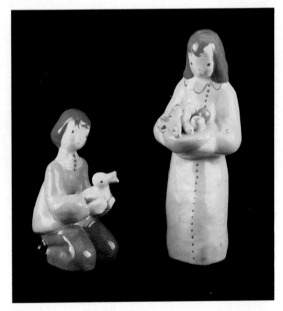

JEAN MANLEY'S handmade figurines: seated boy holding duck, 4", girl holding bowl of fruit, 5¾". Late forties.

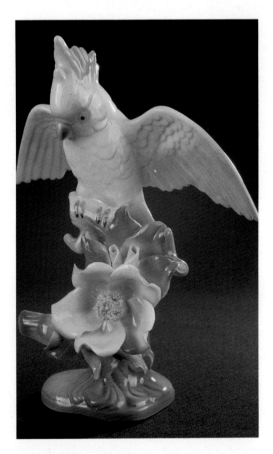

Cockatoo on floral trimmed branch, 11", by WILLIAM MADDUX, c. 1947. In-mold "Wm. Maddux."

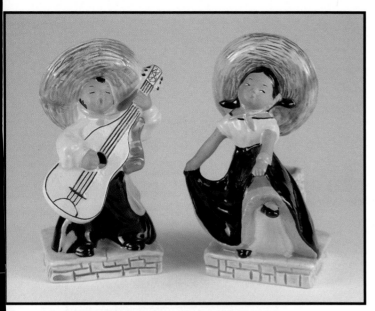

Charming set of McCARTY BROTHERS Mexican children planters of the mid forties. In-mold marks.

PADRE honey jar in maroon high glaze. In-mold mark.

POXON'S Mission vase, 10¼", was produced in a light colored bisque finish with glaze inside only. Impressed "Poxon Los Angeles." Marker reads: "El Camino Real." c. 1920. Bauer and Padre produced later versions of this design.

PADRE calla lily wallpocket, 7", satin-matte cobalt blue glaze, c. 1939. In-mold mark.

California Pottery

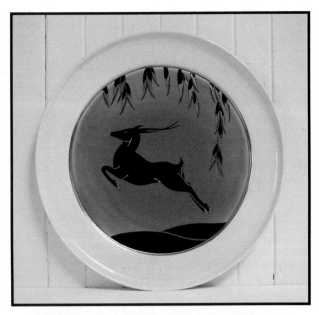

ROBERTSON hand-decorated 10½" plate of silhouetted antelope. Artwork by George Robertson. Signed "Robertson Hollywood 149."

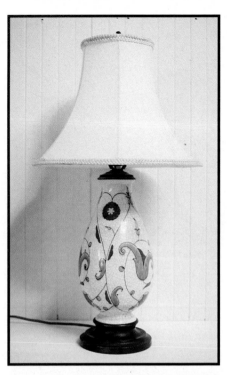

Table lamp by the ROBERTSON POTTERY c. 1945. Ceramic base measures 11½". White crackle high glaze with hand-painted design. Signed "Robertson Hollywood."

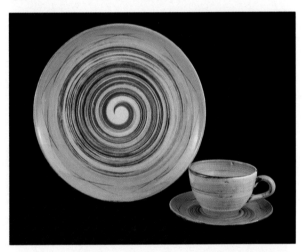

From the "Vreniware" line by SANTA ANITA: "Stylized Spirals" pattern 10½" dinner plate and cup & saucer. Fifties period stamped marks.

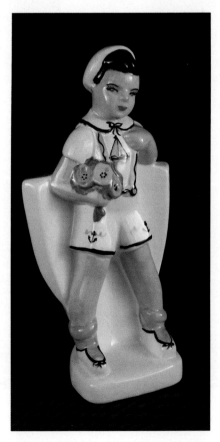

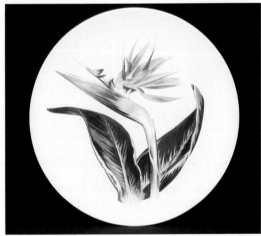

"Bird of Paradise" 10½" dinner plate from SANTA ANITA'S "Flowers of Hawaii" series of the fifties. Stamped mark.

WEIL sailor boy vase, 10¾". Hand-decorated, c. 1943. Stamped mark.

California Pottery

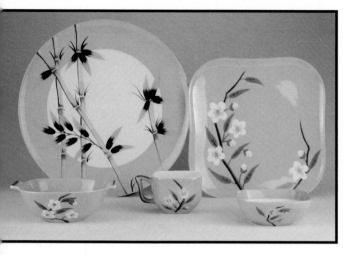

Dinnerware of the late forties by WEIL: "Malay Bambu" round design 13" chop plate with "Malay Blossom" square design dinner plate, 9¾", lug soup, cup and fruit bowl.

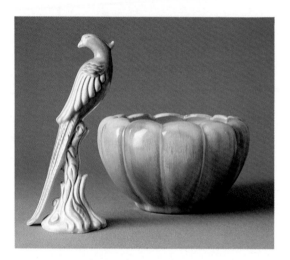

WEST COAST stylized pheasant, 7¾", and rose bowl, 4¼". In-mold mark on bowl.

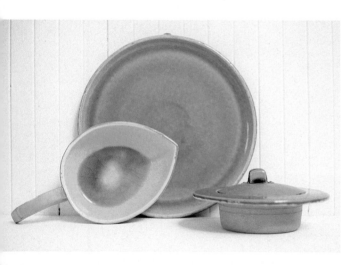

Utilitarian artware by EUGENE WHITE: tray, 11" (dated 1942), handled dish, 2¾" x 11", and small bowl with hammered copper lid. Incised "Eugene White."

VALLY WERNER hand-decorated vase, 7½", c. 1949. Incised "Vally."

Jennifer figurine, 5½", by YNEZ. Hand-decoration with added hair curls and lace trim, c. 1946. Incised mark.

Vase with under tray, 8" x 7¾", and small round jar (cover missing) from the studio of VALLY WERNER, c. 1942. Incised. "Vally."

BARBARA WILLIS' distinctive floral artware: jug vase, 7", vase, 6", vase, 4½". Forties period incised marks.

California Pottery

Glossary

Over the years that I have been a dealer it has become apparent that many pottery collectors, especially beginners, are unfamiliar with the terminology of the ceramic industry. The following glossary is included for them.

Airbrush Decoration — Decorative process whereby an atomizer employing compressed air is used to spray paint in a fine mist.

Bisque — Ware which has been fired but not glazed.

Body — Structure of a ceramic object.

Cast — See slip cast.

Ceramics — All-inclusive term for the art of making objects of fired clay.

China — Ware made from a vitrified body. See porcelain.

Clay — Earthy mineral substance composed largely of a hydrous silicate of alumina which becomes hard and rock-like when fired.

Crackle Glaze — Decorative glaze having intentional crazing (a fine network of cracks) which is sometimes augmented with stain.

Decal Decoration — Process of decorating china or other types of ware with printed decals. Also known as decalcomania.

Earthenware — Relatively low-fired pottery, usually buff, red or brown in color.

Engobe — A layer of slip applied to objects to alter body color.

Faience Tile — Polychromed decorative tile. Originally the tin-glazed ornamental earthenware of Faenza, Italy.

Finishing — Process of removing mold marks and rough edges from cast ware prior to firing.

Glaze — Glass-like coating on a clay surface.

Green — Ware that is dry but unfired.

Hand Thrown — Objects formed by hand on a potters wheel.

Jiggered — Objects formed between a revolving mold which shapes the inside and a template which shapes the outside. Semi-automated pottery.

Jobber — Individual or organization which obtains ware directly from producers (sometimes under exclusive contract) and sells it to retailers.

Kaolin — Relatively scarce, non-plastic type of clay which is indispensable in the making of porcelain.

Kiln — Oven designed specifically for the high temperatures required for baking and glazing clay objects.

Metallic Oxide — Elemental mineral combined with oxygen which is used to impart color to glazes or clay bodies.

Modeling — Process of sculpting an original object from which molds are made for production purposes.

Mold — A hollow plaster of Paris form into which plastic clay is pressed or liquid clay is poured.

Periodic Kiln — Kiln in which ware is heated in a gradual cycle and allowed to cool before removal.

Porcelain — Objects made from a white, vitrified and translucent body. Popularly called china.

Pottery — Objects, especially vessels, which are made from fired clay. General term that includes earthenware, stoneware and porcelain.

Press Molded — Objects which are duplicated by hand-pressing thin slabs of clay into plaster molds.

Ram Press — Fully automated machine for mass-producing clay objects.

Short Set — Basic dinnerware service lacking most or all of the accessories.

Slip — A fluid suspension of clay and water used for casting and decorating.

Slip Cast — Objects which are duplicated by pouring liquid clay into plaster production molds.

Slip Decoration — Underglaze decorative process employing colored slip as a painting agent.

Stoneware — Semi-vitrified pottery made from clay which is dense and usually light in color. Non-translucent.

Talc — Fine-grained mineral which is used instead of clay to produce a body especially suited to commercial production.

Tunnel Kiln — A continuously operating, tunnel-like kiln in which ware is moved through varying heat zones on slow-moving flat cars or slabs.

Vitrified — Ware which has been fired at a very high temperature to the point of glassification.

Credits

These generous collectors and dealers loaned key examples of
California Pottery to be photographed for this book.

Melinda Avery, *Metlox Potteries, Manhattan Beach*
Sharlene Beckwith
Fred and Ruth Eilenfield
Delleen Enge, *Franciscan Matching, Ojai*
Jeanne Fredericks
Van Fryman and Paul Lenaburg
Norman Haas
Wilbur and Virginia Held
Gary Keith
Cynthia Kern
Betty Lopez, *Holly Street Bazaar, Pasadena*
Gary and Caroline Kent
Bill Kochanski
Jack Moore, *Jack Moore Gallery, Pasadena*

Stan Palowski
Jerry Robin and Melanie Peterson
Keith Robinson, *Manhattan Beach Historical Society*
P.A. Roswell
Bob Schmid
Carl and Maire Schrenk
Jack Shafer
Judy Stangler
Alvah Stanley, *Slightly Crazed, Los Angeles*
Bill Stern
Baron Stoelting
Marilyn Webb
Helen Wenko
Buddy Wilson, *Buddy's, Los Angeles*

Although most of the photography was undertaken by the author, the
following photographers contributed to this book. In addition a
number of photos are of archival nature, drawn from public and
private sources. The photographers in these instances are unknown.

Tony Cuñha
Roger Gass
Bruce Handelsman
Richard N. Levine
C.L. McClanahan
Julius Shulman

Bibliography

Abelson, Cheryl A.; *Hagen-Renaker Collector's Catalog.* (privately printed, 1980.)

Anderson, Timothy J.; Eudora M. Moore; Robert W. Winter, eds., *California Design 1910.* (Santa Barbara/ Salt Lake City: Peregrine Smith, 1980.)

Bray, Hazel V.; *The Potter's Art In California: 1885-1955.* (The Oakland Museum, 1980.)

Chipman, Jack; Judy Stangler, *The Complete Collectors Guide To Bauer Pottery.* (Culver City, CA: California Spectrum, 1980.)

Derwich, Jenny B.; Mary Latos, *Dictionary Guide To United States Pottery & Porcelain.* (Franklin, MI: Jenstan, 1984.)

Enge, Delleen, *Franciscan Ware.* (Paducah, KY: Collector Books, 1981.)

Evans, Paul, *Art Pottery Of The United States.* (New York: Charles Scribner's Sons, 1974.)

Fridley, A.W., *Catalina Pottery: The Early Years 1927-1937.* (Long Beach, CA: Privately printed, 1987.)

Held, Wilbur, *Collectable Caliente Pottery.* (Claremont, CA: privately printed, 1987.)

Henzke, Lucile, *Art Pottery Of America.* (Exton, PA: Schiffer Publishing, 1982.)

Lehner, Lois, *Complete Book Of American Kitchen and Dinnerwares.* (Des Moines: Wallace-Homestead, 1980.)

Lehner, Lois, *Lehner's Encyclopedia Of U.S. Marks On Pottery, Porcelain & Clay.* (Paducah, KY: Collector Books, 1983.)

Nelson, Maxine, *Versatile Vernon Kilns (Book II).* (Paducah, KY: Collector Books, 1983.)

Rhodes, Daniel, *Clay And Glazes For The Potter.* (Philadelphia: Chilton, 1957.)

Roller, Gayle; Kathleen Rose; Joan Berkwitz, *The Hagen-Renaker Handbook.* (Vista, CA: privately printed, 1989.)

Stiles, Helen E., *Pottery In The United States.* (New York: E.P. Dutton, 1941.)

Interviews

Sascha Brastoff
Herb Brutsché
Carlotta (Mrs. George) Climes
Frances (Mrs. Will) Climes
Kay Finch
Betty Davenport Ford
Douglas and Claudia Gabriel
Anna (Mrs. Virgil K.) Haldeman
Bunny (Mrs. Thomas F.) Hamilton
Ida Harris
Victor Houser

Tracy Irwin
Marie (Mrs. Harold) Johnson
Phil Keeler
Brad Keeler Jr.
William Manker
Howard Pierce
John and Maxine Renaker
Hedi Schoop
Richard Steckman
Roger (Bud) Upton
Don and Bruce Winton

Price Guide

Although it's been said many times, many ways, a price guide is simply a guide. It should not be a substitute for knowledge or experience!

Of all the factors influencing pricing, the most critical is the degree of desire on the part of a purchaser. It is the demand for a particular item which finally determines its value. Scarcity would follow as the second most important criteria. After these, condition is considered.

Prices given in this book are for ware in near-mint to mint condition, meaning: no chips, cracks, or obvious signs of wear and tear. Prices also reflect first grade, meaning: no factory flaws like underglaze chips, uneven glaze application, unfin-ished mold lines or warpage. A moderate amount of crazing is acceptable on artware and to a lesser degree on dinnerware. In the case of rare pieces, a buyer may overlook these factors for the sake of adding a highly sought example to his or her collection. Again, it is demand which ultimately determines price.

Geographic location is the final factor to consider. The prices given in this book largely reflect a specific market (California). The high end is especially indicative of the localized demand. Unless one is mail-order selling, the supply/demand factor of one's particular region must be carefully considered.

Pg.	Item	Price
13	Batchelder landscape tree tile	$125.00-175.00
15	"Ring" covered water jug & tumblers	$200.00-250.00
	ea.	$15.00-20.00
	Bauer "Ring" ware pitcher/mugs	$200.00-250.00
	ea.	$75.00-100.00
	"Ring" Mixing Bowls (complete)	$225.00-275.00
16	Sascha Brastoff cigarette holder	$35.00-45.00
	Sascha Brastoff lighter	$45.00-60.00
20	Brayton Laguna colored bowls ea.	$50.00-75.00
	Colored mug	$45.00-60.00
	Fighting pirates set	$300.00-400.00
21	Castle piece	$65.00-85.00
30	Kay Finch "Missouri Mule" tumblers ea.	$50.00-75.00
31	Cocker	$300.00-400.00
	Pomeranian (Mitzi)	$225.00-300.00
39	Gladding McBean's "Contours" artware:	
	large twin vase	$50.00-75.00
	tall bottle (stopper missing)	$40.00-55.00
	bird	$50.00-75.00
	"Franciscan Pottery" ashtray	$50.00-75.00
	"Franciscan Ware" 50's dealer sign	$150.00-200.00
	"Franciscan-Cal. Craftsmen since 1875"	$100.00-150.00
	"Franciscan Fine China" dealer sign	$150.00-200.00
42	Mini bunnies ea.	$20.00-30.00
	"Malificent"	$300.00-400.00
45	"Caliente Pottery" low flower bowls ea.	$20.00-30.00
49	14" Lobed vase	$300.00-400.00
51	Metlox Miniatures:	
	Poppytrail dealer sign	$200.00-275.00
	horse	$45.00-60.00
	hippo	$65.00-85.00
	crocodile	$75.00-100.00
	cubistic dog	$75.00-100.00
	reclining bear	$65.00-85.00
	elephant	$100.00-150.00

Pg.	Item	Price
51	standing turtle	$45.00-60.00
	seal	$65.00-85.00
	scottie dog	$35.00-45.00
53	Metlox Leo vase	$100.00-150.00
57	Howard Pierce Native Pair ea.	$65.00-85.00
61	Hedi Schoop Tiny	$75.00-100.00
65	Twin Winton miniature skunk/bear ea.	$25.00-35.00
66	Vernon Kilns figurines from "Fantasia"	
	centaurette #18, 7½"	$650.00-850.00
	pan, 4¾"	$250.00-350.00
	centaurette #22, 8"	$750.00-1,000.00
70	"Eaton's Rancho" dinner plate	$35.00-45.00
71	Wallace China "Westward Ho":	
	Mark Twain ashtray	$75.00-100.00
	cowboy ashtray	$75.00-100.00
	"Kit Carson" ashtray	$75.00-100.00
	"Rodeo" covered sugar bowl	$65.00-85.00
	"Rodeo" cream pitcher	$45.00-60.00
	Wallace China "Boots & Saddle" & "Rodeo"	
	pattern 13" chop plates ea.	$200.00-275.00
73	Will-George brown cocker spaniel	$150.00-200.00
	Will-George black cocker spaniel	$150.00-200.00
74	"Flower Vendor"	$125.00-175.00
75	Pink cockatoo	$100.00-150.00
78	American Pottery Bambi	$150.00-200.00
80	American Pottery Elmer Fudd	$45.00-60.00
	American Pottery Bugs Bunny	$75.00-100.00
81	La Mirada Pottery candle holder	$15.00-20.00
	vase	$25.00-35.00
	Oriental Man	$30.00-40.00
	vase	$25.00-35.00
	water buffalo planter	$30.00-40.00
	mandarin figure	$30.00-40.00
	Oriental child planter	$25.00-35.00
	fish wall pocket	$45.00-60.00

Pg.	Item	Price
81	La Mirada Potttery cock	$50.00-75.00
82	Winfield China "Bird of Paradise" plate	$12.00-15.00
	cup & saucer	$18.00-25.00
	coffee pot	$45.00-60.00
	"Bird of Paradise" mug	$15.00-20.00
	"Dragon Flower" plate	$12.00-15.00
	"Desert Dawn" mug	$12.00-15.00
	"Blue Pacific" cheese dish & cover	$45.00-60.00
	"Desert Dawn" 14" Chop plate	$45.00-60.00
	coffee pot	$40.00-55.00
	cup & saucer	$15.00-20.00
	covered sugar	$15.00-20.00
	creamer	$9.00-12.00
	"Daffodil" dinner plate	$9.00-12.00
	"Apple" cup & saucer	$12.00-15.00
83	Batchelder medieval hunt 4" tile	$100.00-150.00
	Bud with leaves tile 3"	$75.00-100.00
	Unglazed medieval landscape tile 4"	$85.00-125.00
	Unglazed 3½" hexagonal tile	$150.00-200.00
	4" Medieval hunting scene tile	$100.00-150.00
	3" patina glazed grapevine tile	$60.00-80.00
	6" peacock tile	$150.00-200.00
84	6" Hispanic tile	$75.00-100.00
	Oblong vase	$125.00-175.00
	Low bowl	$75.00-100.00
	Batchhelder Ceramics:	
	6" vase	$125.00-175.00
	9½" vase	$200.00-250.00
	7" vase	$100.00-200.00
	3" bowl	$75.00-100.00
	4¾" x 5½" vase	$75.00-100.00
	Batchelder 6" vase	$125.00-175.00
	Flared bowl	$75.00-100.00
85	Bauer "Ring" ball jug	$200.00-275.00
	"Ring" covered beater pitcher	$250.00-300.00
	"Gloss Pastel Kitchenware":	
	4 cup teapot	$85.00-125.00
	plain individual coffee pot	$65.00-85.00
	6 cup teapot with wood handle	$75.00-100.00
	"Ring ware":	
	covered baking dish ... (black only)	$75.00-100.00
	4" individual casserole	$100.00-150.00
	cigarette jar	$200.00-275.00
	mustard jar	$200.00-275.00
	"Hi-Fire" style custard cup	$20.00-25.00
	standard custard cup ... (black only)	$40.00-55.00
	berry dish	$18.00-25.00
	lug soup	$60.00-80.00
	cover	$60.00-80.00
	soup plate	$60.00-80.00
	cereal bowl	$40.00-55.00
	refrigerator stack set . (complete)	$200.00-275.00
	casserole in rack	$100.00-150.00
	#3 spice jar	$150.00-200.00
	cookie jar	$200.00-275.00
	"Ring" cylinder vase	$75.00-100.00
	salt & pepper shakers	$25.00-35.00
	covered sugar	$40.00-55.00
	creamer	$25.00-35.00
	goblet	$85.00-125.00
	coffee cup & saucer	$45.00-60.00
	dinner plate	$60.00-80.00
	salad plate	$40.00-55.00
	cereal bowl	$40.00-55.00

Pg.	Item	Price
85	"Ring" 6 cup teapot	$85.00-125.00
	with 6" bread & butter plates ea.	$12.00-15.00
86	8 cup yellow teapot	$150.00-200.00
	Decorative pots:	
	10" lion pot	$150.00-200.00
	8" hanging basket	$200.00-275.00
	6" Indian bowl	$200.00-275.00
	7" Indian bowl	$150.00-200.00
	8" Biltmore jar	$100.00-150.00
	"Hi-Fire" 5" deep flower bowl	$40.00-55.00
	5½" hand-made vase	$60.00-80.00
	rose bowl	$40.00-55.00
	Bauer mixing bowls:	
	#24 Tracy Irwin design	$15.00-20.00
	#24 premium line	$15.00-20.00
	#18 Gloss pastel kitchenware	$25.00-35.00
	#24 "Ring"	$35.00-45.00
	#36 "Hi-Fire"	$20.00-30.00
	#9 early "Ring"	$125.00-175.00
	"Plain" design	$100.00-150.00
	Mat Carlton 9½" vase	$450.00-600.00
	Handled vase	$800.00-1,200.00
	Ruffled vase	$200.00-275.00
87	10" "Cal-Art" ewer	$100.00-150.00
	Bauer dealer sign	$450.00-600.00
	Bauer Floral artware:	
	8" vase #506	$35.00-45.00
	13" vase #678	$65.00-85.00
	8" vase #505	$35.00-45.00
	8½" vase #684	$40.00-55.00
	8" vase #502	$30.00-40.00
	22" #100 oil jar (orange red)	$1,000.00-1,500.00
	"Cal-Art" scottie	$200.00-275.00
	"Cal-Art" hippo	$150.00-200.00
88	9½" Sascha Brastoff native wall mask	$150.00-200.00
	8¼" freeform ashtray	$30.00-40.00
	3¼" x 5½" round domed ashtray	$30.00-40.00
	2¼" x 10" three-footed bowl	$75.00-100.00
	10½" horse figure	$150.00-200.00
	Sascha Brastoff 12" abstract vase	$85.00-125.00
	13½" "Alaska" line	$100.00-150.00
89	10½" "Star Steed" plate	$200.00-250.00
	Circus elephant set	$250.00-350.00
	Enamel ware ashtrays:	
	artichoke shape	$25.00-35.00
	leaf shape	$25.00-35.00
	7" x 9" poodle	$125.00-175.00
	"Winrock" porcelain dinner plate	$35.00-45.00
	"Night Song" salad plate	$25.00-35.00
	6" cereal bowl	$25.00-35.00
	"Alaska" 3½" square dish	$30.00-40.00
	oblong footed dish	$40.00-55.00
90	7½" horse head sculpture	$200.00-250.00
91	Durlin Brayton flower pot	$45.00-60.00
	5½" vase	$75.00-100.00
	8" snake bud vase	$100.00-150.00
	Durlin Brayton 5" pitcher	$75.00-100.00
	5½" teapot	$150.00-200.00
	5½" pitcher	$75.00-100.00
	7¼" loop-handled pitcher	$100.00-150.00
	Durlin Brayton handmade tiles:	
	cats on roof	$75.00-100.00
	fanciful tree	$100.00-150.00
	mushrooms	$75.00-100.00

Pg.	Item	Price	Pg.	Item	Price
91	"Hillbilly Shotgun Wedding"	$450.00-600.00	100	Yorky pup	$200.00-275.00
	9" Mexican man	$85.00-125.00		English village bank	$125.00-175.00
	7¼" x 10" mule	$60.00-80.00		Girl figurine	$60.00-80.00
92	Fox	$50.00-65.00		dog head ashtrays	$45.00-60.00
	St. Bernard	$75.00-100.00	101	Hannibal the angry cat	$200.00-275.00
	Chinese boy & girl set	$95.00-125.00		Yorky pup	$200.00-275.00
	Black children (single figure)	$225.00-300.00		Low flower bowl	$75.00-100.00
	Mexican Peasant couple	$85.00-125.00		"Song of the Sea" ashtray	$25.00-35.00
	3¼" x 6" Sniffing Pluto	$125.00-175.00		9" Footed vase	$45.00-60.00
	Howling Pluto	$150.00-200.00	102	Florence Cynthia figurine	$150.00-200.00
	6½" Pedro	$60.00-80.00		Merrymaids & matching shell bowl:	
	5½" Rosita	$60.00-80.00		Jane	$150.00-200.00
	9" woodtone Toucan	$65.00-85.00		Rosie	$150.00-200.00
	Polychrome Toucan	$85.00-125.00		Betty	$150.00-200.00
93	Abstract man with cat	$200.00-275.00		bowl	$60.00-80.00
94	Catalina Artware of the early thirties:			Boy & girl busts in bisque finish ea.	$75.00-100.00
	handled vase	$300.00-400.00	103	Victoria on divan	$275.00-325.00
	9" vase	$275.00-325.00		Louis XVI figurine	$275.00-325.00
	7½" vase	$300.00-400.00		Marie Antoinette figurine	$275.00-325.00
	7¼" vase	$375.00-500.00	104	Shirley figurine	$150.00-200.00
	covered dish	$200.00-275.00		Priscilla figurine	$200.00-275.00
	bowl	$275.00-325.00		John Alden figurine	$200.00-275.00
	tea tile	$150.00-200.00		6" Kay figurine	$75.00-100.00
	Monk design bookend	$300.00-400.00		Florence dealer sign	$300.00-400.00
	Old Mexico 11½" plate	$450.00-600.00	105	Lace & fur trim ballerinas ea.	$150.00-200.00
	"Submarine Garden" plate	$800.00-1,200.00		7" Violet wallpocket	$100.00-150.00
95	Moorish design 11" plate	$300.00-400.00		Florence figurines of children:	
	Dinnerware designs:			girl holding skirt	$75.00-100.00
	coupe design plate	$35.00-45.00		boy holding ice cream cone	$75.00-100.00
	wide shoulder design dinner plate ..	$35.00-45.00		seashore girl and seashore boy . ea.	$75.00-100.00
	salad plate	$35.00-45.00		Figurine flower holders:	
	"Rope" design dinner plate	$25.00-35.00		girl holding skirt	$35.00-45.00
	punch cup	$30.00-40.00		book girl (June)	$35.00-45.00
	coffee/tea cup	$35.00-45.00		girl holding parasol	$45.00-60.00
	refrigerator jar	$35.00-45.00	106	Freeman-McFarlin Giraffe, 21" male	$60.00-80.00
	cup & saucer	$50.00-75.00		Giraffe, 11" female	$60.00-80.00
	"Rope" design cup & saucer	$30.00-40.00		Mermaid holding shell dish	$45.00-60.00
	hexagonal design creamer	$75.00-100.00		Elephant planter	$35.00-45.00
	Catalina glazes:		107	Pair of amorous cats ea.	$45.00-60.00
	monterey brown tumbler	$30.00-40.00		11¼" vase	$35.00-45.00
	demitasse cup in pearly white	$25.00-35.00		10¾" stemmed vase	$25.00-35.00
	coffee mug in Catalina blue	$35.00-45.00		8" bud vase	$20.00-30.00
	pitcher in Toyon red	$150.00-200.00		Freeman-McFarlin small owl	$35.00-45.00
	Rolled edge design tray	$100.00-150.00		Freeman-McFarlin large owl	$60.00-80.00
	forged iron handle	$200.00-275.00	108	Gladding-McBean "Cocinero" bowl	$45.00-60.00
96	Catalina Island souvenir items:			custard cups ea.	$20.00-30.00
	goat ashtray	$300.00-400.00		"Coronado" placesetting:	
	seal candlelabra	$375.00-500.00		service plate	$15.00-20.00
	bear ashtray	$350.00-450.00		rim soup	$20.00-30.00
	Seashell wallpocket	$150.00-200.00		cup & saucer	$15.00-20.00
	"Rope" design covered sugar	$35.00-45.00		tumbler	$20.00-30.00
	teapot	$100.00-150.00		salt & pepper shakers	$15.00-20.00
	creamer	$25.00-35.00		8½" vase	$60.00-80.00
97	Cleminson pie bird	$25.00-35.00		"Coronado" teapot	$50.00-75.00
	Early egg cups ea.	$30.00-40.00		covered sugar	$20.00-30.00
	Crowing rooster plate	$20.00-30.00		covered creamer	$15.00-20.00
	Jumbo size cup & saucer	$25.00-35.00		Gladding-McBean's "Catalina Pottery":	
98	Chef design wallpocket	$50.00-75.00		5" fish vase	$75.00-100.00
	Spoon rest	$20.00-30.00		8" vase (original Island mold)	$100.00-150.00
99	Kay Finch Chanticleer	$250.00-350.00		mermaid figurine	$125.00-175.00
	Sea shell low flower bowl	$40.00-55.00		Catalina Pottery line vase #C381	$100.00-150.00
	fish	$65.00-85.00		low bowl #C282	$35.00-45.00
	Cotton tail	$75.00-100.00	109	Satin glaze Samoan woman	$125.00-175.00
	Santa Claus tumbler or vase	$65.00-85.00		Terra cotta Samoan woman	$150.00-200.00
	Pair of circus monkeys set	$175.00-250.00		Peasant woman vase	$50.00-75.00

Pg.	Item	Price
109	Ox-blood glazed artware:	
	4½" square vase	$125.00-175.00
	9½" vase	$250.00-350.00
	6" trumpet shaped vase	$250.00-350.00
110	Leaf shaped wallpocket	$50.00-65.00
	Advertising ashtray	$50.00-65.00
	"Metropolitan" dinnerware:	
	dinner plate	$15.00-20.00
	cream soup	$25.00-35.00
	after dinner coffee cup & saucer	$25.00-35.00
	teapot	$65.00-85.00
	"Tiempo" tumbler	$15.00-20.00
	teacup	$12.00-15.00
111	"Trio" coffee pot	$60.00-80.00
	shakers	$15.00-20.00
	dinner plate	$15.00-20.00
	"Franciscan Fine China" patterns:	
	"Debut" teapot	$100.00-150.00
	"Mesa" coupe soup bowl	$45.00-60.00
	"Westwood fruit bowl	$35.00-45.00
	"Brentwood" oval vegetable bowl	$50.00-65.00
	"Cherokee Rose" sauce boat	$50.00-65.00
112	Hagen-Renaker The Three Bears set	$45.00-60.00
	"Black Bisque" line items:	
	dodo birds	ea. $45.00-60.00
	flat face fox	$45.00-60.00
	Hagen-Renaker early (Monrovia) horse	$75.00-100.00
	Arabian stallion	$200.00-275.00
	Arabian colt	$100.00-150.00
113	"Fantasia" Baby Pegasus	$150.00-200.00
	unicorn	$200.00-275.00
	Pan on Greek column	set $250.00-350.00
	Bacchus	$200.00-275.00
	Wall plaque	$150.00-200.00
	Pig Bank	$300.00-400.00
	Pasha the baby elephant	$75.00-100.00
	Miss Pepper	$150.00-200.00
114	Standing goose	$75.00-100.00
	baby rabbit	$45.00-60.00
	Carmencita, begging chihuahua puppy	$75.00-100.00
	Squirrel named Peggy	$40.00-55.00
	Hagan-Renaker minis (all current):	
	kitten who lost her mittens	
	creeping siamese kitten	
	baby bear	
	chipmunk	
	hippo	
115	Caliente monkey	$45.00-60.00
	Artware low flower bowl	$30.00-40.00
	rose bowl	$35.00-45.00
	The Caliente clay menagerie:	
	5" deer	$20.00-30.00
	Caliente Pottery dealer sign	$150.00-200.00
	comic elephant	$35.00-45.00
	duck	$20.00-30.00
	sad hound	$25.00-35.00
	fire hydrant	$25.00-35.00
	pointer	$30.00-40.00
	goose	$20.00-30.00
	seated deer	$20.00-30.00
	penguin	$25.00-35.00
	Caliente dancing lady #408	$50.00-65.00
115	lady #412	$50.00-65.00
	lady #402	$50.00-65.00

Pg.	Item	Price
115	lady #401	$50.00-65.00
	lady #403	$50.00-65.00
	lady #405	$50.00-65.00
	lady #407	$50.00-65.00
	Floral Artware:	
	5¾" vase	$25.00-35.00
	7½" vase	$30.00-40.00
	10" ewer	$25.00-35.00
	6½" triple bud vase	$30.00-40.00
116	Decorative Caliente Pottery:	
	low flower bowl/dahlia & leaves	$20.00-30.00
	low flower bowl/dogwood & leaves	$20.00-30.00
	low bowl with hand-coiled handles	$20.00-30.00
	candle holder	$12.00-15.00
	Chinese style flared bowl	$35.00-45.00
	Slave woman at block figure	$75.00-100.00
	low bowl	$20.00-30.00
	Swan planter or candy dish	$25.00-35.00
	Pink shell planter	$30.00-40.00
	Wall Pocket	$35.00-45.00
117	Brad Keeler flamingo	$60.00-80.00
	Canary set (female)	$30.00-40.00
	male canary	$30.00-40.00
	10½" seagull	$65.00-85.00
	Naturalistic blue jay	$50.00-65.00
118	Siamese cat	$45.00-60.00
	Pair of graceful flamingos	set $125.00-175.00
	Begging cocker spaniel pup	$30.00-40.00
	Pair of small-scale ducks	set $30.00-40.00
119	7¼" William Manker vase	$75.00-100.00
	6" citron green covered jar	$100.00-150.00
	Exceptional floral artware:	
	rectangular vase	$75.00-100.00
	square vase	$75.00-100.00
	fluted vase	$75.00-100.00
	William Manker artware:	
	small egg shape bowl	$50.00-65.00
	cylinder vase	$75.00-100.00
	tall cylinder vase	$200.00-275.00
	stilted vase	$50.00-65.00
	8" cylinder vases:	
	citron green and dove grey	$75.00-100.00
	powder blue and light rose	$75.00-100.00
120	16½" low flower-arranging bowl	$150.00-200.00
	Leaf shaped luncheon set bowl	$125.00-175.00
	cup & saucer	$45.00-60.00
	7½" plate	$40.00-55.00
	Miniatures by Manker:	
	six sided vase	$75.00-100.00
	2½" vase	$75.00-100.00
	4" fawn figurine	$100.00-150.00
	2¾" vase	$75.00-100.00
	Christmas design candle holders	$30.00-40.00
	oblong design	$30.00-40.00
	leaf design candle & flower holder	$30.00-40.00
	Fish design condiment tray	$150.00-200.00
121	Metlox 8¾" figurine-flower holder	$150.00-200.00
	Metlox Miniatures monkey	$75.00-100.00
	5" cubistic dog figurines	ea. $75.00-100.00
	9" Indian brave	$200.00-275.00
122	Angel fish vase	$75.00-100.00
	Pintoria dinnerware service bowl	$60.00-80.00
	dinner plate	$40.00-55.00
	small bowl	$35.00-45.00

Pg.	Item	Price
141	9½" plate	$20.00-30.00
	Egg cup lineup: "Modern California"	$20.00-30.00
	"Early California"	$20.00-30.00
	"Multi Flori"	$30.00-40.00
	"Casa California"	$25.00-35.00
	"Ring Bowls": #1 Blue	$60.00-80.00
	#2 ivory	$50.00-65.00
	#3 pink	$45.00-60.00
	"Ecstacy" 2 qt. disk pitcher	$75.00-100.00
	"Early California" 1 qt. pitcher	$25.00-35.00
	"Early California" 3 pint jug	$35.00-45.00
	"Calico" syrup pitcher	$50.00-65.00
	"Ultra California" dinnerware:	
	1 pt. bowl bowl in buttercup	$20.00-30.00
	luncheon plate in aster	$15.00-20.00
	bread & butter plate in gardenia	$6.00-8.00
	chowder bowl in carnation	$20.00-30.00
	cup & saucer in ice green	$20.00-30.00
142	Rockwell Kent's Salamina chop plate	$250.00-350.00
	Fantasia "Nutcracker" coffee pot	$300.00-400.00
	mug	$125.00-175.00
	4½" satyr figurines	ea. $250.00-350.00
	"Lei Lani" 14" chop plate	$75.00-100.00
	"Hawaiian Flowers" ice tea tumbler	$35.00-45.00
143	"Dewdrop Fairies" salt/pepper shakers	$100.00-150.00
	"Winchester 73" 13" chop plate	$60.00-85.00
	large ceramic/wood shakers	$75.00-100.00
	Hollywood souvenir plate	$35.00-45.00
	Commemorative Vernon Kilns plate	$75.00-100.00
	"Chatelaine" dinner plate	$20.00-30.00
	tea cup & saucer	$20.00-30.00
144	Wallace China "Rodeo" 7½ oz. cup	$45.00-60.00
	"Rodeo" saucer	$25.00-35.00
	dinner plate	$60.00-80.00
	bread & butter plate	$35.00-45.00
	"Pioneer Trails 13" chop plate	$200.00-250.00
	Hibiscus pattern dinner plate	$15.00-20.00
	"Chuck Wagon" bowl	$25.00-35.00
145	Biltmore Hotel ashtray	$45.00-60.00
	"Desert Ware" line bowls	ea. $15.00-20.00
	Plate displaying colors for patterns	$25.00-35.00
	Ashtray with Christmas greetings	$50.00-65.00
146	Will-George's elegant flamingos	ea. $100.00-150.00
147	Artist and model set of figurines	set $100.00-150.00
	Small rooster tray	$50.00-65.00
	Small bird on brach	$45.00-60.00
	Cardinal on branch	$85.00-125.00
148	Dachshund	$125.00-175.00
	Gondola-shaped flower bowl ..complete	$75.00-100.00
149	Winfield "Primitive Pony 9" bowl	$40.00-55.00
	cup & saucer	$20.00-30.00
	"Geranium" dessert/breakfast plate	$20.00-30.00
	undecorated coffee pot	$35.00-45.00
	Winfield porcelain artware 4¾" vase	$25.00-35.00
	4¼" vase	$20.00-30.00
	8½" vase	$60.00-80.00
	deer	$100.00-150.00
	Early artware bottle with stopper	$35.00-45.00
	5¼" vase	$40.00-55.00
	cylinder vase	$30.00-40.00
	4" vase	$45.00-60.00
	Winfield's sq. dessert/breakfast plate	$15.00-20.00
	7½" salad plate	$12.00-15.00
	4¾" dessert bowl	$15.00-20.00
	small cream pitcher	$20.00-30.00
150	Hot chocolate set covered server	$75.00-100.00
	small handled mugs	ea. $25.00-35.00
150	Winfield covered mustard jar	$20.00-30.00
	covered honey jar	$50.00-65.00
	covered jam jar	$25.00-35.00
	turtle shaped cigarette box	$35.00-45.00
	Double boat-shaped relish	$25.00-35.00
	scoop	$20.00-30.00
	single boat-shaped relish	$25.00-35.00
	Individual casserole in chartreuse	$20.00-30.00
	9" square plate	$30.00-40.00
	Winfield casual porcelain:	
	coffee pot in yellow-sage	$35.00-45.00
	1 quart pitcher in chartreuse	$25.00-35.00
	coffee/tea pot in azure-brown rim	$30.00-40.00
	scuttle in yellow-sage	$30.00-40.00
151	Ball Artware pheasant	$50.00-65.00
	Marc Bellaire "Friendly Island" tray	$75.00-100.00
	Arcadia Ceramics salt/pepper	ea. set $35.00-45.00
	Marc Bellaire candlesticks	set $75.00-100.00
152	Cemar deer figurine	$35.00-45.00
	Cemar fish shaped condiment jar	$35.00-45.00
	De Lee Art "Skunkettes"	ea. $20.00-30.00
	De Lee Art Latino dancers	ea. $45.00-60.00
153	Doranne of Cal. tortoise/hare cookie jar	$45.00-60.00
	Flintridge China dinner plate	$25.00-35.00
	teapot	$60.00-80.00
	Guppy "Island Ware" service plate	$15.00-20.00
	stacked saucers	ea. $6.00-8.00
	cup	$20.00-30.00
	shaker	$15.00-20.00
	tumbler	$20.00-30.00
	tumbler/vase	$20.00-30.00
	Harold Johnson's low flower bowls	ea. $35.00-45.00
154	La Canada dinner plate	$15.00-20.00
	small pitcher	$25.00-35.00
	Maddux cockatoo on floral branch	$60.00-80.00
	Jean Manley's boy holding duck figurine	$35.00-45.00
	Jean Manley's girl holding fruit figurine	$45.00-60.00
	Robert Maxwell's stoneware vase	$30.00-40.00
	Maddux's double flamingo vase	$50.00-65.00
	single flamingo planter	$50.00-65.00
155	McCarty Brothers Mexican children	set $35.00-45.00
	Padre honey jar	$35.00-45.00
	Poxon's Mission vase	$125.00-175.00
	Padre calla lily wallpocket	$50.00-65.00
156	Robertson hand-decorated plate	$150.00-200.00
	Santa Anita "Stylized Spirals" plate	$12.00-15.00
	cup & saucer	$15.00-20.00
	"Bird of Paradise" dinner plate	$15.00-20.00
	Robertson Pottery table lamp	$200.00-275.00
	Weil sailor boy vase	$45.00-60.00
157	Weil "Malay Bambu" chop plate	$30.00-40.00
	"Malay Blossom" dinner plate	$15.00-20.00
	lug soup	$15.00-20.00
	cup	$8.00-10.00
	fruit bowl	$8.00-10.00
	West Coast pheasant	$15.00-20.00
	rose bowl	$20.00-25.00
	Eugene White tray	$60.00-80.00
	handled dish	$45.00-60.00
	bowl with hammered copper lid	$70.00-100.00
	Vally Werner vase	$25.00-35.00
	Ynez Jennifer figurine	$35.00-45.00
158	Vally Werner vase with under tray	$35.00-45.00
	small round jar	$20.00-30.00
	Barbara Willis jug vase	$35.00-45.00
	6" vase	$40.00-55.00
	4½" vase	$40.00-55.00

Schroeder's ANTIQUES Price Guide

. . . is the #1 best-selling antiques & collectibles value guide on the market today, and here's why . . .

Schroeder's ANTIQUES Price Guide

OUR #1 BEST SELLER!

Identification & Values Of Over 50,000 Antiques & Collectibles

8½ x 11, 608 Pages, $12.95

- *More than 300 advisors, well-known dealers, and top-notch collectors work together with our editors to bring you accurate information regarding pricing and identification.*

- *More than 45,000 items in almost 500 categories are listed along with hundreds of sharp original photos that illustrate not only the rare and unusual, but the common, popular collectibles as well.*

- *Each large close-up shot shows important details clearly. Every subject is represented with histories and background information, a feature not found in any of our competitors' publications.*

- *Our editors keep abreast of newly developing trends, often adding several new categories a year as the need arises.*

If it merits the interest of today's collector, you'll find it in *Schroeder's*. And you can feel confident that the information we publish is up to date and accurate. Our advisors thoroughly check each category to spot inconsistencies, listings that may not be entirely reflective of market dealings, and lines too vague to be of merit. Only the best of the lot remains for publication.

Without doubt, you'll find
SCHROEDER'S ANTIQUES PRICE GUIDE
the only one to buy for
reliable information and values.

COLLECTOR BOOKS
A Division of Schroeder Publishing Co., Inc.